Digital Photographer's Guide to B&W Landscape Photography

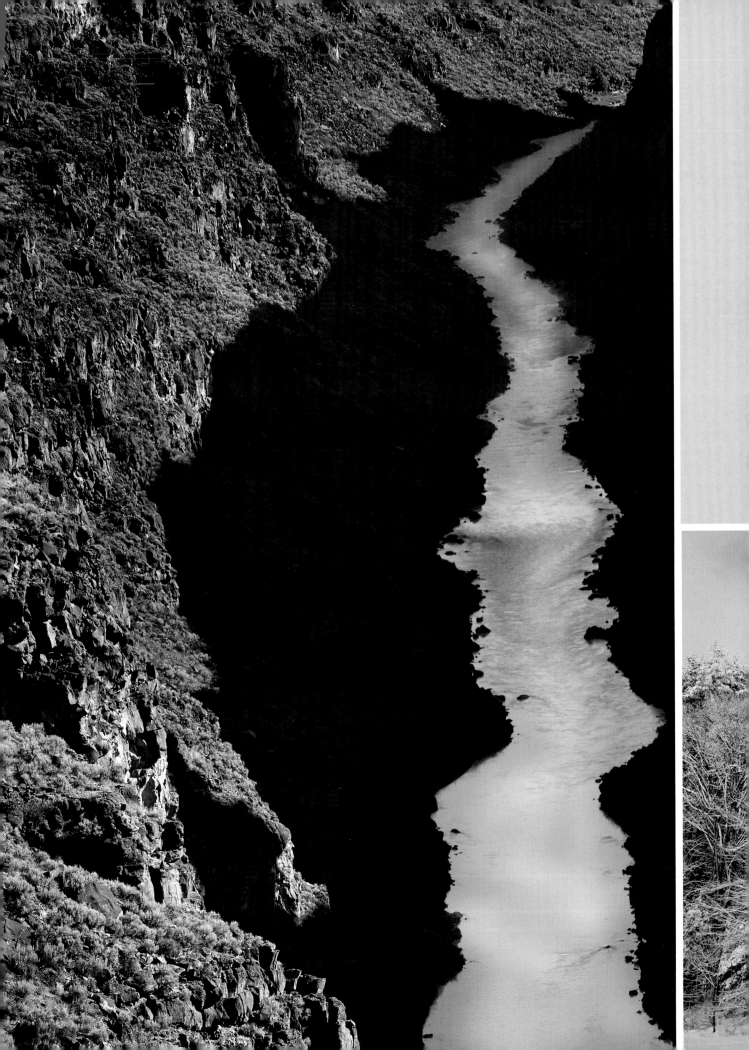

Digital Photographer's Guide to B&W Landscape Photography

George Schaub

LARK BOOKS

A Division of Sterling Publishing Co., Inc.
New York / London

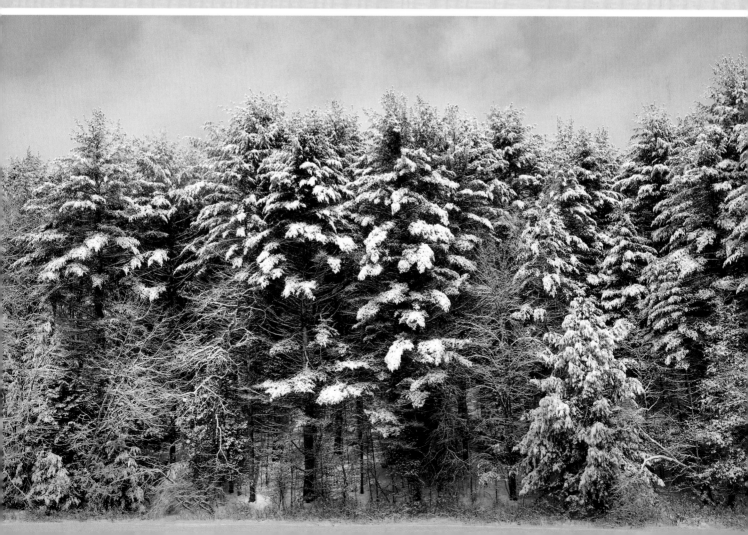

Art Director: Tom Metcalf
Cover Designer: Thom Gaines
Production Coordinator: Lance Wille

Library of Congress Cataloging-in-Publication Data

Schaub, George.
 Digital Photographer's Guide to B&W Landscape Photography / George C. Schaub.
 — 1st ed.
 p. cm.
 Includes index.
 ISBN 978-1-60059-390-1 (pb-pbk. with flaps : alk. paper)
 1. Photography—Digital techniques. 2. Landscape photography. 3.
Black-and-white photography. I. Title.
 TR660.S35 2009
 778.9'36—dc22

 2008028376

10 9 8 7 6 5 4 3 2 1

First Edition

Published by Lark Books, A Division of
Sterling Publishing Co., Inc.
387 Park Avenue South, New York, N.Y. 10016

Text © 2009, George Schaub
Photography © 2009, George Schaub unless otherwise specified
Illustration of woman with camera on page 8: Courtesy of George Eastman House, International Museum of Photography and Film
Back flap photo of the author © Grace Schaub
Flower photos on page 27 © Kevin Kopp

Distributed in Canada by Sterling Publishing,
c/o Canadian Manda Group, 165 Dufferin Street
Toronto, Ontario, Canada M6K 3H6

Distributed in the United Kingdom by GMC Distribution Services,
Castle Place, 166 High Street, Lewes, East Sussex, England BN7 1XU

Distributed in Australia by Capricorn Link (Australia) Pty Ltd.,
P.O. Box 704, Windsor, NSW 2756 Australia

If you have questions or comments about this book, please contact:
Lark Books
67 Broadway
Asheville, NC 28801
(828) 253-0467

ISBN 13: 978-1-60059-390-1

For information about custom editions, special sales, premium and corporate purchases, please contact Sterling Special Sales Department at 800-805-5489 or specialsales@sterlingpub.com.

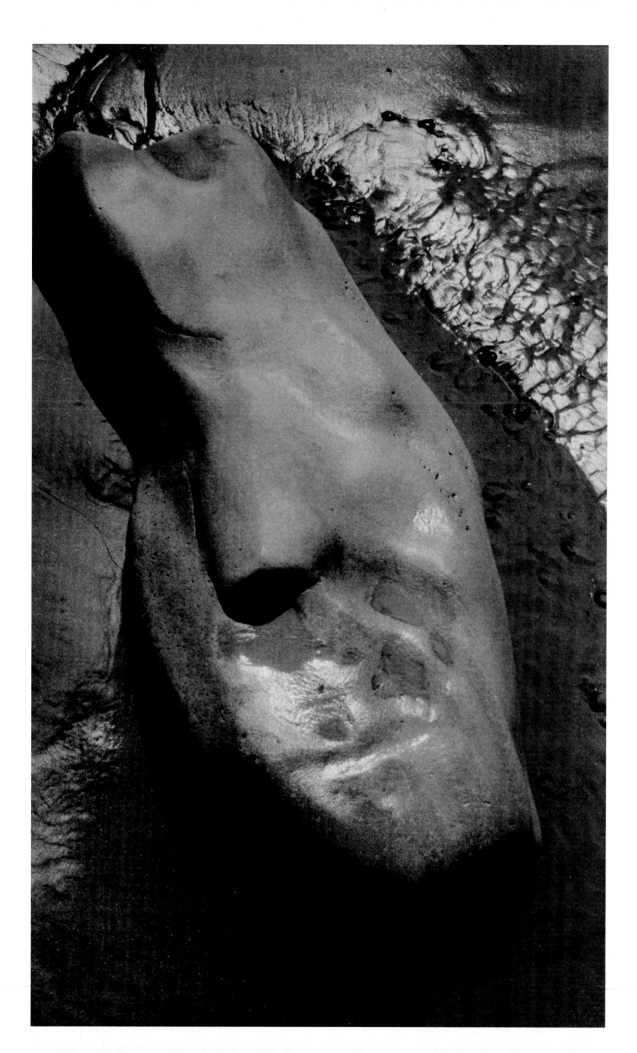

contents

Introduction ..8

Black and White: From Film to Digital10
 Density..12
 Format..12
 RAW ...12
 RGB..14
 Why Black and White?14
 Key: High and Low............................18
 Interpretation19
 Scanning Film Images22

Seeing in Grayscale.................................24
 The Panchromatic Illusion26
 Monochrome Digital Filters27
 Study the Light..................................28
 Infrared Black and White30
 Contrast ..32
 The Freedom of Digital.....................35

Composition ...36
 Rule of Thirds....................................38
 The Wheel and the Spoke.................39
 Perspective ...40
 Foreshortening.............................40
 Stacking...40
 Selective Color Conversion to Grayscale42
 Abstraction ..42
 The Flow of Light and Forms47
 Compositional Zones48
 Previsualization..................................52
 More than Rocks and Trees...............52

Shooting the Best Images54
 File Format ...56
 Optimizing Images in Camera58
 Color Space58
 Monochrome Option58
 Tone Curve Control......................60
 Sharpness and Depth of Field...........61
 Focus ...66

Bracketing...70
Shutter Release Options......................72
Custom Functions................................73

Exposure..74
 The Digital Exposure..........................76
 Objective and Subjective Exposure............78
 ISO ..79
 Shutter Speed80
 Aperture83
 Exposure Value and Equivalent Exposure...84
 Maintaining Equivalent Exposure84
 Dynamic Range85
 Metering Systems88
 Multi-Pattern Metering................90
 Center-Weighted Average Metering90
 Spot Metering...............................91
 The Grayscale Spectrum...............92
 Handheld Meters...........................93
 Exposure Modes93
 Manual Exposure Mode94
 Autoexposure Lock96
 Exposure Compensation......................97
 Autoexposure Bracketing & HDR.....................98
 Exposure Diagnostics in the Field100
 Highlight Warning100
 The Digital Dynamics of Overexposure!.....101
 Histograms102
 Test Your Camera's Exposure System..............104
 Summary of Exposure Tips and Guidelines104

Image Processing106
 RAW Converters106
 Color Conversion to Grayscale111
 Using Image-Processing Programs...................112
 Working in Layers113
 Layer Masks113
 Exposure.......................................114
 Contrast116
 Selective Exposure and Contrast Control120
 Selection Tools.............................121

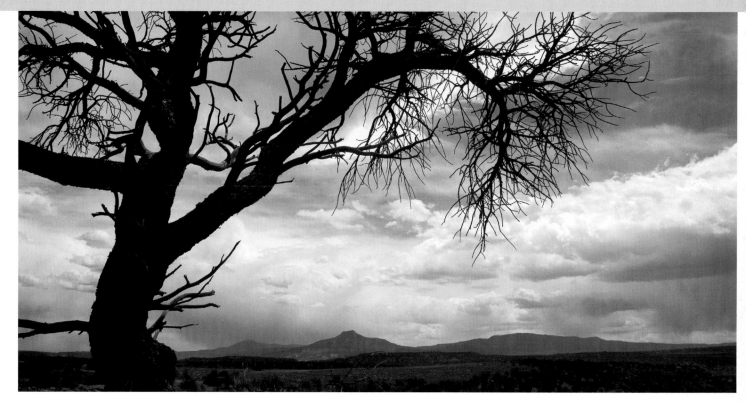

Refining Local Exposure and Contrast........126

Special Effects ...129

 Toning..129

 Duotones, Tritones, Quadtones.................131

 Emulations ...133

 Colorization..134

 Hand Tinting..136

 Low Saturation...137

 High Contrast ..138

 Combining Bracketed Exposures139

 Grain...140

Printing...142

 Paper Profiles ..145

 Papers...146

 Inks..147

 Printing Step by Step148

Glossary...152

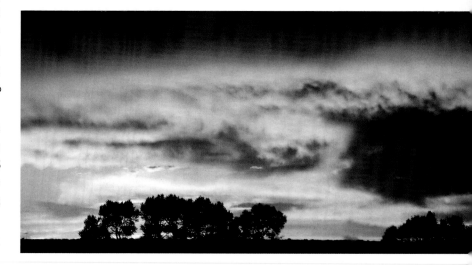

Index ..156

introduction

I have a copy of an old drawing showing a nineteenth century photographer going into the field to make pictures. He is heavily laden with a backpack that carries his camera (the smallest box in the kit), a rolled up tent (his portable darkroom where he prepared his wet plates for exposure), and a large box in which he kept his chemicals and glass plates. There are also some pointed sticks that I assume are the legs of his tripod, absolutely necessary for the long exposures he undoubtedly made. I look at this picture occasionally to remember the dedication of those photographers, all the stuff they had to carry to make photographs outdoors in those days, and to remind myself of how much things have changed.

Today those chemicals and plates have been replaced by a solid-state memory device and a microprocessor inside the camera. As with the woman in the illustration, the tripod might still be there. But the emulsions once mixed on site have been replaced by sensors and programmable electronics that can respond frame by frame to a wide range of light and color conditions.

You don't have to go back 130 years to see how technology has transformed the way we make black-and-white photographs—it was only several years ago that most photographers were still choosing film of a certain light sensitivity that was generally fixed throughout the roll, or changed from sheet to sheet in a large-format camera. Exposure was matched with developing times based upon contrast and light levels. The image was created by running the film through a series of chemical baths, and printing was done in an amber-lit darkroom. While the equipment had certainly become more portable and emulsions more light sensitive, there was really not that much of a fundamental difference between the chemical/metallic photography of 130 years ago and that practiced at the turn of the twenty-first century.

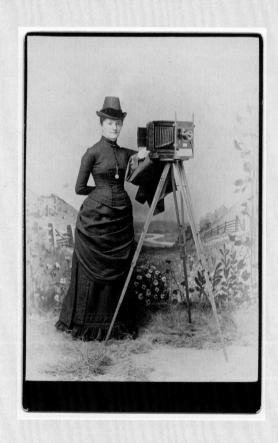

However, all that has now changed. This book explores those changes and how they affect the craft of fine art landscape photography. It covers exposure, processing, and printing—the chain of events that leads to a completed vision. Digital has changed the way you expose and how you should consider contrast and the direction of light. Processing, which in film developing is a variable used to control contrast and density, now encompasses a much broader range of controls that overcome the restrictions of the past—you can now reach back into settings made in the field and change them after the exposure has been made. Indeed, there is no more dye and density—it's now bits and bytes. Printing has finally left the chemical darkroom offering photographers more access for expression than ever before.

The focus here is solely monochrome photography. This does not exclude the use of color as a stylistic or emotional factor in the images; that would be too restrictive and go against a long tradition in black-and-white photography where toning, colorization, and low saturation color effects were perhaps first used as a substitute for the lack of color recording materials, but later became an important part of the aesthetic of the medium. Happily, digital is eminently suited to this approach—you can emulate virtually any period or style you desire and even create new looks on your own.

And naturally, this book is also about landscape photography, images created by the sea or in the mountains, woods, and deserts of the world. The photographs I have chosen are a mix made over many years that illustrate craft, applications, and specific techniques. They include both broad and more intimate studies. Except where images are noted as a scan from film negatives or positives, the images in this book were made with digital cameras.

Many of the photographs were inspired by a play of light, a rough texture, or a pattern that caught my eye; or because I saw a tonal potential that could be enhanced further in processing and printing. My approach to the landscape is quite simple—to walk in nature and literally see what happens.

My aim in this book is to share what I have learned about digital landscape photography over the last ten years. For me this type of photography has arrived at a point where it merges both classical and modern black-and-white practice—classical in the sense that it allows for mastery and enhancement of contrast and tonality previously available to only the most highly trained black-and-white film photographer; modern in the sense that the photographer is able to bring the full power of digital imaging into play for his or her personal expressive and interpretive ends.

Black and White: From Film to Digital

1

Though this book is dedicated to digital techniques, let's begin with a discussion about the similarities and differences between film and digital when it comes to black-and-white photography.

This photo, made in 1992 with a Rolleiflex 2-1/4 camera on Ilford chromogenic film, was scanned to create a digital grayscale file. Having also made this print in the darkroom, I can attest to the greater flexibility, and much greater ease, of getting the tonal play I desired using digital image processing techniques.

First, remember that not all digital images are generated by digital cameras. Perhaps you've got a number of great landscape photos made using film. That doesn't mean you can't email them to friends or print them from your computer. Film images can be digitized with a scanner (see pages 22-23). Photographs in negative, transparency, or print form, either color or black and white, are excellent sources for black-and-white pictures in the digital realm. Once digitized, the former silver-based image becomes subject to the same wide-ranging controls as one made with a digital camera, and can be enhanced and processed with software in the computer.

However, in making the transition from film to digital, perhaps you have brought some assumptions with you about how things work. And, even if you have never shot film, you have probably been exposed to information conveyed by film photographers. Either way, there are a several matters at the heart of black-and-white photography that should be looked at in a new light.

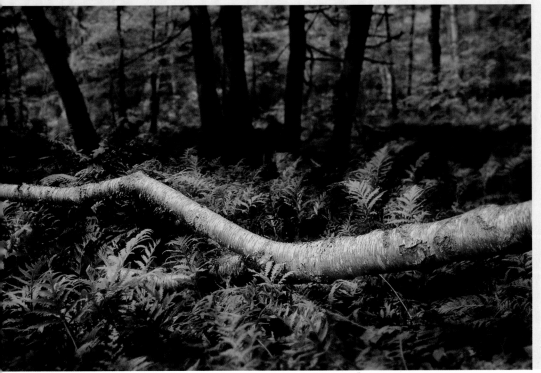

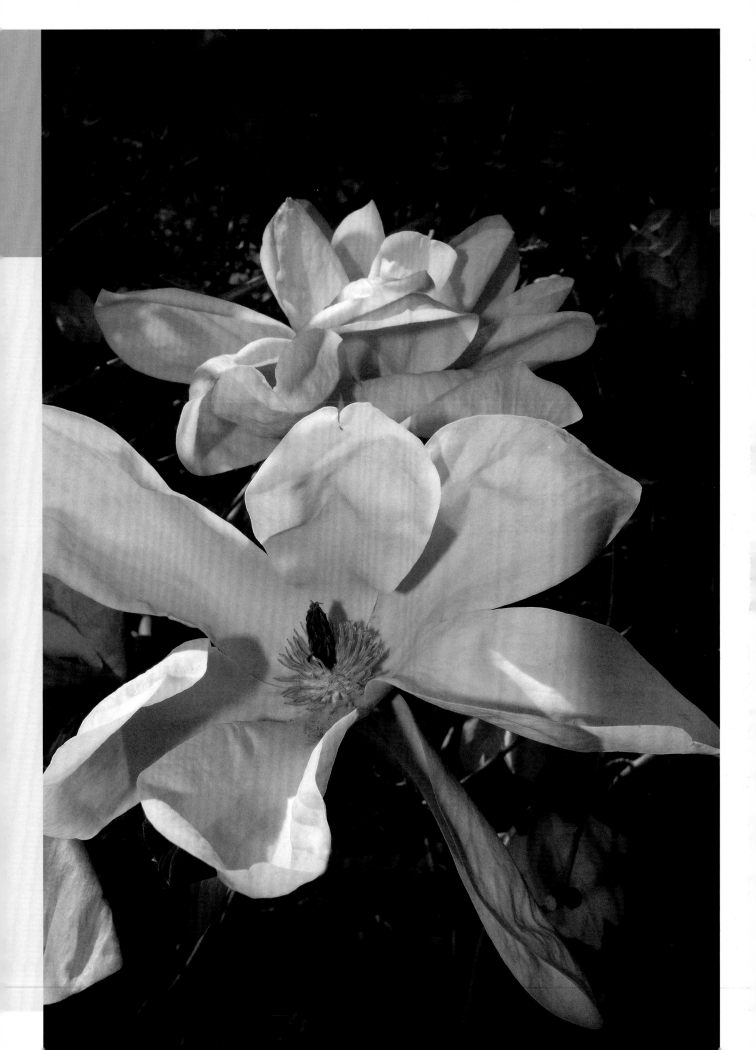

Density

Density on film results from the metallic buildup of silver as a result of exposure and development: The brighter the light, the greater the density on the negative. It determines tonality, as well as contrast. Tonality is another word for shades of gray, or the spectrum from white to black that makes up a black-and-white photograph. More shades of gray are usually associated with a richer, more detailed image.

In digital photography, the image is an amalgamation of codes and instructions that tell the translation devices what to do with the data recorded by the sensor in the camera. There is no material buildup to create density. Indeed, there is actually no image in the camera memory or the computer drive onto which you download—there is simply a bunch of numbers that is later reassembled to look like an image on a monitor or to lay down a particular ink pattern by a printer. So density in a digital image is "virtual"—the light and dark areas are results of codes being translated by the computer onto a display. Many experienced film photographers find this fact weird because it is so different than the analog image generated on a piece of film. But these codes for digital are incredibly malleable and allow for changes that go beyond what can be done when manipulating the light shining through a negative in silver-based photography.

Format

Another factor to consider is format, or size of the medium. Historically, large format film, which is 4 x 5 inches or larger (102 x 127 mm), was attractive because it required less magnification to make large prints and, when used with proper printing techniques, yielded incredible detail and tone. Photographing through a large viewfinder or ground glass was a wonderful way to immerse yourself in the image in the field. Currently, a large format effect can be obtained digitally through sensors that are comparatively big with high resolution (megapixel count) and relatively large pixel (photosite) sizes.

While smaller sensors exist on point-and-shoot digital cameras, there are presently four general classes of sensors in digital single-lens relfex cameras (D-SLR): The 4/3 sensor, the APS-C (or DX) sensor, the FX sensor (full-framed sensor, or roughly equivalent to the size of a 35mm film frame, 24 x 36 mm), and the "large format" sensor, which is roughly equivalent to a 645 film frame (6 x 4.5 cm) or 2-1/4 square 120 film (6 x 6 cm), and is often found as a back modified to fit onto 4 x 5 or medium format cameras. Depending on how large you plan to make prints, and all other things being equal, all these sensors produce image quality at least equivalent to a properly exposed and processed 35mm black-and-white film photo. The FX sensor yields results equivalent to medium format film; and the large format sensor yields results equivalent to large format film.

RAW

Throughout this book I make reference to RAW, which is a digital file format, as being the best way to record images for overall quality. This format is available with every recent D-SLR and some compact digital cameras. When an exposure is made in digital photography, information about the exposure settings, lens, and more is captured by the image processor and applied to the image. In RAW format, this data is appended to the image as a kind of an information sidecar. The RAW file receives little in-camera processing, so it can therefore be manipulated at later stages of processing with greater ease than other types of file formats, such as JPEG or TIFF. In addition, RAW files are capable of gathering more brightness and color information because they contain greater bit depth than JPEG files. Bit depth is a way of structuring information (10, 12, or 14-bit in RAW files, versus 8-bit in JPEG), and higher bit depth can hold substantially more information than lower. This provides more flexibility for processing and enhancing your photo files. We will look more closely at RAW file format and RAW image processing in the chapters that follow.

The top photo, made in late fall, was recorded in RAW and converted to black and white (bottom) using Photoshop® Camera Raw software. In the conversion to grayscale, the yellow/orange colors were brightened and the blue values were darkened. The manipulation of tonality and contrast using color values is an amazingly powerful tool that opens up new creative doors for photographers, similar to the way photographers have used colored filters over their lenses in black-and-white film photography.

RGB

Every image you make in a digital camera is a color image (RGB: Red, Green, Blue)—there is no more black and white! The vast majority of digital cameras have a checkerboard red, green, and blue filter (Bayer pattern) between the lens and the sensor through which light is sorted and then reintegrated in the image processor to create a color image. When you photograph with a digital camera you are recording in three separate color channels that are integrated by the image processor.

So, how do we get a digital black-and-white image? This must be done as an image-processing step, either with a JPEG file using an in-camera setting for monochrome recording, or as a conversion of any file in the computer. (Monochrome images consist of different tones of a single color, not necessarily just shades of gray.)

Converting an image to black and white allows for a great amount of tonal control, as each color can be manipulated, within limits, to create a certain grayscale value. This is quite a difference from trying to wring a decent black-and-white image from color film using conventional darkroom techniques.

Why Black and White?

There's a magical quality to the black-and-white image, whether it be silver-based or digital. Tonality, the interplay of light and dark, is at the heart of black-and-white photography. These tones are interpretations of how bright (or dark) those colors are in the scene.

In terms of pure visual enjoyment, there is beauty in these tonal values—the shades of gray, deep blacks, and bright whites—that express the interaction between light and shadow unlike any other medium. The tones are versatile, and can be made to represent with equal power both the hard glint off freshly-fallen snow and the soft, diffuse light of fog rising from a river valley on an autumn morning.

Black and white is a fascinating medium for several reasons. It allows us to visualize the world without the distraction of color. This permits us to approach the heart of a subject or natural design in its purest form. It offers tremendous flexibility to control brightness and contrast, as well as a unique capacity to express feeling and atmosphere.

You will find a special sense of freedom to create with black and white, because each step of making the image presents numerous choices for artistic interpretation that affect the look and feel of the final photo. Through exposure, camera settings, image manipulation using computer software, and printing, the black-

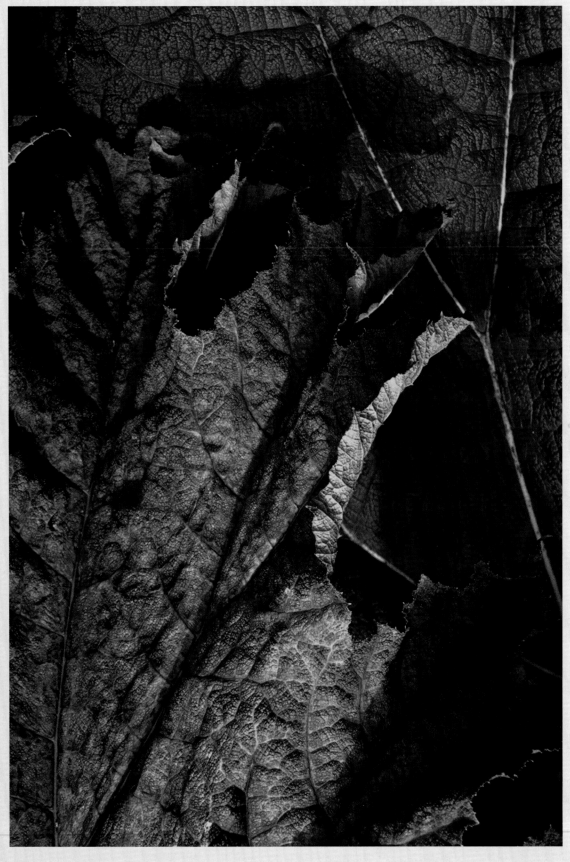

There is a wide range of gray tones from white to black in this close-up of a leaf. I often use this as a test image to check out a new printer or software because there is detail in both the highlights and the shadows.

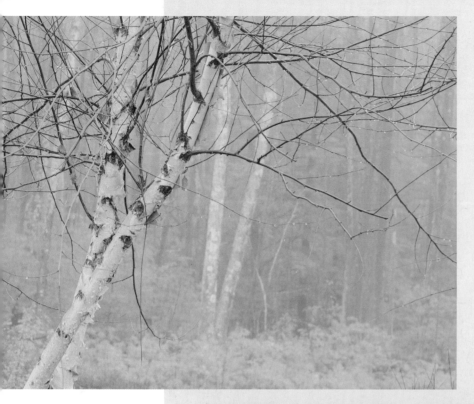

and-white photograph can be altered to reflect a personal interpretation or vision. Knowing the different choices and options available to fulfill your vision is important; knowing how to apply them to the image at hand so that you achieve a desired result is equally important.

Monochrome images often reveal mood or emotion in a scene. There is a delicate and ethereal feeling to the photo of a foggy morning in New Hampshire (left), and to the ghost-like tree on the opposite page. The photo below, made using a specialized accessory called a Lensbaby, conveys a sense of mystery.

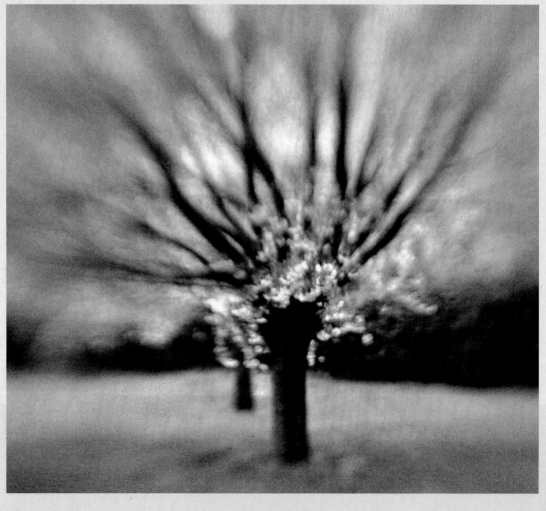

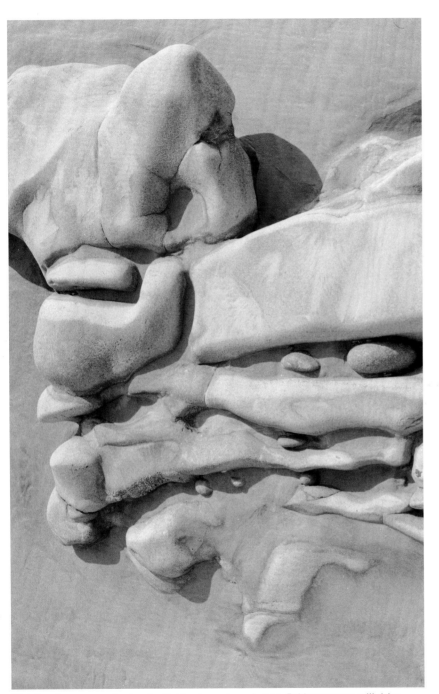

Key: High and Low

One term that helps define the light and tonality in a photograph is "key." When applied to your photography, the word refers to high-key and low-key scenes and prints. A low-key image is one dominated by dark tones and has few if any bright or highlight values. It may set a somber mood or convey a scene that says deep shade or early morning, or it may simply explore the play among the darker tones of gray and black. A high-key scene often creates a lighter mood, with an airiness or openness that is enhanced by the bright values of light grays and whites.

High-key images emphasize the lighter tones in an image. Subject matter will drive your interpretation, which can be enhanced in software. This arrangement of rocks on a beach was exposed normally, then made into a high-key image using the Levels control. Note that the highlights are preserved, while the shadow areas have been opened to become much lighter.

Interpretation

One of the great attractions of black-and-white photography is that it facilitates the ability to interpret the subject in new and sometimes unusual ways. Some images seem to point in a specific interpretive direction, while others are fairly open-ended. Understanding the scene's capability for tonal play helps you previsualize possible final effects while still in the field, making black-and-white photography challenging and exciting. The aim for the photographer, and hopefully for the viewer, is to develop a deeper consciousness and awareness of light, form, and perhaps even visual metaphor.

This is achieved by merging your artistic vision with the application of techniques. The techniques can be used to enhance both the record of the scene (making an image with tonal values that are true to the scene) or your perceptions and feelings about it. Depending on your decisions, you can create an image of a scene pervaded by light or one set in deep, dark tones. The objective record that is true to the scene does not change; what changes is your interpretation, the way the scene is altered by journeying through your mind's eye.

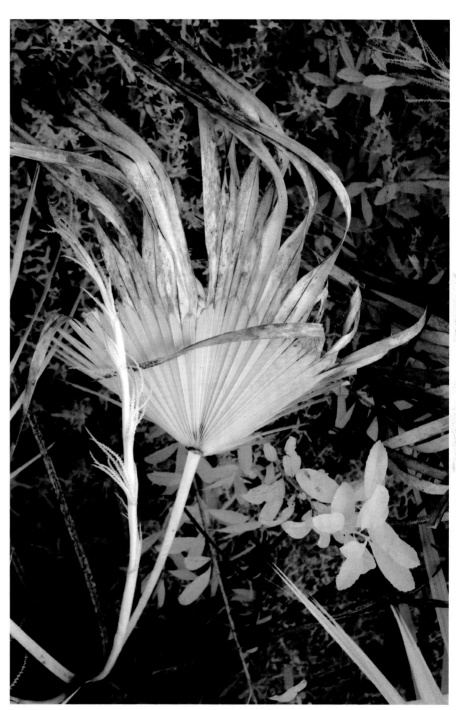

Because they lack color that distracts our attention, black-and-white compositions often make successful abstract images, giving our minds license to wander. One interpretation of this infrared photo might emphasize the well-ordered lines of the palm frond as they spread from the stem, only to wither in decay. Another narrative might include form and tone as a layered matrix of different grayscale values.

When I came upon this pattern in a frozen pond (above), I knew before even raising my camera how I wanted it to look after exposure, processing, and printing. The first step in the computer was converting it to black and white (right). I then used several software tools to create a deep black and to reveal the brighter values (opposite page).

This ability to influence the interpretation of a place or event in an image is one of the powers granted to all photographers, one that is now greatly enhanced through the use of digital image-processing techniques. The final image can become a remembrance of the objective scene as interpreted through the artistic eye of the individual photographer. Indeed, most effective and expressive black-and-white images are re-interpretations that result from the photographer's exploration of the visual possibilities.

In fact, I often approach an image differently each time I open it on the computer, especially if I haven't looked at it in a long time. The key is exposing an original photo so there is a broad range of values that don't constrain your expression later.

SCANNING FILM IMAGES

Though I now photograph solely with a digital camera, I still have lots of film images from my pre digital days. If you are in the same boat, I encourage you to resuscitate those old negatives and slides. Scanning and inkjet printing is a sensible and creative means to realize them.

Scanners vary greatly in their specifications and capabilities, so do some research to understand the best scanning procedures, and find a quality scanning system for the format you want to digitize. While dedicated film scanners often yield the best results, modern flatbed scanners (for reflective as well as transmissive material, i.e., film) have improved dramatically.

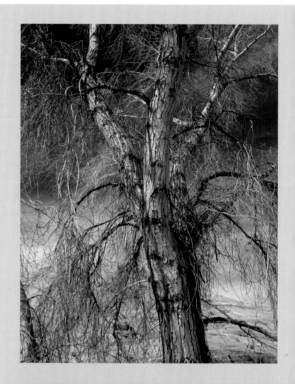

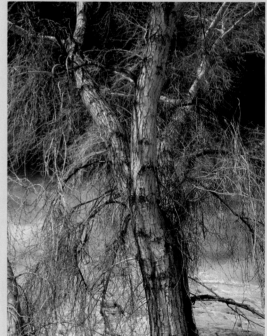

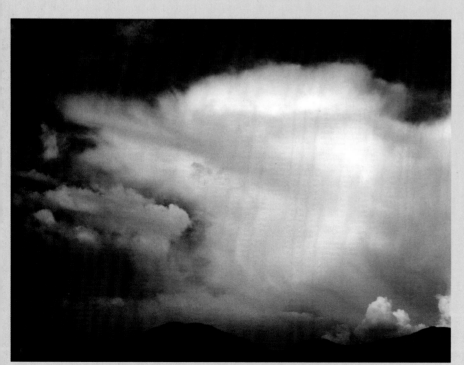

The mantra to "do no harm" was important for this scan as I could have added excessive contrast, which would have blown out the highlight areas in the cloud.

You can store and view all of your landscape images from film, slides, and negatives on the computer. Scan your color slides to create digital files and convert them later to black and white with image-processing software.

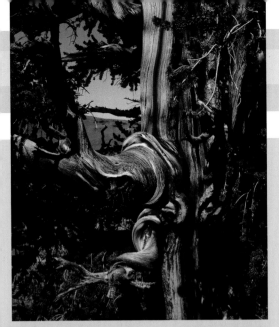

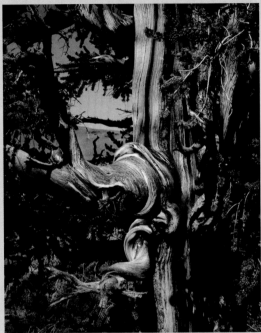

Slides that have begun to lose dye integrity can often be digitally salvaged for black-and-white printing. Though this Ektachrome slide from nearly thirty years ago has begun a magenta shift (top), it can be rendered as a very pleasing black and white, making an excellent 13 x 19 inch print (33 x 48 cm).

The main thing when scanning is to "do no harm." My approach is to scan at the maximum optical resolution of the scanner, not using any interpolation, in order to get as much image information out of the film as possible without doing many corrective procedures in the scanner stage. You can also have a pro lab scan the images you want to print.

Scanning Tips

• Do No Harm. Do not try to enhance contrast too much or fix exposure problems; save that for the image-processing software.

• Scan for the highest non-interpolated resolution you think is necessary. Do not resample in the scanner software. Never exceed the scanner's optical resolution.

• Scan at the highest bit depth available.

• It's often advantageous when scanning color negatives or slides to convert to black and white later in image-processing software.

• Test the dust and scratch removal software in your scanner to see if and when it causes unsharpness. While excessive use will harm image integrity, such programs can help save retouching time later (Note: it does not work with black-and-white negatives and Kodachrome slides.)

• Scanning from slides is often easier than working from negatives because well-exposed slides do not have blown highlights, though they tend to be higher in contrast, which is a challenge onto itself.

• Watch for highlights. If necessary, lower contrast in the scan phase. You are collecting information, and if you do not record the information in the scan you will not have it to work with later.

Seeing in Grayscale

2

The world is filled with color in all its hue and shades, from the brilliant azure of a tropical sea to the rich red of a garden rose, yet we accept black and white as quite natural, as a fair and reasonable representation of what we have photographed. And even further, a black-and-white print can be more evocative and dramatic than a color print. It can reveal the detail, design, and texture of a subject in a more powerful way, as if color is a distraction from what really stands before our lens.

"Seeing" in black and white comes naturally to some photographers; for others the translation of light and color to black and white—or more properly, grayscale values—can be more difficult. Fortunately, seeing how a scene might translate to black and white is a skill that can be acquired with practice. Digital cameras with Monochrome recording mode (or a variation) make it possible to see this transformation on the LCD monitor, either after the image is made or, if the camera is capable, as the image is being composed using Live View.

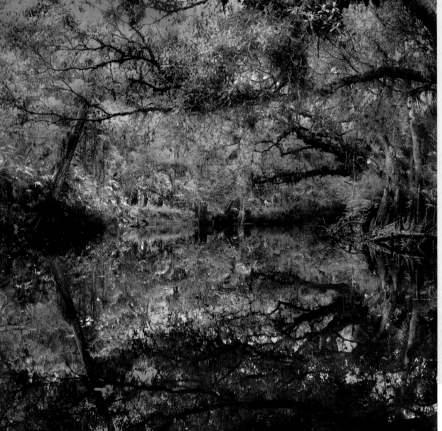

Think of grayscale values as tones within the spectrum between pure white and black, each one a mixture that yields a shade of gray. When you first look at a black-and-white print, you might not see these individual shades, since they form a continuous tone image. But over time, as you learn to discern those shades of gray, along with pure black and white areas, you will understand how they contribute to the verisimilitude of the photographic image.

This photograph shows a wide array of tones that reveal shadowed areas, reflections, reflective fill, and bright highlights. Image processing was done in the computer to add richness and contrast to those grayscale values.

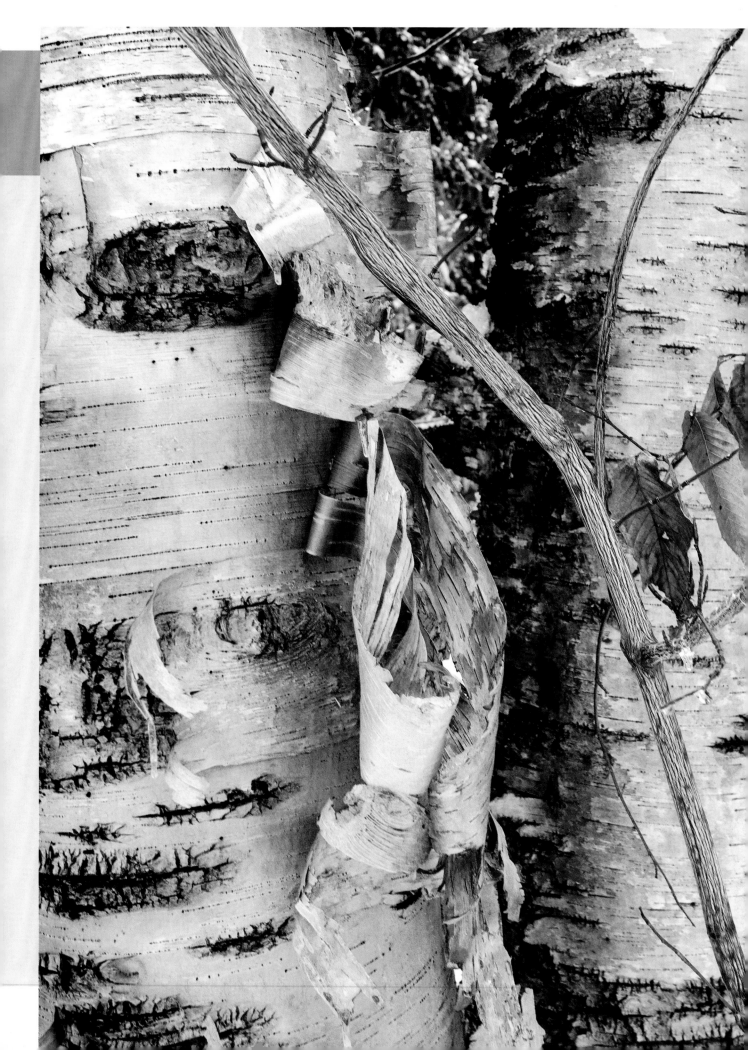

Graytones in a well-exposed image of a standard subject can be seen from bright white to deep black. Making exposures that encompass as many of these brightness values as possible allows a wide range of expression, including the option to enhance the image using software tools in the computer after you have recorded it (see Chapter 6 on processing images in the computer).

The Panchromatic Illusion

Keep in mind that every digital image you take is an RGB (color) image, and that the standard black-and-white version generated by the camera emulates how black-and-white panchromatic film would portray those colors. When panchromatic film renders a full color scene to black and white, a red rose appears fairly dark, blue sky is fairly light, and green grass is a deep midtone. These graytones vary according to the brightness of the light striking the object and to the object's color.

This panchromatic response can be manipulated in digital because every image you expose is originally composed of RGB channels that allow changes in how each is converted to grayscale. This alters much of what you might have learned about black-and-white photography with film, because film emulsion has a pre-determined response to color that cannot be changed after an exposure is made, while the digital response for converting color into grayscale values can, to a great extent, be controlled.

Recording in digital also makes moot traditional methods of manipulating contrast and the grayscale rendition of certain colors with black-and-white film. For example, when photographing with film, you would change how a specific color records as a graytone by using a color filter on the lens. This would block and pass certain colors, depending upon the color of the filter; like colors would pass (and create more density in the negative, thus print lighter) and opposite colors would be blocked (thus create less exposure density, and print darker.) Using color filters with a digital camera would affect the character of your image, but there is no need to do so because all you need do is program the processor to imitate the effect you desire.

MONOCHROME DIGITAL FILTERS

The translation of color to grayscale, which we'll call a conversion, raises interesting options in black-and-white digital work. Grayscale conversion is commonly performed in the computer using a number of tools available in image-processing programs (see Chapter 6).

However, most cameras provide menu options for controlling certain aspects of image processing. One such option found in many of today's D-SLRs is a Monochrome recording mode that often allows adjustments that emulate the effects of using color contrast filters with black-and-white film as described on the opposite page.

The following images illustrate how digital filters imitate the use of color contrast filters on the lens:

Photo A is an RGB image of a red flower.

Photo B is a photo of the same flower with an in-camera setting applied for a monochrome digital filter. It shows how a red flower would appear when shot on panchromatic film with a red filter on the lens, lightening the red.

Photo C similarly emulates a monochrome conversion, this time with an in-camera green filter effect applied. It is as the picture would appear if shot on panchromatic film with a green filter used on the lens. The green leaves in the background are lighter, but the red flower is darker.

Photo D shows how a red flower looks when a yellow filter effect is applied. The tone of the flower is darker than the red filter effect, but lighter than the green filter effect.

A

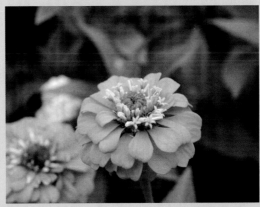

B

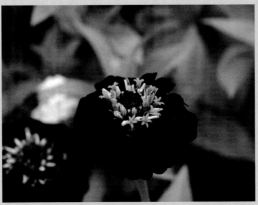

C

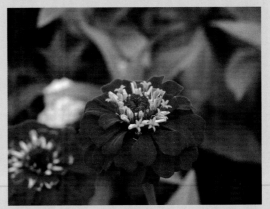

D

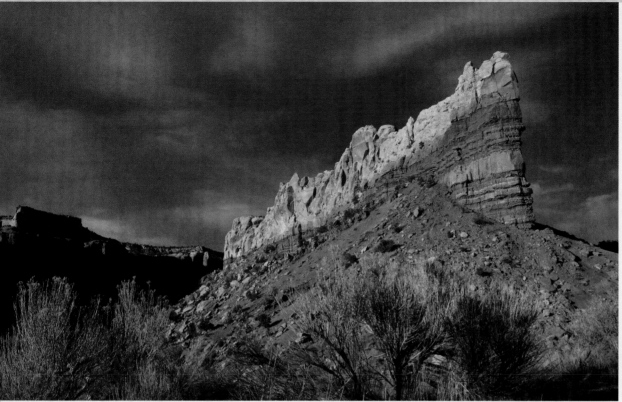

This photo is defined by t[he]
point of view and directio[n]
of the light. The shadows
frame and highlight the
massive formation while
light coming from the side
catches the towering rock
against the darkening sk[y]

Study the Light

One of the best and most enjoyable (and inexpensive) ways to become a better photographer is to study light. You will notice that the value or brightness of light reflected from various subjects within the scene is rarely the same. In fact, images would be very boring and quite flat if that were the case. The direction and intensity of light and the way they interact in the scene create shadow, forms, and dimensions. Study the light as it illuminates a scene. Move around and place yourself in relation to the light source so it strikes the scene from various viewing angles. Expose the same image at various times during the day. Learn how to use the light to enhance contrast, to reveal texture, and to highlight certain important parts of the scene in front of you.

Take the time to look at how light falls, how it defines form, and how the interplay of light and shadow create volume, scale, and space. Consider how to make light an ally to your expression. Once you have made a habit of looking at light, the process of using your camera to fully capture what you see will unfold. You will begin to understand how the camera "sees," and how it might see differently than you. This will yield exposures that bring the optimum potential out of every subject and scene.

The study of light rewards the effort in many ways. For instance, while you might assume that low contrast scenes should be flat when compared to photographs made in bright light, you may discover they can often have a dra-

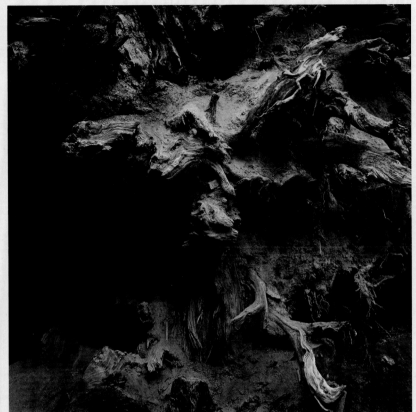

Photographs are often as much about what is hidden as what is shown. This photo of a tree root was properly exposed, originally showing a large amount of detail in the shadow areas. A well-exposed file permits an array of creative choices during image processing. In this case I chose the mystery of obscuring the details by turning portions of the shadows into deep, dark tones with my image-processing software.

matic low-key effect. Paying attention to light can open your eyes to the picture possibilities that occur throughout the day. Every moment becomes unique; light is always particular to the time of day, weather, and environment. The idea is not to put light in a box and categorize it so that you respond automatically to whatever that box is labeled. There are no set rules on interpretation. There are, however, guidelines on how to record information, because making the best exposure possible will afford you the most creative freedom later in processing and printing.

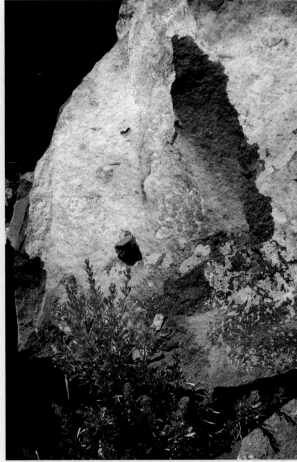

At high altitude on a crisp, clear day, I knew I wanted the edges of this boulder to appear hard and sharp. By Spot metering a light area on the rock's surface (see page 91), I was able to retain detail in the brighter areas. I later introduced additional contrast as well as sharpening using image-processing techniques in the computer (see Chapter 6).

INFRARED BLACK AND WHITE

Here's an interesting characteristic of light: Not all wavelengths are visible. The wavelengths that you can see, measured in nanometers (nm), occur in a range from approximately 380 nm (violet) to approximately 700 nm (red). Infrared light (actually radiation) represents wavelengths that reside above the threshold of human vision, and is therefore invisible. But it can be recorded, and many digital sensors are infrared (IR) sensitive. IR recording often creates an eerie, otherworldly representation that can be a creative way to photograph the landscape in black and white.

In the pre-digital days, photographers used black-and-white infrared film in landscape photography. But that kind of film is becoming quite rare, and since digital cameras make shooting infrared easier and more enjoyable, most infrared landscapes created today are digital. However, digital camera manufacturers usually block the infrared in the scene by inserting a special IR cutout filter in the light path from the lens to the sensor. This is because if the sensor were allowed to record infrared, it would produce a poorer quality visible light image with ghosting and other image flaws. So, if you want to shoot IR images, you have to overcome the effect of the internal IR cutout filter and allow infrared light to reach the sensor.

There are a couple of ways to do this. One involves the removal of the IR cutout filter and the insertion of a corresponding filter that will block visible wavelengths (below 700 nm). This requires a skilled customization that cannot be reversed. Because the IR cutout filter has been removed, the camera is quite sensitive to IR wavelengths, permitting you to shoot IR at relatively low ISO settings and relatively fast shutter speeds, meaning you can often hand-hold the camera. You can also see your subject through the viewfinder to compose and focus.

There are three common types of infrared filters that block visible light of various wavelengths. One, a red filter, prevents visible light below about 600 nanometers from reaching the sensor. It is often known as a Wratten 25A, and is one that former black-and-white film photographers might still have in their closet. It blocks the majority of, but not all, visible wavelengths. Another filter (identified by various names according to the manufacturer, such as a Wratten 87 or an R72), blocks progressively more visible light with wavelengths under approximately 750 nanometers, creating a "purer" IR image. The highest blocking filter (830 nm and above) can be very expensive and is generally for purists and aficionados. Certain cameras made for law enforcement and forensic photography (offered chiefly by Fuji Film Company) come IR-ready.

You can choose to make IR exposures using camera settings for RGB mode or Monochrome mode. Monochrome mode removes the red cast that you see in the image in RGB when you view it, but only experience will tell you what the final image can look like after image enhancement. I always shoot IR (and all my images) in Raw mode so that I will have greater flexibility in adjusting the appearance of the image without degrading it.

Setting proper exposure for IR is different than in normal photography because exposure meters are made to measure visible light. The

IR photography creates a unique black-and-white image due to the way objects reflect infrared radiation—highlights generally flare or glow, leaves become chalky white, while other areas go quite dark. Knowing this influences the way I set up images and later how I process them.

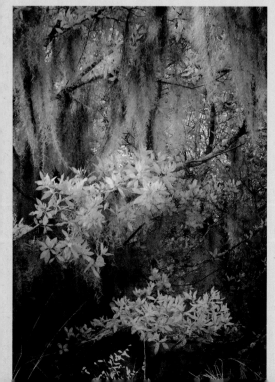

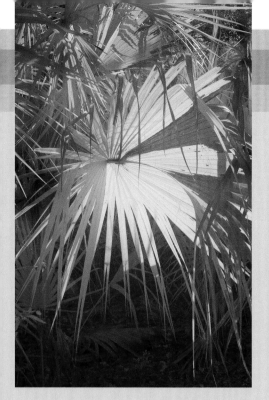 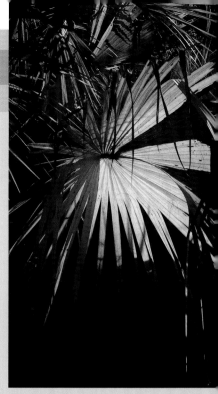

It can be difficult to make accurate judgments during playback on the camera's LCD about the ultimate look of an IR exposure. Here is an image right after download into the computer, approximating how it looked in the camera's LCD when shot in RGB mode (far left) and in Monochrome mode (middle). The final image (right) shows how it looks after basic contrast adjustments in software.

best way to make IR images is to set Manual mode and start with an arbitrary exposure, for example f/11 at 1/125 second. Shoot and then review the image on the LCD to get an idea of how it looks, and adjust accordingly. You will usually have to repeat this procedure several times to find the exposure that is working for that particular subject under present lighting conditions.

Some IR photographers buy a filter that is a bit larger than the largest diameter lens they own (thus it can be used on all of their lenses). Or they purchase a large square filter offered by filter manufacturers such as Cokin. They first frame and focus the tripod-mounted camera, then hold the filter over the lens while the exposure is made. This technique can obviously allow some light to leak in from the corners, but that can often be eliminated with practice in holding the filter properly over the lens.

Exposing invisible light and recording ethereal, snow-like images is a strange concept, but also part of the IR mystique. IR black and white has always been near and dear to landscape photographers, and now that high-speed IR black-and-white film has been discontinued by major film makers, digital is the only way to go.

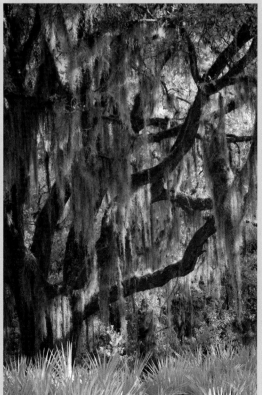

This shot made in the Everglades shows a few hot (blown) highlights you can get with IR. With image-processing software, I added contrast using tone curve controls and a sepia tone.

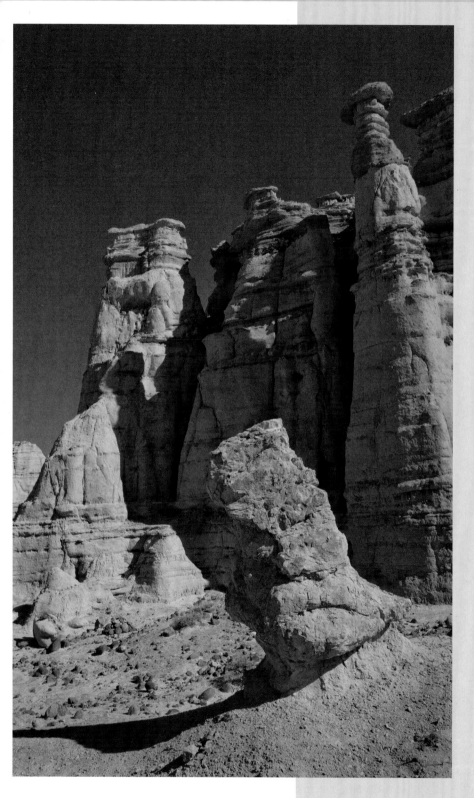

Contrast

Contrast is the difference in brightness between the lightest and darkest areas of a scene. Technically, it is a major consideration when making exposures, giving you creative options to experiment with tonal relationships. However, if it becomes excessive through poor exposure or processing technique, the result will be a harsh, unattractive image where details in the brightest or darkest areas are lost. Conversely, too little contrast can make an image appear flat and lifeless, dulling the sense of presence and liveliness in a scene.

In short, contrast is what gives images richness and separation of tone. But it can also cause problems that get in the way of making a pleasing photo. That tug-of-war will be explored and discussed throughout this book.

The photo of the rock formations (left) was made in very bright light. The challenge was to tame the high sunlit contrast to reveal the natural texture in both the bright and shadow areas. This was accomplished by such field techniques as making spot meterings and applying exposure compensation combined with post-exposure techniques for managing tonal range. We will discuss all these techniques further in later chapters of this book

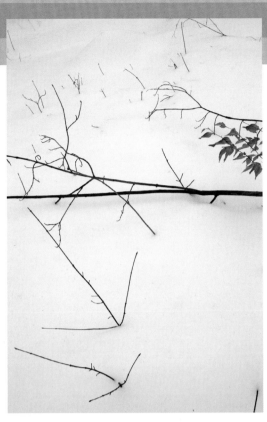

Although you can't always predict how your final interpretation of a subject will look, there are often times when you know just how you want to work with an image. I knew when I saw this scene in the Adirondack Mountains that I would expose to keep the highlights in range (left) and later create a cropped and rotated high-contrast derivation in software (below).

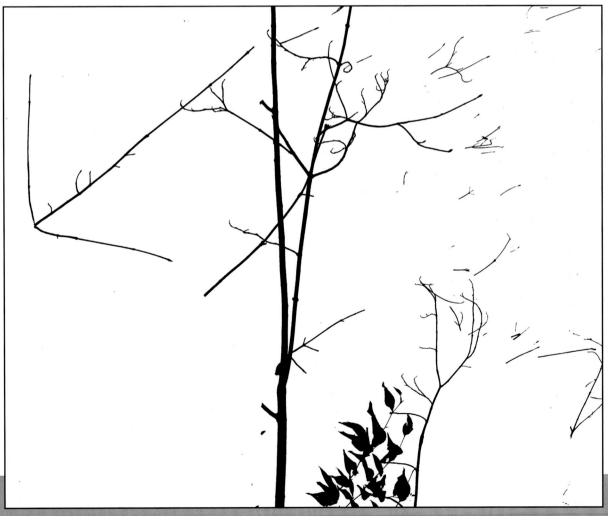

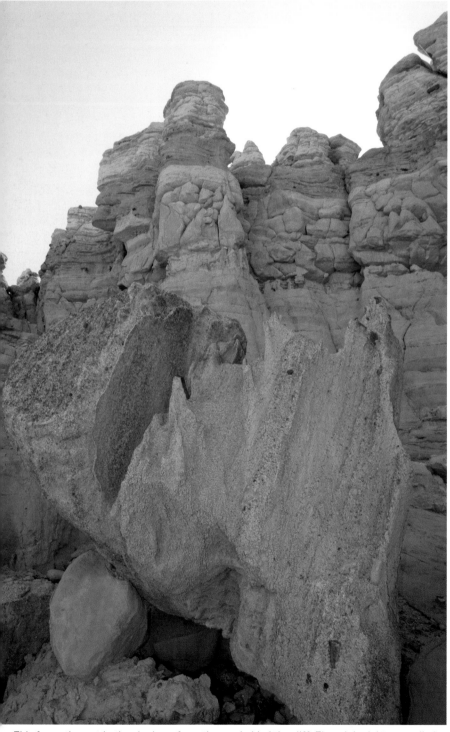

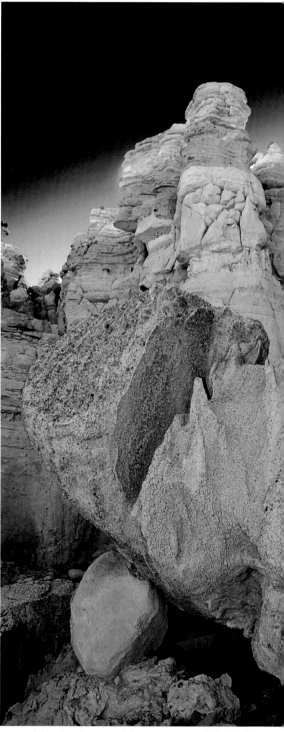

This formation sat in the shadows from the sun behind the cliff. Though I might normally have exposed for the sky to avoid overexposure, I decided to meter the rocks in the shadows because I knew I was going to work this image in black and white, not color. In software I manipulated the tonal values of the rock formations first, then added a light graduated-density layer to the sky area (more aboutimage-processing in Chapter 6).

The Freedom of Digital

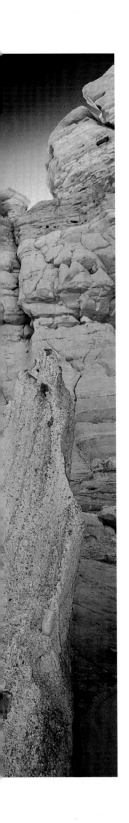

In film photography, certain modifications can be made to the image depending on the development or printing procedures you choose, but these modifications are limited by the chemical processes involved. However, digital offers more freedom and fewer limitations in making adjustments to the image. There are some boundaries, of course, but not a great many. In general, just about every facet of the image can be manipulated.

The type of control you can have over digital image processing includes exposure correction, digital emulation of color filters over the lens, and even adjustments to grain and sharpness qualities. It extends to the print, where toning and other image effects are much less difficult, and certainly less malodorous, than they had been in the past.

Knowing that you can change tonal values and relationships after shooting opens up more picture possibilities as you work in the field. This doesn't mean that you can be intentionally careless when taking photos, but it provides the insurance to know you can handle some exposure problems and mistakes later if need be. This should not lead to lack of attention setting your camera, but more to a sense of adventure as you shoot. Your goal in the field with digital is to record all the values possible. Once the image is in the computer, you can enhance it without the constraint of prior contrast or exposure choices.

Think of what previsualization might mean to you as a digital photographer. I find it next to impossible to predict precisely how the image might look after all is said and done. It's not that I lose control of the image; it's just that the digital process allows me to follow many different paths. This can be disquieting at first. Previsualization is no longer limited by what a fixed ISO, chemistry, film, and silver paper can produce. It can include decisions about the light sensitivity of the sensor, the tone curve of the recording (the contrast), and even the panchromatic response of the various colors in the image—both in the global (overall image) and local (areas within the image) sense. Yes, previsualization is still about seeing the light, reading and recording it to maximize its potential, and then re-interpreting or refining that vision later. The range of digital tools might seem overwhelming at first, but dealing with each as you work in the field and later process and print your images will soon reveal how much has changed in the creation of black-and-white images. For me, and hopefully for you, it will reveal how your expressive abilities have expanded in ways only dreamed of in the past.

Composition

3

Composition is how you frame the wide world in your viewfinder. When you consider the visual space you intend to fill, there are certain arrangements that lend themselves more than others to a natural sense of balance. Every culture and tradition might have a different sense of that balance, like grace notes or musical tonal scales that differentiate one culture's music from another. But if you look at photographs of natural subjects, you notice a common sense of balance. That's because the subject matter has a rhythm and order that instill our sense and appreciation of beauty in the first place.

There are various visual arrangements that speak to form and order and how we perceive them in nature. These include the circle, the spiral, the s-curve, the convergence of parallel lines at infinity, and the leading line, which in general is diagonal in the picture and leads the eye from the lower portion of the frame towards the center of the image. We see these forms emerging from nature, and our images often resonate with the recognition of them. Like Navajo blankets in which patterns seem to emerge from the surrounding natural landscape, photographs can identify that which we find most inspiring and beautiful around us.

Photographic composition, particularly in landscape and nature work, is unique among the arts in that the content is not imagined or created by the photographer—he or she photographs what is found in whatever light is available at the moment. Yet because imagination is at play, as in any artistic endeavor, the photographic composition has a context for creation, and the photographer can take the image in many different directions. The grayscale tones are like musical notes, bass for shadow and treble for highlight; while the scene is like the sculptor's block, where the exposure is winnowed and enhanced by obscurity and revelation.

After practicing a number of rules for composition, you will probably find that they are sometimes made to be broken. Almost all are helpful, but they are only a beginning point in considering composition, and are often altered or bent for effect or some sort of statement. But let's take a look at some of the better-known compositional guidelines and concepts.

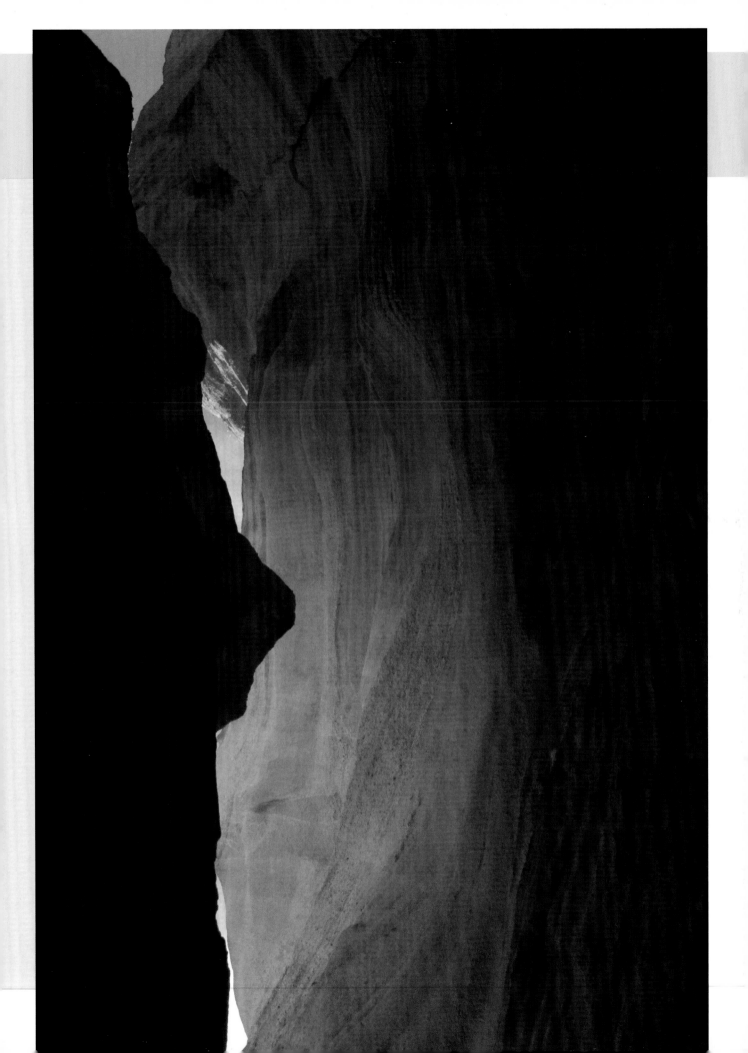

Rule of Thirds

The Rule of Thirds is a classic compositional technique that often emerges in scenes with a horizon. It divides the image into three parts, both horizontally and vertically (imagine a tic-tac-toe game), and therefore avoids splitting a composition in half. The segments need not be literal lines of demarcation, but are guides for placing points of interest or importance along them. For instance, turn to page 41 and look at the photo of rocks on the beach, where the face in the rock is in the lower third of the picture, while the line of white surf is in the upper third.

The Rule of Thirds is also evident in the photo below, with a distinct break in the upper and lower portions of the composition. The upper third is relieved by the mountain behind the trees that weave in and out of the break. The small triangular shaped mountain on the left helps differentiate the sky further, while the bottom of the picture is delineated by the dark stretch at the bottom of the tree line and the parallel sunlit brush.

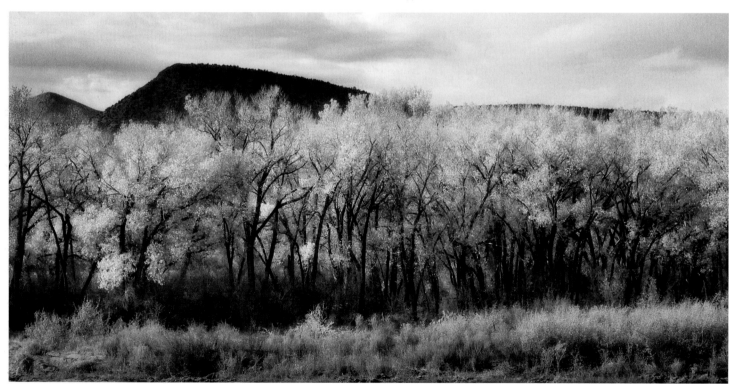

The Rule of Thirds does not always imply the image is perfectly divided into three equal portions. This slightly colored landscape (see Chapter 6) has three discernable segments, though clearly the dividing horizontal lines are not placed exactly at thirds in the composition.

The Wheel and the Spoke

Though taken many years apart, the shots below and to the right share a common compositional form—they are like spokes of a wheel spinning off a central post or axis. In the lower picture, photographed on a trail along the Rio Pueblo River in New Mexico, and the picture to the right, shot in the Florida Everglades, the spokes jut out and approach the edge of the frame. This joins the edges to the middle, while the space between the spokes allows all sorts of detail and tonal values to show. It's as if the arms of the subject are holding the frame at bay while they simultaneously support the entire form and shape.

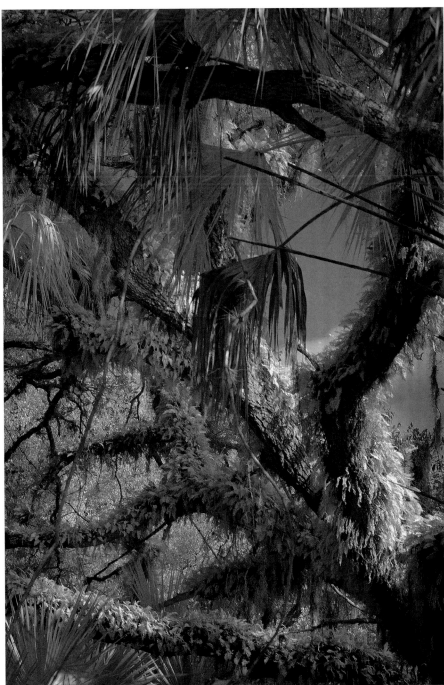

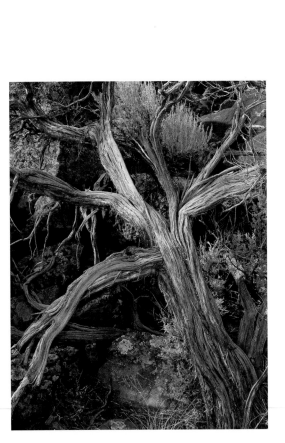

Don't take the term Wheel and Spoke literally. It means that some type of compositional lines travel from a convergence inside the photo toward the outside frame. It is an aesthetic that ties the outside portion to the inside portion, as illustrated in both of these photos, giving the image a certain wholeness.

Perspective

Perspective is a tool that places the viewer in the scene. It creates context, places subjects at a certain distance from the point of view, and yields a narrow or wide view of the scene. It can be used to create visual perceptions that appear to modify reality. These perceptions include foreshortening, where close subjects seem closer and those in the background farther away than normal, and visual stacking, where subjects at different distances seem to sit atop one another. Perspective has a profound influence on the viewer, be it created by the point of view of the photographer (standing, lying down, looking up or down) and/or the use of different focal-length lenses.

Changing lenses is a great tool for creating images not available to the unaided eye. Super wide lenses can stretch peripheral vision; telephoto lenses create a tunnel vision and a stacked perspective. Close focusing (macro) lenses bring the eye into worlds rarely visited except by children (who love to examine their world very closely). Combine these lenses with selective focusing techniques, where foreground and background both remain sharp, or where foreground stands out from the background due to shallow depth of field, and you have another strong compositional tool at hand.

Foreshortening

Foreshortening is a perspective effect that displays an exaggeration of the foreground subject. This is achieved by shooting very close to the subject with a wide-angle lens set to a small aperture. This distorts the close subject while creating an optical illusion of depth that would be lost without sharpness throughout the image space.

The photo to the right above was shot with a 20mm lens pointed down so that the foreground rock seems to sit underfoot. The bright, semi-circular surf line coaxes the viewer's eye from the rocky face in the lower central portion to the top of the frame. The rocks are slightly lighter than the sand, although the original image shows them almost equal in tonal value. This contrast was produced quite easily by using image-processing tools in order to create a "footpath" for the eye to travel while viewing the image.

Stacking

A long telephoto lens compresses space and is a way to create the illusion of stacked objects in the scene. In truth, you would create the same effect if you cropped into an image made with a normal focal length lens. It's just that the telephoto lens makes a more obvious effect of objects looking closer together than they really are.

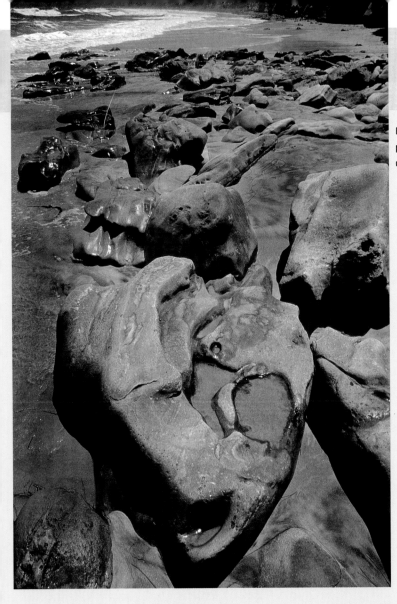

Foreshortening can offer a creative perspective on objects that are close to the camera.

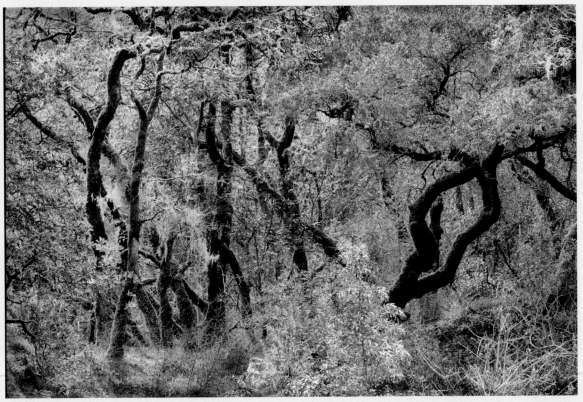

This photo was made from about 50 yards (45.7 meters) with a 300mm lens. The tangle of trees and brush appears to be within the same plane, when in fact, they are quite spread apart. The line drawing effect is enhanced through the addition of grain and contrast, with a sepia tone thrown in for good measure.

Selective Color Conversion to Grayscale

Black-and-white photography, where increasing degrees of brightness are expressed as ever lighter shades of gray, becomes artistically interesting when you understand that certain colors translate to gray in rather different ways. This is because black-and-white digital has been programmed to emulate panchromatic film, which makes reds a bit darker and blues a bit lighter than they might appear to the eye. The twist is that you can alter these relationships and, in effect, lighten red and deepen blue using software and image-processing techniques.

With film you can alter the grayscale appearance of colors (to an extent) in the image using color filters over the lens. These filters block opposite colors and allow like ones to pass, leading to different grayscale densities. Digital lets you do this selectively to every color in the image. Since grayscale values are a major compositional element, this has a profound effect on black-and-white composition, completely changing how you might have previously worked with black and white film. Thus the processing of the black-and-white digital image plays an important role in compositional.

Abstraction

Abstraction is not easy to explain, but it is a way of seeing that redefines subject matter. Black-and-white photography, based as it is on a grayscale spectrum, is abstract right out of the box.

An abstract photo departs from reality. By concentrating on an aspect of a subject, such as tone or form, or through taking an unusual point of view or isolating a detail, a photographer can render subjects to look different or unrecognizable. It is a wonderful compositional tool that frees you from following such photographic "rules" as producing straight horizon lines, or the obligation to photograph and process things as they are.

More often than not, abstract images can be used for allegorical purposes, to allow viewers to take themselves where they will. Landscape photography is great for this purpose, because it tends to be subjective and more interpretive than some other types of photography—that's what attracts artists to it. It's also less predictable than other genres, which is another reason for its strong appeal. I believe that this subjective nature allows for a more liberal compositional sense, where the main actor does not have to be at center stage, or may in fact be hidden from initial view. The layout need not be points on a compass, with north and south clearly delineated.

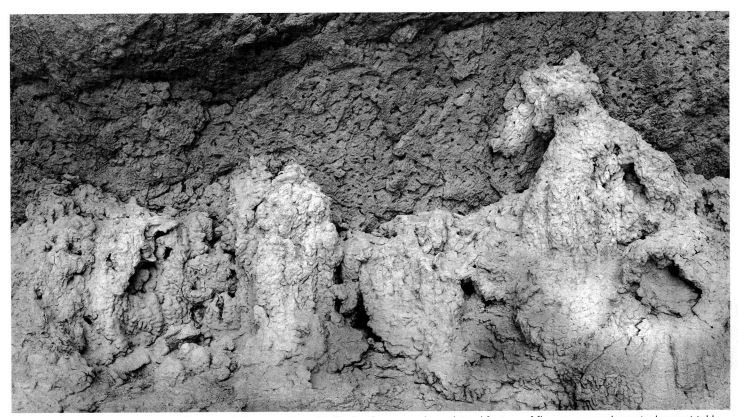

As I see things, this abstract photo shows eroded and weathered tuffa that has created a sculptural fantasy of figures on parade or at a banquet table.

While perhaps a cliché, the term transcendent comes to mind with abstract photographs, because content can be more than just the objective "what you see." The content of the photo becomes a metaphor for other thoughts or different states of mind. Rather than say, "This is a detail from a rock wall I found when I pulled over in the Arkansas River Valley in Colorado," I might be thinking, "This is a Sufi dancer tumbling through the universe surrounded by unformed energy that will be manifest through love." Now that's an entirely different trip.

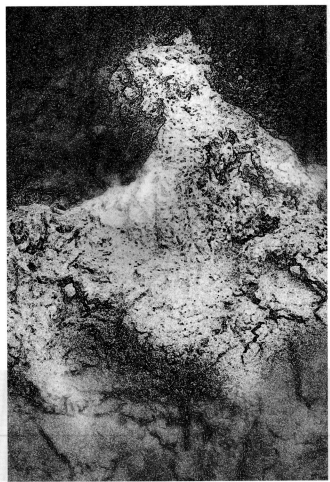

This close-up of one of the parading figures from the photo above illustrates how tonal manipulation during processing can emphasize form and light play.

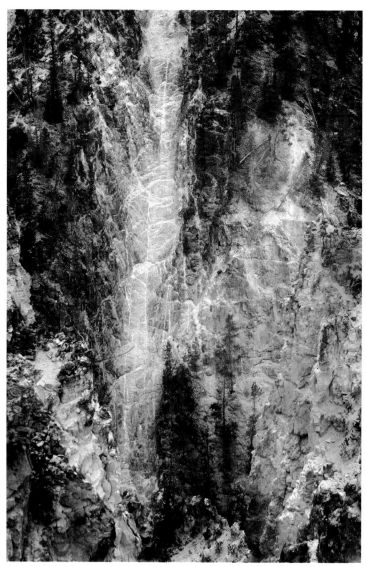

Photographed looking across the valley at Artist Point in Yellowstone, this image was made with a 300mm lens. If you look closely you'll see the trees that hug the precarious incline. They all looked like streaks of light to me, with the lighter colors of the rock spreading like fingers into the upper portions of the frame.

This cliff has been twisted by various forces of nature. When I come upon such subjects, I try to project how the forms and various tones can be adjusted in post processing. I sometimes see immediately the way it might look; but more often I make several shots and, after downloading, view them with a more contemplative eye to find their hidden secrets.

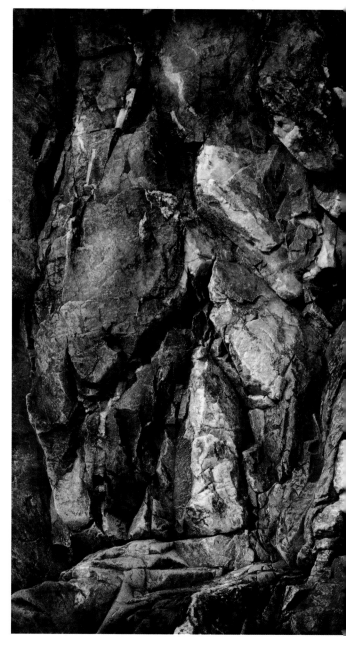

The stream under the snow in this picture broke the cover in some spots, which made for some interesting and modernistic forms. They were enhanced during image processing by increasing contrast.

You can see this picture as algae and weathering on a piece of volcanic rock, or you can choose to bring some narrative to the arrangement of forms. I often compose with narrative in mind, although I cannot always say what that tale will tell.

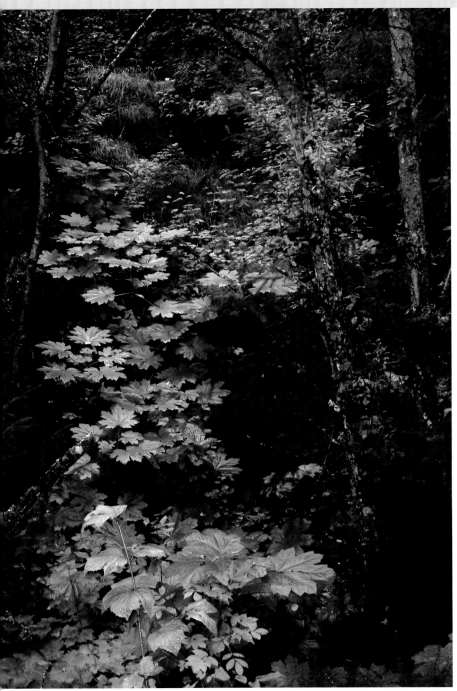

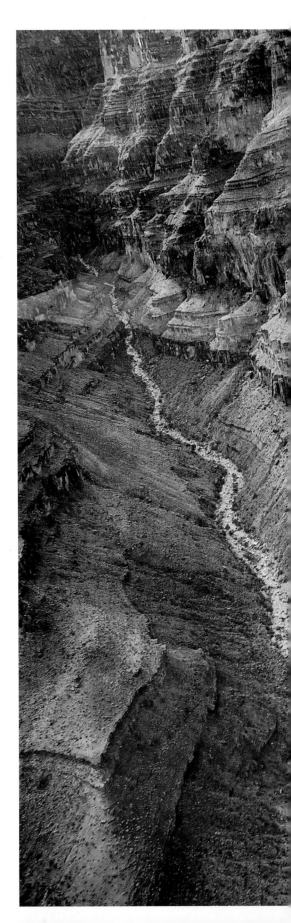

The heavy canopy and low clouds blocked most of the light in the Alaskan woods, but a few stray beams broke through to illuminate the forest floor. The result is a fan of light coming down and spreading out before your eyes.

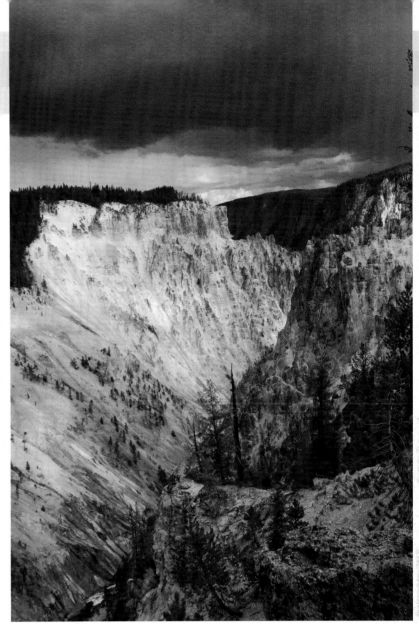

A breaking storm over Artist Point in Yellowstone provided everything needed to shoot this photo, leaving me little to do but follow the light and make sure I got the exposure right.

The Flow of Light and Forms

If you want to find interesting compositions in nature, consider following the flow of light or form through the frame. You will notice the interplay of light and dark tones, interesting light patterns, and reflections. These create a full range of tones that contribute to strong composition

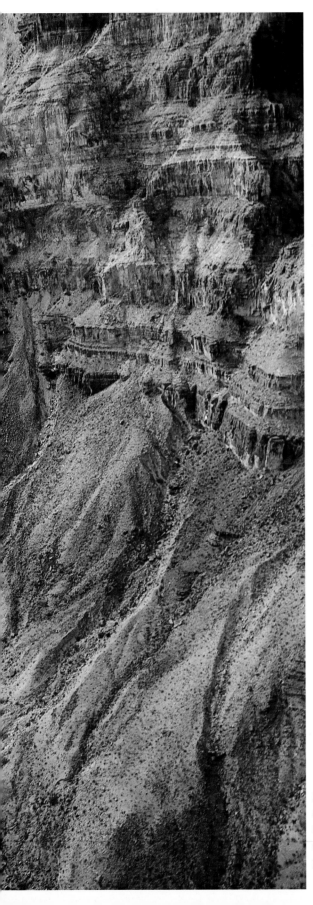

Following natural forms, this picture brings together a meandering line made by a river with the design of striated rocks in the Grand Canyon. The triangles and horizontal lines create a strong, basic composition, enhanced by the subtle interplay of shadow and bright areas in the frame.

Compositional Zones

There are certain places that will resonate with you and bring you into what I call a "compositional zone." These might be areas such as mountains or beaches, or certain locales where you feel very close to the land. Some magical places for me are areas of geyser activity in Yellowstone Park. While rich in color, I see these as amazing opportunities for grayscale tonal play. The break between lights and darks, the odd formations, and the incredible depth of the light itself keeps me quite busy and blissful. Perhaps it is the absolute strangeness of the place that makes it so attractive and rich with picture potential.

The photos on this and the next three pages are all examples taken from my Yellowstone zone. The photo to the right was made in the geyser area close to Old Faithful. The sulfurous deposits on the opposite shore, consisting of bright red and orange colors, made a great design break in the otherwise continuous tone when converted to grayscale. The scene contrast was raised considerably in processing.

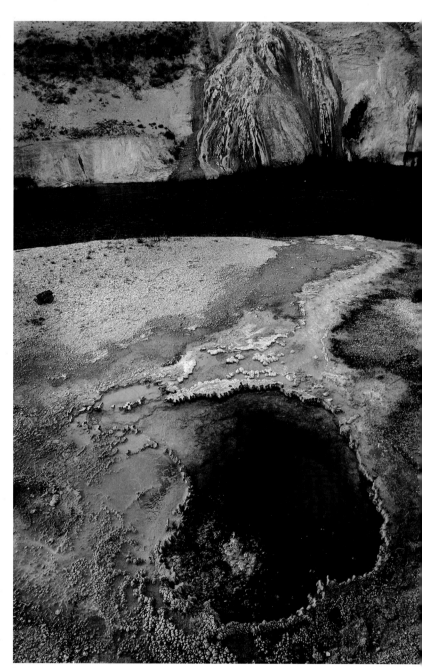

A wide-angle lens was used to foreshorten the natural bubbling pot in this photo. I composed it to show mineral deposits running over a slight cliff to the river in the center of the frame.

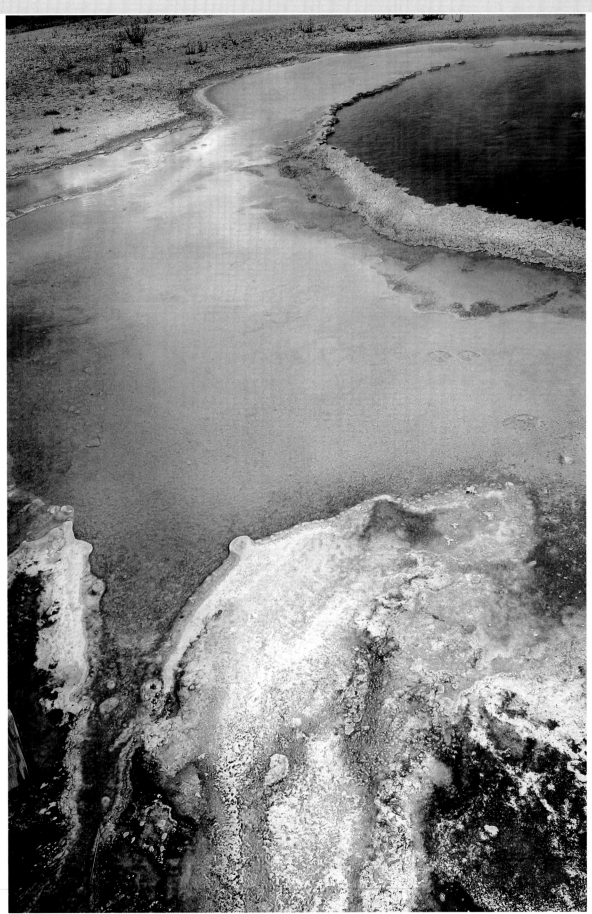

The mineral deposit from the geyser in this scene creates natural highlights as well as an interesting form by meandering up and out of the frame. I enhanced the contrast in processing to emphasize these highlights against the deeper tones on the rock in the foreground.

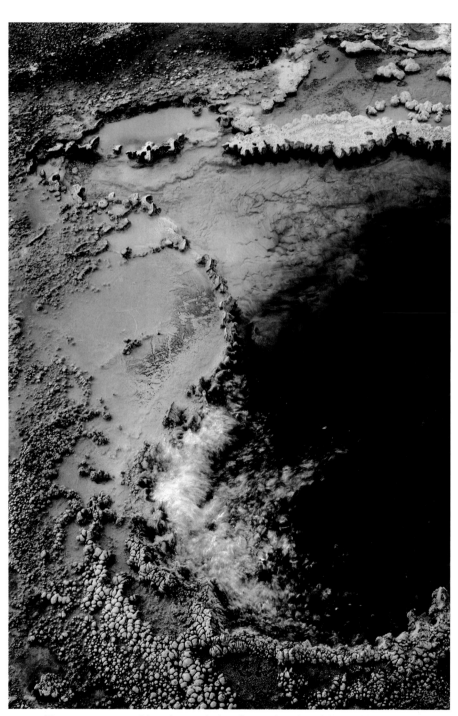

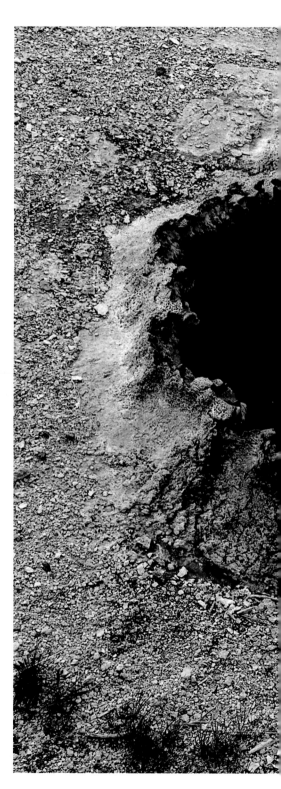

The camera was positioned to catch the glint on the edge of the pool in this picture. It is more about light, darkness, and texture than about an identifiable subject. I knew the colors would create an interesting translation into black-and-white tones.

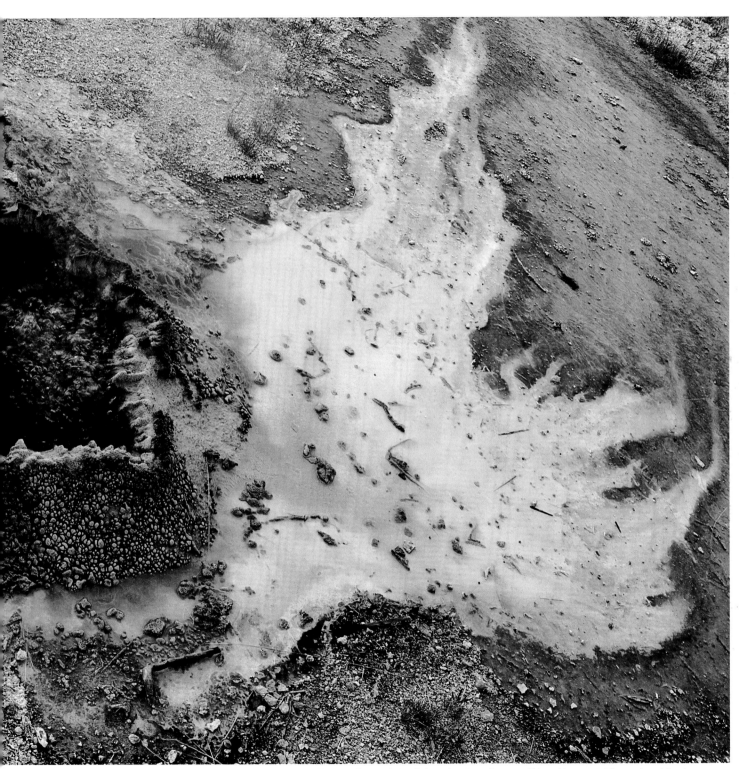

The contrast between the deep blue of the geyser pot and its sulfurous flame-shaped deposit created compositional interest. I knew I could enhance this contrast selectively when converting the image to black and white. Understanding what can be done with image-processing software while you are photographing leads to achieving the potential within each image.

Previsualization

Composition begins in your mind's eye before making an image. Even as you raise the camera to shoot the picture, you will want to take into account how the finished photo will interpret the scene. Mentally seeing the final print before you shoot the photograph in the field is known as previsualization. It is important to think about where to place the camera, what settings and lens to use, how to utilize the light and forms to best advantage, and what you will be able to do with image processing to affect the image.

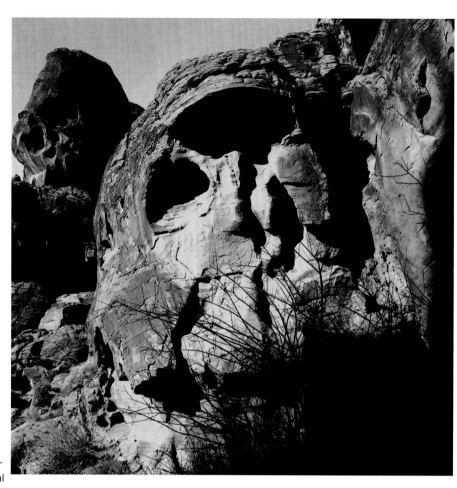

This composition was guided by previsualization. The dark foreground brush, the face in the rock, and the looming form in the background were all considered before releasing the shutter. I then made this print considerably darker and higher in contrast than the original exposure to complete the image I envisioned.

This brown and gray mud puddle, photographed in late spring, had a covering of thin ice. The pattern in the ice caught my eye, and I knew I would treat it with the high-contrast rendition shown here.

More than Rocks and Trees

One of my favorite stories about compositional form was told to me by Fred Picker, with whom I taught one summer at his photography workshop. He had brought his portfolio of work to an art institution in Boston and laid the prints out. The curator gave them a bit of a once over and turned Fred down, saying, "We have enough rocks and trees." Indeed.

Clearly his photography was not just about making pictures of rocks and trees, but a considered study of composition and tone. The curator had failed to comprehend the allegorical nature of his images.

Composition is a rather personal matter, and the decisions you make should be based on visual literacy (knowing the rules of the road and obeying them, or defying them for good reason), honesty, and having something to say. What's to explain the fact that if you and I go into the field together we would both come back with rather different images? Isn't what's in front of us the same? We might agree on the horizon line, or even the fact that a large tree sits on the right, but that may be as far as it goes.

As you photograph, you can assemble your own narratives, or let the work guide you into themes and approaches to seeing. In many cases the location will have its own aesthetics that will infuse your vision. As you work on your own images, you will begin to understand the process. You will also understand how previsualization—what you expect will result later from the exposure—and the final image sometimes match, and also how they sometimes end up as something completely different, and surprising. But that's part of the process as well.

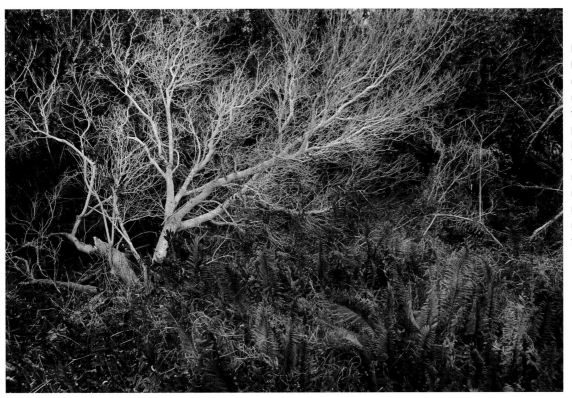

I saw this fallen tree as a strong highlight among textural shadow and midtone values. In essence, it is a tonal play with the values reinforced by image processing in the computer. When you make photos like this, you take the chance of whether or not they will work well once you bring them into your image-processing software. I always am willing to take that chance.

Shooting
the Best Images

4

You can think of a digital camera as a microprocessor with a lens. While it still does the things cameras have traditionally done, it must also convert analog data to digital by performing an immense amount of processing before the image is recorded to the memory card. In addition, most of today's D-SLRs offer a number of options to change the character of an image in the camera, though my advice is to use the camera's processor only for a few basic tasks and leave the heavy lifting to your computer and its image-processing program. For one reason, the LCD on the camera is not the monitor on which to make critical judgments—that's better left to your much larger computer monitor. Secondly, camera manufacturers, while amazingly clever, have not been able to install the type of sophistication that is available in image processing software made for computers. And finally, some enhancements you might be tempted to make are simply choices made by the camera companies about certain effects (or degrees of an effect, such as Vivid or Natural, etc.), which might not be precisely what you had in mind for a particular image.

These preset enhancement options to "flavor" an image do come in handy, however, when you shoot JPEG files for direct printing from the camera, or when you want to take the memory card to a kiosk or lab and have them make prints for you. Doing this is usually fine for quick family snapshots or travel photos, but to get optimal image quality for your fine art, black-and-white landscapes, you will want to have the most latitude possible in making adjustments before printing or posting on the web. In this case, the best choice is without doubt to shoot RAW format.

File Format

Digital cameras, especially D-SLRs, give a choice of file formats, most often JPEG or RAW. When choosing JPEG format, you will usually also have to select settings for image quality (degree of compression) and file size (resolution). When you choose RAW, you need not make separate settings for quality or size. RAW will produce the largest files your camera is capable of producing with the largest bit depth—16-bit files that actually contain 12 or 14-bit depth data from the sensor.

RAW offers many advantages, in part because greater bit depth yields more image information (always a good thing), a wider range of brightness values, and in general will offer more image fidelity and tonal variety (given proper exposure, a good lens, etc.). RAW also offers much more in terms of image processing flexibility with less destructive compression of image information. Many cameras have the ability to record RAW and JPEG simultaneously, which I recommend because it makes two images, one in each file format. You can always use the JPEG for direct printing, and still have the superior quality RAW file.

RAW files are proprietary: Each camera manufacturer produces its own version of RAW. Software, often called a RAW converter, is required to open and enhance RAW files in the computer (there are a number of different RAW converters available). When a RAW image file is opened in Photoshop®, Adobe's RAW converter, Photoshop® Camera RAW, is opened as well. The photo in the screen (above top) was

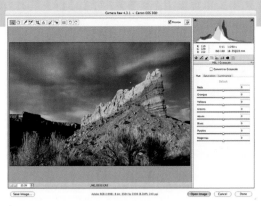

This screen for Camera Raw displays when you open a RAW file in Photoshop.

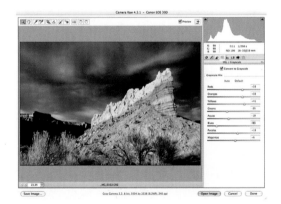

Use the grayscale sliders to convert a RAW file to black and white.

made with a Canon D-SLR (note the .CR2 extension, denoting Canon's exclusive RAW format).

After opening the RAW file in your computer, you can apply various adjustments with the program's available software tools. You can also make the basic conversion to other file formats (TIFF, JPEG, PSD, DNG, etc.). The grayscale conversion in Camera RAW (bottom screen) works with sliders that change color/tonal value relationships. You can also change image attributes to match the end use. By clicking on the blue information line at the base of the work area, a Workflow Options dialog box appears that allows you to make choices about working color space, bit depth, resolution, and pixels per inch (see illustration at top of next page).

This Workflow screen in Photoshop's Camera Raw plug-in shows the image is set as a 16-bit grayscale file at a resolution of 300 pixels per inch (ppi) and large file size (for printing.)

You can adjust these settings in Camera Raw for a different purpose. This is set to 72 ppi, the best screen resolution for a slide show on the computer. A full discussion of RAW processing is available in chapter 6.

A JPEG file contains embedded information, sort of like having DNA for color, brightness, overall contrast, exposure etc. However, JPEG is a compression standard, so JPEG images are always compressed, which means they do not retain all the information you recorded; they cede some of that information to algorithms that later reconstruct it when the file is opened on your screen. In cameras, this is done to save memory card space. That made sense when memory cards were $1000 for a single gigabyte (no kidding), but that is not the case today.

That compression, or rather lack of it, is one factor that makes RAW the best choice for recording high-quality images. (While some cameras do compress RAW files, they are done so in a "lossless" fashion, which means there is virtually no difference between an uncompressed and lossless compressed RAW file when opened.) RAW captures more information than JPEG, and all of it accompanies the file in a kind of sidecar—none is lost due to compression. Practically, this means more leeway for enhancing a RAW file than a JPEG, not only to address problems with the image, but also to make creative choices.

A more straightforward reason for choosing RAW is that JPEG records 256 levels of brightness, while the RAW file records upwards of 4000. This has major implications for image processing, tonal response, and the overall fidelity of the image. The reasons for choosing RAW will become more evident in the Processing Image chapter of this book.

There is a small price to pay for this quality, and that is the need for a RAW converter program as described previously. You can't email a RAW file or place it into a printer directly from card or camera without converting to another format, such as JPEG or TIFF. While this might seem inconvenient at first, since it represents an extra step in the processing workflow you did not count on, it is often worth the effort. It is actually not too much additional time or energy once you get used to working with RAW files.

Optimizing Images in Camera

Camera makers have gone to great lengths to offer a host of image optimization or "picture style" options, including changing the color saturation, contrast, sharpness, color space, and tone curve compensation of every frame. You can work with these in the camera if you like to set up the image prior to downloading, but keep in mind that all these settings, including white balance and even exposure, can be customized to a fine degree in RAW processing later. You might find that you work better if an image is already very sharp when you open it for processing in your computer. This might inspire you to raise the in-camera sharpening level a bit. Setting that level is personal matter, and fine if you shoot JPEGs, but I don't think it is necessary when shooting RAW landscapes. In fact, this might tend to make you over-sharpen an image, something that impedes image quality and is best left to post-exposure processing in the computer.

Color Space

One setting you might consider adjusting in your camera is the color space. I recommend you set this to Adobe ® RGB. The default is most likely sRGB, which has a smaller range of colors (gamut) than Adobe RGB. The differences are slight in most cases, but using Adobe RGB and shooting RAW (actually you can change color space later in processing as well) is a good course of action because that color space's wider gamut provides finer color adjustment and offers more subtle color controls, which means greater flexibility in processing and printing.

Monochrome Option

One option to try, if only to help you visualize in black and white, is the camera's Monochrome setting. This does not record images in grayscale—they remain RGB composite files—but the function does allow you to view your images in black and white right after exposure (or before exposure with camera's that offer Live View, a technology that projects the image onto the LCD monitor as you view the scene before you release the shutter). Never before have D-SLR photographers had the chance to do this, and it's a real change agent.

There are several other monochrome options often available in D-SLRs, such as color toning (opposite page) and color contrast filter effects (see page 25). The settings for color contrast filters alter the way certain colors are recorded as gray tones. These filters block, to an extent, complementary colors and allow like colors to pass. If your camera has these settings, practice to learn how tones appear when recorded with and without their application, and you will go a long way toward understanding how to visualize in black and white.

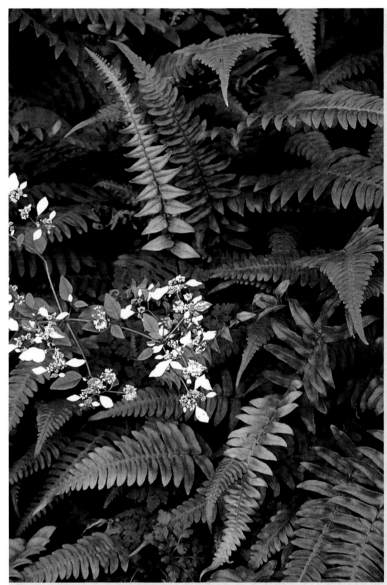

Toning effects can be done in-camera or on the computer after downloading. Toning applies a color cast to the black-and-white image. These images demonstrate the before (above) and after effect (right) with blue color tone.

Tone Curve Control

Another internal camera setting that may be available in your D-SLR is an adjustment for tone curve. This can be an effective tool to control harsh highlights in high-contrast conditions. When activated, the tone curve control on some camera processors will shift highlights toward middle values while maintaining the other values in the recording. This does not expand or change the dynamic range (recording scale) of the sensor, but moves the highlight curve lower. Having worked with numerous cameras that feature this option, I can attest to the fact that it works as advertised.

Many times in lowlight conditions (flat), you will realize your subject could benefit from some "snap." If you don't want to increase ISO for more light sensitivity, you can try using a slight increase in tone curve to raise the image contrast and help bring out detail in the scene. This option will necessarily intensify noise, similar to film grain, but sometimes grain can lend a certain desired "look" to an image.

As you work with your camera and begin to learn its limitations, you will recognize when this setting can be helpful. While tone curves can be applied using image-processing software in the computer, I often find that I see differently when I set image characteristics in the camera, in the same way that the type of film once affected how I photographed and read light in the days before digital. And if I decide to change my mind, I have a backup option knowing that when I shoot RAW files it is easy to change that character later.

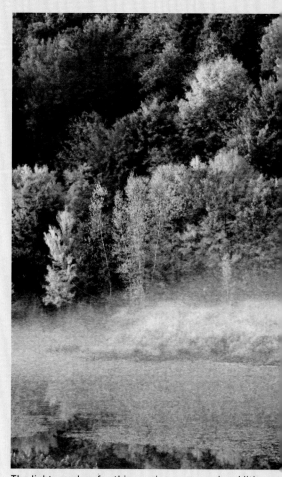

The light was low for this sunrise scene, so in addition to raising the tone curve for more contrast, I also increased ISO. This gave me more light sensitivity for a handheld shot s well as creating more separation between the tonal values.

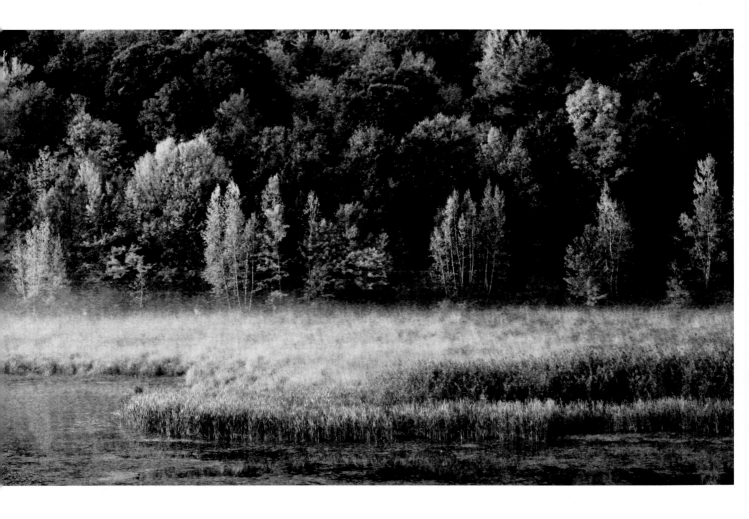

Sharpness and Depth of Field

Depth of field is the range of subject distances within a scene that appears acceptably sharp to our eyes. In fact, there is only one point of sharpness: the distance at which you are focused. But because of the way our eyes resolve, we see areas in front and behind that point of focus as also being sharp. That area of perceived sharpness (depth of field) can vary from shallow to great depending on several factors. The depth of field spans from about one-third its distance in front of the point of focus to approximately two-thirds behind it.

This knowledge can help you determine how much of your scene will be sharp, increasing or decreasing the depth of field as you work.

Whether you use manual focus or autofocus, one of the most important decisions you can make in landscape photography is the aperture setting. This, along with focused distance and lens focal length, influences depth of field. You can control what appears sharp and what appears unsharp in a picture by juggling these three variables. Determining depth of field

becomes a critical choice because you never know what size your image will be enlarged to, and enlargement amplifies unsharpness.

• The shorter the focal length, the greater the depth of field at a given aperture and focused distance.

• The smaller the aperture, the greater the depth of field at any given focused distance and focal length.

• The longer the focused distance, the greater the depth of field at any given aperture and focal length.

• The converse of each is also true.

This is also why Aperture-priority exposure mode is sometimes called Landscape-priority. It is the mode that provides the most accessible control of depth of field in landscape and nature photography.

Sometimes desirable, shallow depth of field is achieved by using a wide aperture, long focal length, and/or a close or short focused distance. It is a wonderful technique for isolating subjects against a busy background, or simply for creating a softer background effect. When photographed up close with a wide aperture, foreground subjects seem to spring to the surface against the background blur. By varying the factors that affect the depth of field, background forms can become either more recognizable or a total blur. A "deep" depth of field, on the other hand, where the apparent sharp-

ness extends from a close subject to the farthest point in the photo (or to infinity), is created by working with shorter focal lengths, smaller apertures, and/or by focusing about one-third into the scene.

Another way to exploit depth of field so you can extend sharpness is to work with the hyperfocal distance. This allows you to work with a given aperture and focal length combination to take greatest advantage of the depth of field they provide. If you have a fixed focal-length lens with a depth of field scale (rare these days), you can position the setting for infinity on the lens focusing scale opposite the shooting aperture on the depth of field scale. The middle of the focusing scale will indicate the hyperfocal distance, while at the other end of the focusing scale a mark for the same aperture points to the closest distance that would be acceptably sharp through the range to infinity. You could aim your camera anywhere between the closest point of acceptable sharpness and infinity without moving the focusing ring and all would appear sharp in the scene.

Though these scales are not often found on recently manufactured lenses, and are not considered practical on zoom lenses, the principle is as effective as always. Especially for landscape photography, understanding how to work with the hyperfocal distance can improve sharpness. You can use this technique by looking up tables of hyperfocal distances for given focal lengths and apertures on charts that can be found on the internet.

The depth-of-field preview button on your camera, while not precise, can also be an important aid in getting the depth of field you want. When pressed, a preview displays (either in the viewfinder or on the LCD in Live View) showing how sharp your scene will look as an image. You normally view the scene through the camera's widest aperture—the camera is engineered that way so the most light is available. But when you engage depth-of-field preview, the lens stops down to the taking aperture, offering a look at how the sharpness will appear at that aperture.

Shallow depth of field helps isolate and distinguish a subject against the background. This close-up was made with a moderate telephoto lens at its maximum aperture of f/4.

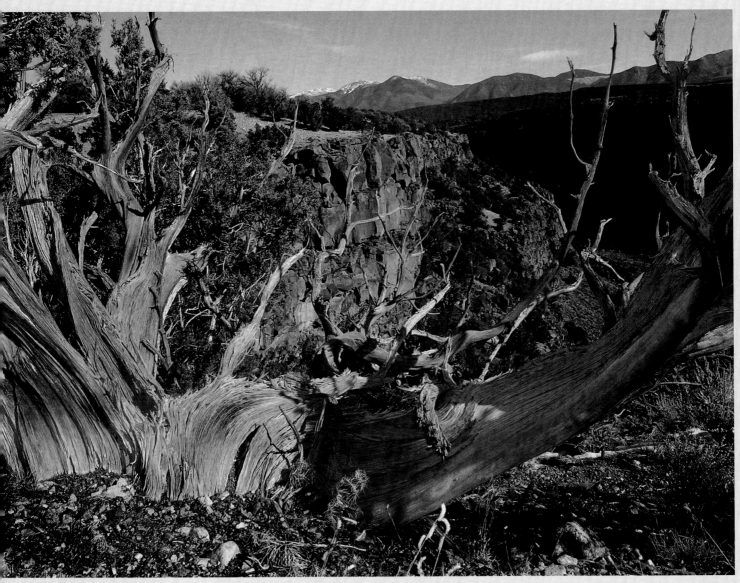

Large depth of field provides acceptable sharpness from quite close to far away. Here, a wind-shaped tree trunk was photographed from four feet (1.2 meters) with a 24mm lens at f/22, which provides sharpness from the nearest point to infinity.

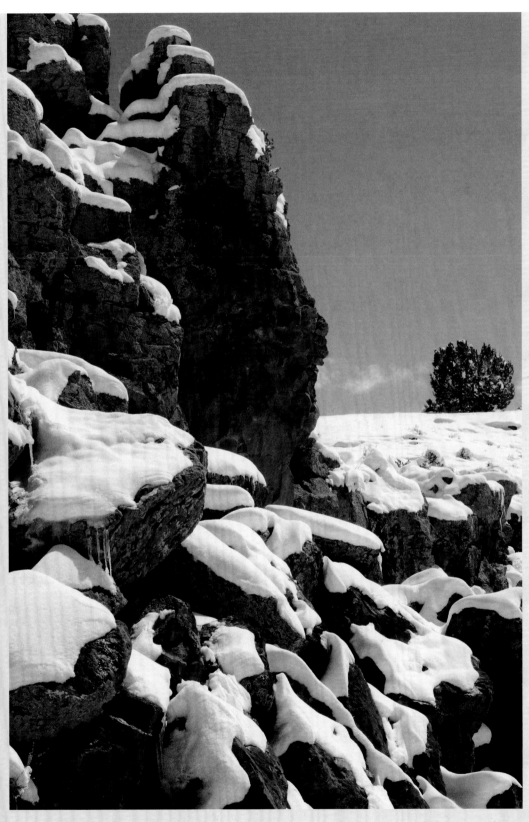

To make sure the image was sharp from the nearest rock to the tree in the distance, I focused on the closest cliff face and framed the scene, setting the aperture to f/11. I then activated the depth-of-field preview. When reviewing the image in my camera, I noticed that the foreground was still a bit unsharp. So I reset the aperture to f/22.

Focus

Making choices about sharpness is one of the most important creative decisions in shooting landscape photos. You can usually choose to work in either manual focus or autofocus. This is a personal decision, but the main reason to choose autofocus is because the viewfinder on many D-SLRs is quite small and it can be difficult to discern precise focus, especially in low light. On the other hand, the problem with autofocus is that the camera takes over and makes decisions for you, which can result in the wrong point of focus being set.

My suggestion with autofocus is to work with the focus indicator in your viewfinder turned on so you know where the camera has set its sights. I also simplify the process by activating only the focusing point or focusing acquisition area in the center of the finder. Generally, landscape work does not require dynamic focusing (the mode that follows a subject in motion from one side of the finder to another).

Another useful option is autofocus lock (AFL), which will hold the focus even if you adjust the framing of the scene. This allows you to focus on an important part of the scene and then recompose. For instance, I like to activate the central focusing point, move the frame to have the foreground subject under the center point, lock focus, and then reframe as desired. This is a great tool when your foreground subject sits at the side of the frame or outside the target areas.

If your main subject sits at the edge of the frame, the camera's autofocus system might bypass if and focus on a subject farther away. In that case, press the AFL button and recompose, or switch to manual focus.

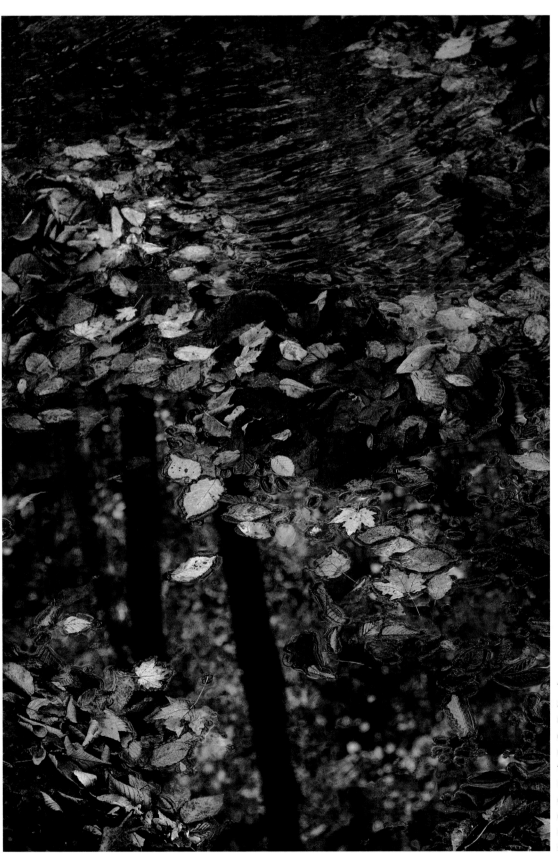

This photo was made using manual focus and depth-of-field preview, which gives me the most control over sharpness. I pondered whether or not to keep the reflections sharp. Making both the reflection and the area around it equally sharp was possible, but by offsetting sharpness against unsharpness, I could add dimension to the image.

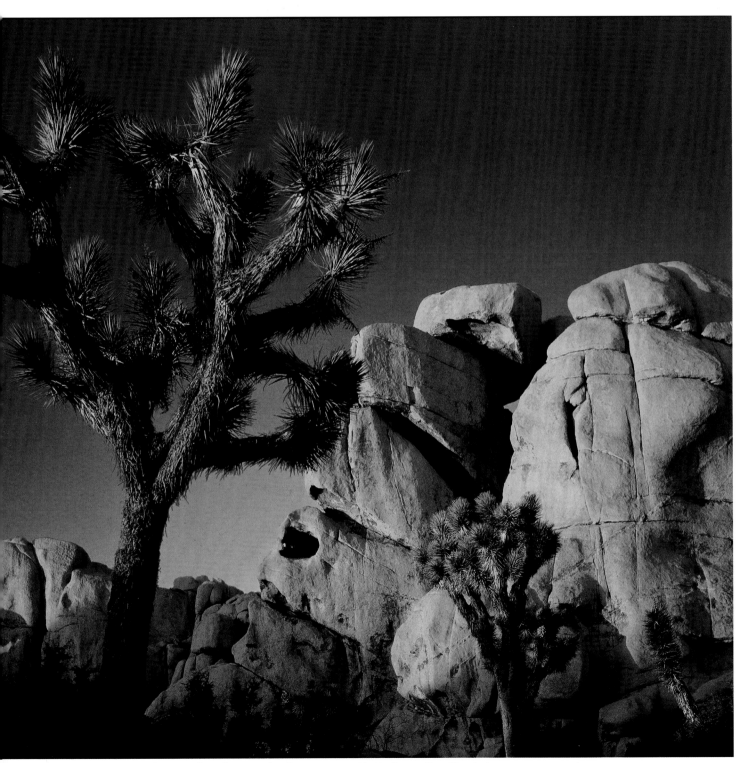

Focus lock was used to set focus on the palm tree when it was centered in the frame, then the photo was recomposed to offset the tree and balance the composition.

When setting up close, the depth of field becomes very shallow. Difficulty in close focusing becomes compounded when there are many potential subjects that might engage the focusing mechanism. That's why manual focus used in conjunctions with depth-of-field preview is often a good idea.

There are other focusing options, but setting the autofocus mode for single shots is best since it is rare for landscapes to have moving subjects. Single AF mode usually will only allow you to release the shutter once focus has been acquired by the camera.

As you can see from this discussion on autofocus and focus lock, there may be times when working in manual focus is simpler and, in fact, allows for more personal focusing control. With manual you can "stretch" the depth of field by stopping down and focusing slightly beyond your subject, maintaining the focusing point should you recompose during a progression of shots.

Close focusing, or macro photography, is best done using manual focus, especially when photographing a complex scene with a number of areas that might grab the attention of the focusing mechanism. You will have more control over close focusing if you use a tripod; but if handholding, set the distance working in manual focus mode and then move the camera into and away from the scene until you achieve the focus point you want before releasing the shutter. I often frame the subject and set focus, lean back a bit and then move into the framing again, and shoot. Depth of field in close focusing situations is very shallow regardless of lens choice and aperture, so utilizing the depth-of-field preview as you work is important to get the effect you desire.

Numerous cameras with Live View allow that function to be used in conjunction with depth-of-field preview, a combination that can be helpful with close focusing work as long as the light is such that you can properly read the LCD. Some camera models even allow you to magnify the image for additional critical focusing. Again a tripod is preferred, but you can always try handholding to see how good the results are.

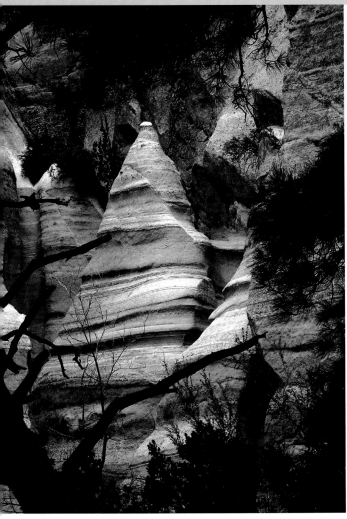 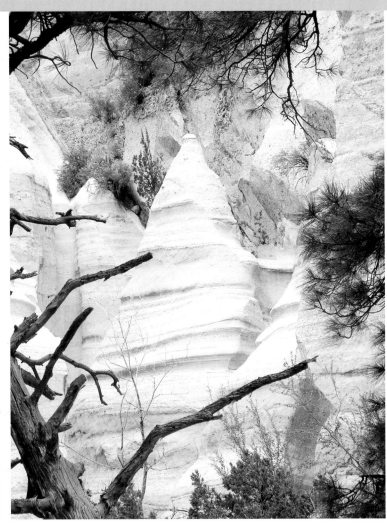

This set shows the darkest (underexposed) shot (above left) and the lightest (above right) from a bracket. A merged image that combines the two is on the opposite page.

Bracketing

Usually the single shot advance or drive mode—where one press of the shutter button produces one image—is the most useful method of exposure for landscapes. However, autoexposure bracketing (AEB), which is shooting a series of consecutive images with different exposure settings, is helpful if you want to create exposure effects or make sure you have the proper exposure in a shot that will not be repeatable. You can also combine an underexposed and overexposed image if you have an automerge feature in your software. Autoexposure bracketing usually incor-

porates three or five exposures (some pro camera models offer up to nine exposures) so shooting them using one of the other drive options, such as low or high continuous, is helpful for maintaining a fairly equal framing when working handheld.

When using the AEB function, space your brackets accordingly. In most cases you will want to make sure to space exposure at least 1 stop (or exposure value, EV; see page 84) to have an effect. Sometimes you need more difference to capture both highlights and shadows.

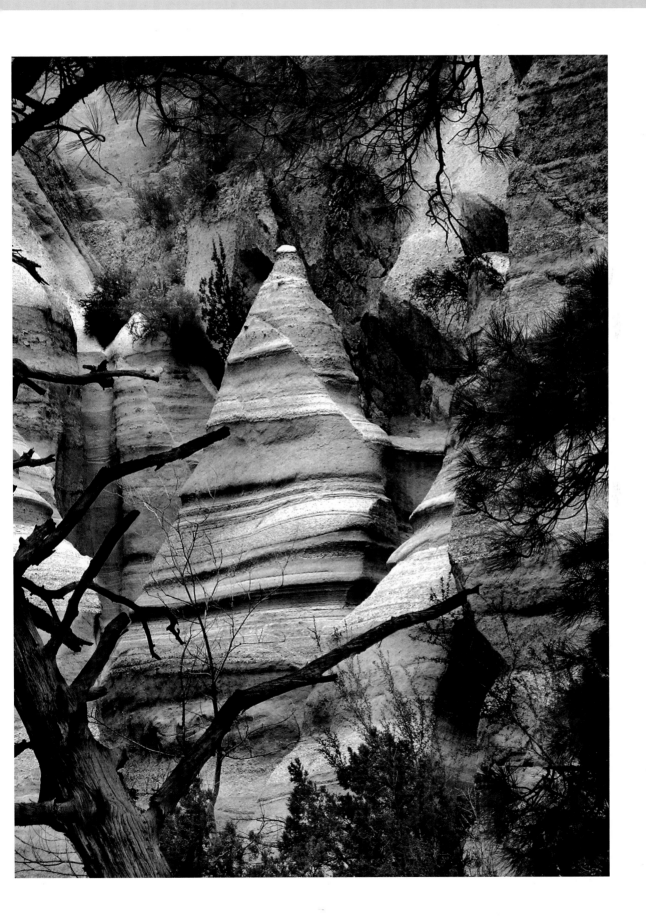

This detail from a sandstone cliff was photographed on a tripod with mirror lockup. This is a good course to follow when doing studies or photographing for big enlargements.

Shutter Release Options

While shutter release might seem a mechanical operation unworthy of discussion, it can affect the steadiness of the image, and shake or movement of the camera can make the image worthless. The simple rule for handheld work is to invert the focal length of the lens in use and make that the minimum shutter speed for the shot. If that is not possible at the ISO you have set and the lighting conditions, consider raising the ISO to attain more light sensitivity, thus gaining more stops you can spend on shutter speed. If you intend to make fair-sized enlargements of your images, do not go beyond ISO 400 unless absolutely necessary. (For more on ISO and exposure guidelines in general, see Chapter 5.)

The answer for many lowlight problems is a sturdy tripod, because that supplies the stability to help eliminate shake at most speeds. To enhance steadiness even more, use a cable release to fire the shutter, eliminating shake induced by the motion of your finger on the release button. Lacking that, you can also fire the shutter using the self-timer (set in the drive modes), which delays shutter release from 2 to 10 seconds in most models.

There are two other options for creating steady shots. One is mirror lockup, which eliminates the vibrations of the mirror springing up and out of the way right before exposure. This cuts off the view through the viewfinder, which for many scenes is not a problem, but usually

necessitates working on a tripod for precise framing. The other is the option to use one of the various forms of image stabilization, a technology found in either the manufacturer's lens or camera body to counteract the effects of camera shake (although not vibrations from the mirror, which has much less of an effect). Both image-stabilized lenses and cameras with internal stabilization have proven to be effective; I have worked with both and gained a two to four stop advantage over the inverse focal length guidelines.

Custom Functions

You can program many of the camera's operations, customized to the way you work and to the types of controls you use most often in the field. Depending on your camera, this can include the number of brackets in a sequence and the number of stops separating the exposures; the separation of the autofocus and autoexposure lock buttons (sometimes this is not offered, so you must shoot with manual focus when doing focus and exposure lock operations); the dial that will allow you to make autoexposure compensation settings; and what functions each button on the camera controls. This is individualized to each brand and model, so I won't attempt to tackle the subject here. Keep in mind that the camera

came out of the box with default (factory set) operational modes, so making the instrument your own is a good idea and will help you concentrate more on making photographs than fiddling with dials and controls.

In short, turn your attention to making a good exposure, insuring a steady shot, getting the focusing and shutter speed image-effects you want, and setting the ISO within a reasonable limit. And of course shoot RAW format. This way you will take care of most of the essential matters. Much of the work beyond this, despite what camera makers provide, is best done in image processing later. Now that we have some of the mechanics out of the way, let's get to the heart of the matter—exposure.

Exposure

5

You might wonder just how important proper exposure techniques are when working with a digital camera. After all, can't you simply review the image in the LCD and reshoot if there's a problem? And can't any exposure problem be fixed with a quick click using image-processing software in the computer?

The fact is that exposures made in a camera are rarely perfect. Some further refinement is always a good idea, although it is true that we are getting closer to the day when some classic exposure problems can be solved by the camera. An important step in correcting imperfect exposures was the introduction of the RAW file format, which allows certain non-destructive exposure modifications during processing. But even with a RAW file, underexposed shadow areas or burnt highlights can only be improved to a limited degree; and RAW cannot expand the dynamic range of the sensor. Gross exposure miscalculations cannot be corrected. In fact, when you push RAW exposure corrections too far, instead of helping the image, you increase noise and other artifacts that often degrade images.

The aim in this chapter is to explore techniques that allow you to make exposures in the field that are good enough to let you spend more time creating with the camera and less time correcting them later in software. Even with the best exposure procedures, every image can be enhanced to some degree in an image-processing program. You will get better results when you start with an exposure that does not put you in a hole that you must dig out of with extensive software manipulation. I'd rather spend my time enhancing, not playing catch-up with a poor exposure.

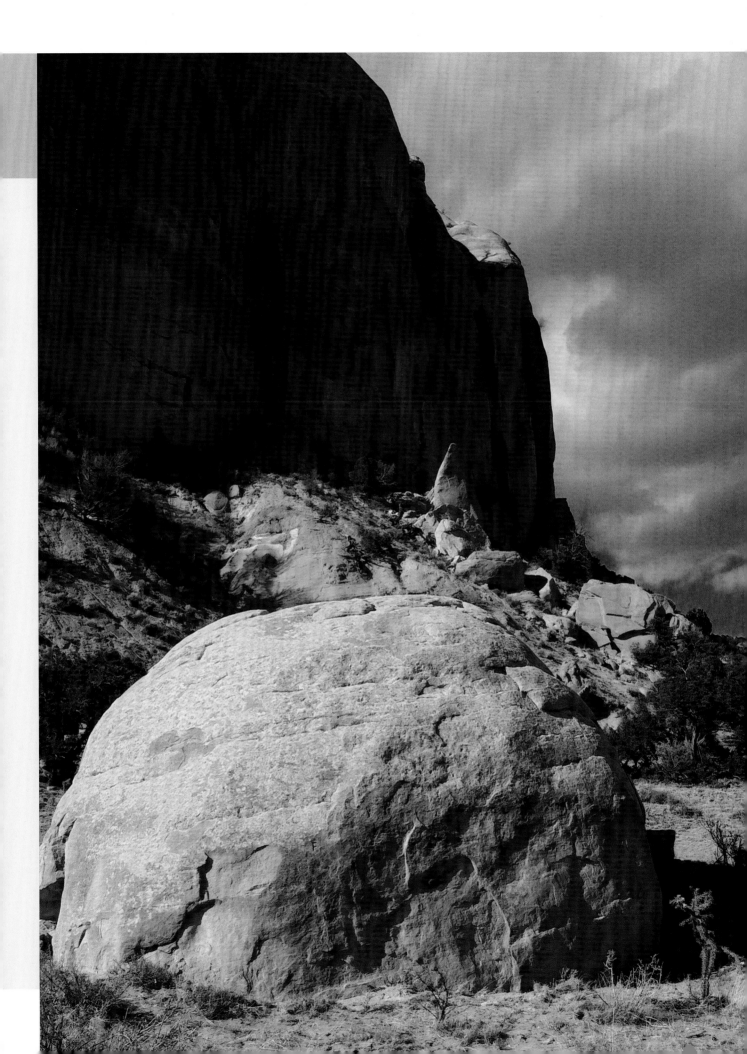

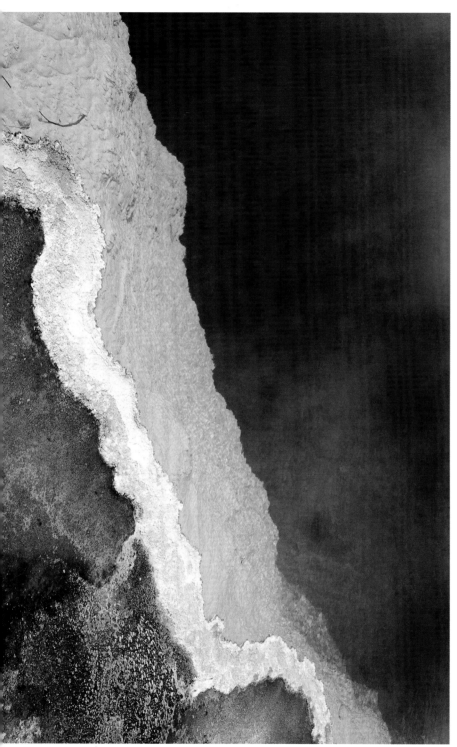

The tonal values in this photo of the edge of a geyser in Yellowstone Park extend from bright, textured highlights to shadow areas with textural detail. This wide range allowed me to spend time enhancing, rather than correcting, the image in software.

The Digital Exposure

A good exposure in digital photography contains as much of the detail, tonality, and dynamic range from the scene as possible. Think of a piano keyboard. If you can play with more keys, you'll get a richer musical sound. Now think of those notes as an array of dark and light tones. The wider the range of tones recorded, the richer the images and the more interpretation available.

Proper exposure is a delicate balance between the sensitivity of the sensor and the amount of light in the scene. The light coming through the lens causes a reaction on the sensor's photosites. The result is an electrical signal that contains information about the light that has struck the sensor. A digital exposure is composed of code that represents the brightness (intensity) of that light, the hues (colors), and the vividness of those hues (saturation). The sensor is like a microphone in that it picks up information and passes it along to a signal processor, which then sends it to the memory card where the actual recording is done.

As we noted previously, with most sensors this light also passes through a checkerboard-like filter composed of red, green, and blue components (Bayer pattern) before hitting the sensor. The light filtered by these components, or channels, is later re-integrated to form the

RGB digital image. The sensor itself is essentially monochrome. All of the information is interpreted by the image processor and turned into binary code, which when reconstructed through a computer, yields a digital image. Aside from the wonder of it all, the important matter for black-and-white photographers is that every image is RGB—full color! This may seem surprising, but is in fact a great benefit that expands the potential of every image.

The amount of light coming through the lens is controlled by the lens aperture and the shutter speed. The aperture is the diameter of the opening in the lens, which is annotated as an f/number, such as f/8; while the shutter speed is the length of time the shutter stays open to allow the sensor to receive the light coming through the lens, usually mere fractions of a second (such as 1/125 second, sometimes noted as 125), though it can also be longer (noted with a quotation mark (") for seconds and with an apostrophe (') for minutes).

The color codes for RGB channels are easily converted to black and white. During the conversion using software, you can enhance the tonal response of any of the colors, which leads to many creative options. More on this in Chapter 6 on Image Processing.

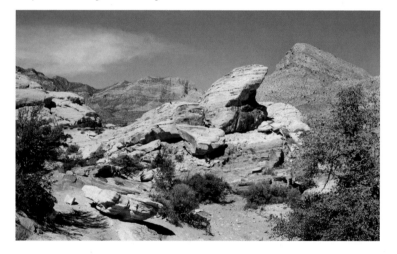

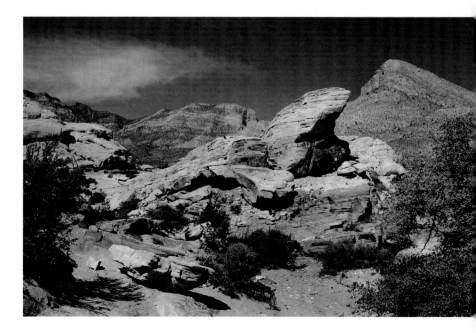

The objective original exposure (left photo) was made in flat light in the shadow of a canyon wall. I envisioned it, however, with more contrast and deeper shadows, so I converted to grayscale, increased contrast, and worked with selective burn and dodge controls (photo on right). Having all of the information in the original exposure allowed me to create a subjective rendition.

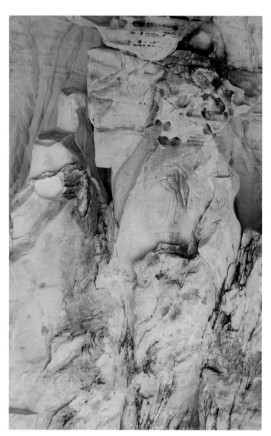
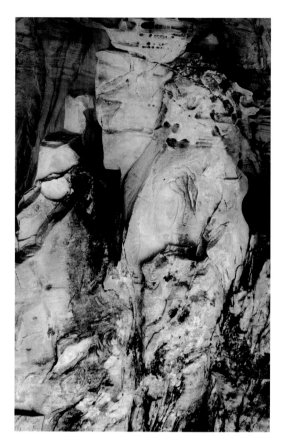

Objective and Subjective Exposure

Processing images to alter exposure and contrast can guide the viewer's eye according to the photographer's artistic pleasure. That's the difference between the objective exposure, which strives to gather and record all of the values in a scene, and a subjective or expressive rendition, which manipulates tonal values for certain aesthetic ends. The former is what you should strive for when making exposures; the latter is what will inform your processing and printing decisions.

Your photos should contain as many tones as possible observed within a scene; but as some musical pieces are best played with a smaller range of notes, so some photography may be more effective with a limited tonal range. In fact, some of the most impressive images are those made from a scene with a broad range of values in the field that become selectively chosen later. An inspection of the black-and-white negatives, and indeed, digital files, along with subsequent prints of some of the great outdoor and nature photographers would quickly reveal this to be the case.

ISO

The ISO defines how the sensor's signal is adjusted for the light. The degree of sensitivity is stated as a number, with ISO 100 being the lowest in most D-SLR camera systems. Think of ISO 100 as what you would use on a sunny day, then consider how, as the light dims, you might have to gain more light sensitivity. You would do this by raising the ISO setting on your camera.

It is important to keep in mind that aperture and shutter speed are not the only factors that determine exposure; we are often limited by the sensitivity of the sensor and the amount of light in the scene itself. One of the advantages afforded by digital cameras is the ability to immediately shift the ISO value at any time (instead of having to change film each time you want a different sensitivity). This freedom gives you the capability to shoot in bright sun one moment, then step into the deep shade of a forest the next to make photographs in very low light levels.

This snow-covered tree was photographed in late afternoon on an overcast day. Exposure at ISO 100 was too slow to handhold the camera and get a steady shot at the desired aperture. Raising the ISO to 800 yielded three stops more light, which brought the shutter speed from 1/15 second to 1/125 second, a much more secure shutter speed to prevent camera motion.

Most landscape photography should be done within the range of ISO 100 to 1600. The higher the ISO, the greater the signal is amplified, which leads to image degradation due to digital noise. If you often find yourself setting ISOs of 1600 or higher in order to achieve acceptable shutter speeds, you should invest in a tripod so you can use lower ISO settings and avoid such noise (you should use a tripod for landscapes anyway). While cameras often pro-vide a top ISO of 3200 (and some sensors can even be "pushed" as high as ISO 25,000!), the cost in image quality can be severe. Staying under ISO 1600 with today's sensors and image processors is ideal. For the best-quality photos, use the lowest ISO setting possible for every shot.

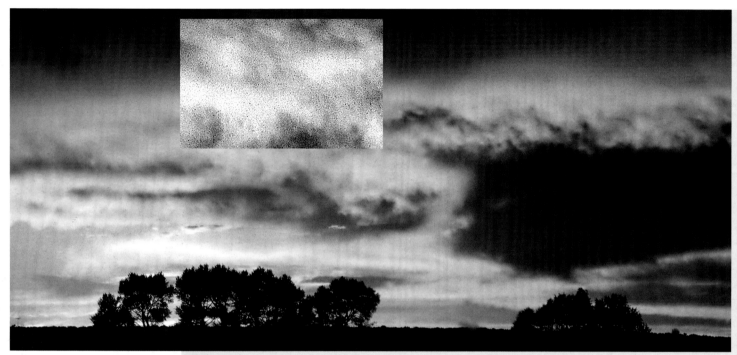

Noise is generated by high ISO settings (as well as by long exposure times). The ISO/noise threshold depends on your particular camera and its electronics. The inset shows a cropped close-up of this darkening sky.

ISO is coordinated with aperture and shutter speed. Every time you double the ISO, you are effectively doubling the sensitivity of the sensor's response, or adding one stop of light sensitivity. This provides another stop to your aperture or shutter speed setting. So, if you need more or less light to affect how the aperture and shutter speed are set, you can raise or lower the ISO setting. Go to a higher number for more light sensitivity (when you need a faster shutter speed or narrower aperture), or a lower ISO for less light sensitivity (when you want a wider aperture or slower shutter speed.)

In order to increase the sensitivity of the sensor, an electrical amplification is applied the by the sensor's circuitry. As mentioned, this gain causes more noise and image artifacts (speckled color, colored fringes). Though many cam-

era microprocessors can apply noise suppression filters, the result is often reduced sharpness because noise reduction tends to smooth the contrast edges between pixels. And, though there are some very good software programs to help reduce noise in image-processing, they still soften images to a degree.

Shutter Speed

An important aspect of creative photography is the balance between shutter speed and aperture, and the way this affects how the subject of your photo is rendered. The relationship between these two factors creates different image effects that are useful in presenting an interpretation of a scene. Let's first take a look at shutter speed.

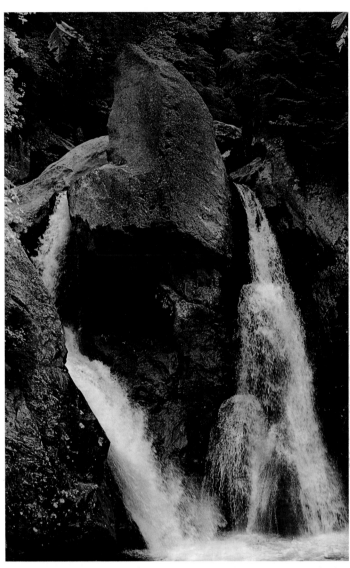

This waterfall was photographed using a shutter speed of 1/8 second (left) and 1/250 second (right). The exposure value was maintained by making a corresponding aperture adjustment. Notice that the difference in the effects of each shutter speed on the appearance of the water is quite dramatic.

Shutter speed determines how motion is depicted. In terms of picture quality, it also has a profound influence on how steady the image appears, depending on the equipment you are using and how steadily you can hold the camera without a tripod or other support. Of course, working on a tripod is preferable whenever possible.

Probably the slowest speed at which most people can handhold a camera without the image showing some blur (due to photographer motion or camera shake) is 1/30 second, though the threshold will differ depending on how steady the person is and the gear they are using (long lenses and/or heavy cameras are more difficult to hold still than shorter or lighter ones). You might be able to get by with a 1/15 second exposure if you use a lens or camera with vibration reduction or image stabilization.

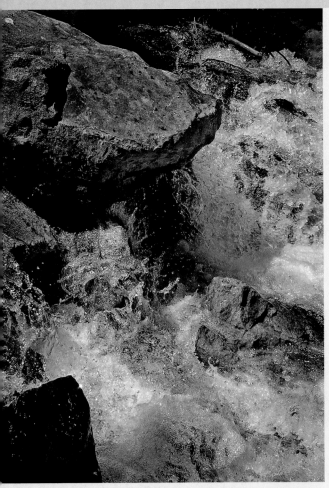

Very fast shutter speeds can reveal motion in ways that the eye never sees. This churning river was photographed at 1/2000 second, suspending the individual drops and splashes of water in mid-air.

I increased shutter speed to twice the inverse focal length guideline on this handheld photo (1/500 second and a focal length equivalent of 250mm) because I wanted to be absolutely sure to eliminate all trace of blur due to camera shake.

By stabilizing the camera with a tripod (or one of several other methods), a slow shutter speed can be used to depict motion in interesting ways. The flow of water, for example, when photographed at a speed longer than 1/30 second can take on an otherworldly look, with the passage of time and motion shown in ways hinted at by physics but rarely seen by the unaided eye. This technique can also be used to photograph clouds moving in the sky, or even star trails.

Fast shutter speeds, on the other hand, freeze motion. Today's digital cameras can often capture up to eight frames per second at shutter speeds as fast as 1/8000 second. This splits time into fractions too small to be seen without a camera. It can show us every droplet in a waterfall or "stop" the motion of a delicate flower blowing in the breeze.

Of course, not every use of shutter speed need be as dramatic as that. In general, shutter speed is used to eliminate blur due to camera movement, because camera steadiness during exposure is such a crucial element in image quality. A speed in the range of 1/125 to 1/500 second will usually do the job, although there are exceptions. You may want to increase shutter speed if you realize your hands are unsteady or you are shooting in strong wind.

Also note that telephoto lenses tend to magnify camera shake, which is important to remember when you are handholding long, heavy lenses. No software program has been invented that can cure picture jitters. There is a generally accepted guideline for setting shut-

ter speed that can consistently reduce the effect of camera shake when handholding your camera. The principle is to set a shutter speed that is equal to or shorter than the reciprocal (or inverse) of the lens' focal length. For example, use Shutter-priority mode to set a speed of 1/250 when your focal length is 200mm or 250mm. (Be sure to take into account the focal length magnification factor for your particular camera.)

Aperture

Remember that aperture refers to the diameter of the lens opening when an exposure is made. It is set according to f/stops that are variable between the maximum (widest) and minimum (narrowest) opening the lens offers. The higher aperture numbers (f/numbers) represent narrower openings, since the numbers are actually fractions. So, f/4 is a wider opening than f/16 as, for example, the fraction ¼ is a larger value than 1/16.

While shutter speed controls light duration, aperture controls light volume. However, aperture also plays a critical role in the depiction of sharpness through the picture space, from near to far subjects. This is known as depth of field (see page 61 for additional information about depth of field). A narrower aperture will increase the sharpness throughout that space (as long as all other factors remain equal, such as the focal length of the lens and the distance between the camera and subject). A wider aperture will yield less of a range of sharpness from near to far. This ability to control sharp-

ness through the choices made in aperture settings is one of the most creative aspects of photography. It has a profound effect on the image and how you depict subjects within the context of the overall scene, and can be applied critically by using the depth-of-field preview function on your DSLR.

When a D-SLR uses a sensor that is smaller than the size of a 35mm film frame, the relationship between a particular f/stop and its depth of field is different from what it would be with an SLR film camera or a full frame digital camera. Smaller sensors produce greater depth of field than full-framed sensors or 35mm film frames do, given that all else is equal. For example, you might get the effect of f/11 when using a setting of f/8 or even wider on a camera that has a sensor smaller than 24 x 36 mm.

Using a wide aperture and moderate to long telephoto lens is a great way to separate foreground subjects from a busy background. These plants along the Rio Grande in New Mexico stand out against the background through the use of f/4 with a moderate telephoto lens.

Maintaining Equivalent Exposure

The settings below show how to make changes while maintaining an equivalent exposure value. The ISO is 100 in this hypothetical situation:

- f/4 at 1/500 second or
- f/5.6 at 1/250 second or
- f/8 at 1/125 second or
- f/11 at 1/60 second or
- f/16 at 1/30 second

Now raise the ISO to 200. The sensor's sensitivity to light doubles, and that gain can be "spent" to achieve equivalent exposure by adjusting either the aperture or the shutter speed (not both) by an additional stop (EV).

- f/4 at 1/1000 second or
- f/5.6 at 1/500 second or
- f/8 at 1/250 second or
- f/11 at 1/125 second or
- f/16 at 1/60 second

Now, at ISO 400

- f/4 at 1/2000 second or
- f/5.6 at 1/1000 second or
- f/8 at 1/500 second or
- f/11 at 1/250 second or
- f/16 at 1/125 second

Exposure Value and Equivalent Exposure

A commonly used abbreviation for aperture and shutter speed combinations is EV, or Exposure Value. EV represents the varied combinations of aperture and shutter speed settings at a certain ISO value that produce a specific exposure. It is a way to measure the light level: +1 EV would increase the level of light by one stop (a change of 1 EV also equals a halving or doubling of light). You'll encounter EV numbers in exposure compensation, flash output compensation, and in some instances, in actual exposure settings.

As we saw in the waterfall shots on page 81, there are many ways to interpret a scene through the use of various aperture and shutter speed combinations that add up to the same amount of exposure. This works because a carefully balanced set of equations used in photography is calculated by the metering system in your camera.

For example, say you are shooting on a fairly bright day with the camera set at ISO 100, and the reading is 1/125 second at f/8. You want to change the shutter speed or aperture to create different image effects, but you do not want to change the exposure, since a certain exposure value is required to record all the brightness values correctly. To achieve an equivalent exposure while maintaining the same ISO, you can progressively open the aperture a stop at a time (let in more light) as you correspondingly increase shutter speed (light flows in for a shorter amount of time). Conversely, as you narrow the aperture, you must slow the shutter speed.

You can utilize faster shutter speeds by going to a higher ISO setting. This certainly helps when you want to use a fast shutter speed to freeze motion. It is also a great aid in low light when you want a shutter speed fast enough to handhold your camera without resulting in blur due to motion shake.

Dynamic Range

Think of using 1/30 second as a base exposure needed to get a steady shot. Imagine you're at a great photographic location but have not brought your tripod. You get a reading with the camera of 1/8 second at f/5.6 while set at ISO 100, and f/5.6 is the maximum aperture (the widest opening the lens offers). In this case you have nowhere to get more light except from changing the ISO setting. How can you boost the reading up to 1/30 second? Here's the way to do it:

• ISO 100 sensitivity yields f/5.6 at 1/8 second

• ISO 200 sensitivity yields f/5.6 at 1/15 second

• ISO 400 sensitivity yields f/5.6 at 1/30 second

The principle of equivalent exposure allows you to make creative decisions about image effects using various combinations of aperture and shutter speed. It also helps maintain image quality when the light is low and shutter speed is approaching that borderline where camera shake might occur.

While aperture, shutter speed, and ISO settings put you in control of exposure, there is a limit to the range of values, or the degree of contrast, that your camera's sensor will be able to record and still show detail in both highlights and shadows. This limit is referred to as dynamic range.

Recording detail in scenes when very bright light and deep shadows are within the same frame can be difficult. Such high-contrast scenes surpass the dynamic range of your camera's sensor. You can still make a picture under these circumstances, but you may have to sacrifice detail in either the dark or the bright areas—the sensor simply cannot handle both extremes.

This means, for example, that if you are recording a picture of a deep canyon with bright snow surrounding it, correctly exposing only for the shadows may result in the snowy field appearing too bright—becoming highly overexposed. In fact, it can often be so bright that it will be "burned up," losing all detail and appearing completely white. On the other hand, if you lock exposure on the brightness of the snowy field, you very possibly won't see any details in the dark canyon. Those areas will appear completely black.

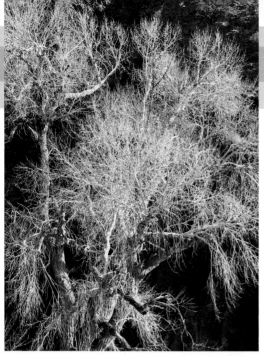

In some cases of extreme contrast, there is no way to properly expose both the very bright highlights and the deep shadows in one shot. Knowing this, you can choose to exploit the unique strength of high-contrast scenes by properly exposing the brighter areas and letting the deep tones become dramatic counterpoints, as illustrated in the photo below.

There is some leeway in resolving high-contrast lighting conditions. Software techniques can reveal information from the shadows that is often not seen at first, but the correction cannot be too radical, as it might introduce noise or digital artifacts into the corrected areas. Making an exposure that controls highlights as much as possible is almost always best. The key is to bias exposure for the highlight; in other words, properly expose the brightest areas in the scene—the highlights—and let the shadows fall where they may. Then if the shadows appear too dark to retain detail, see if you can rescue them with image-processing software. And, as we'll see later in this chapter, you can also use a tripod to take two or more exposures of exactly the same scene and utilize software to combine the files for a result that you simply cannot achieve with one exposure (see page 98).

Knowing your camera's dynamic range limitations is an important aspect of making good exposure decisions. As you gain experience, one of the most important matters to concentrate on is developing a sense of scene contrast and understanding what your sensor can and cannot do with that contrast. In short, you will begin to see as the camera sees and gain a sense of how to handle different lighting conditions.

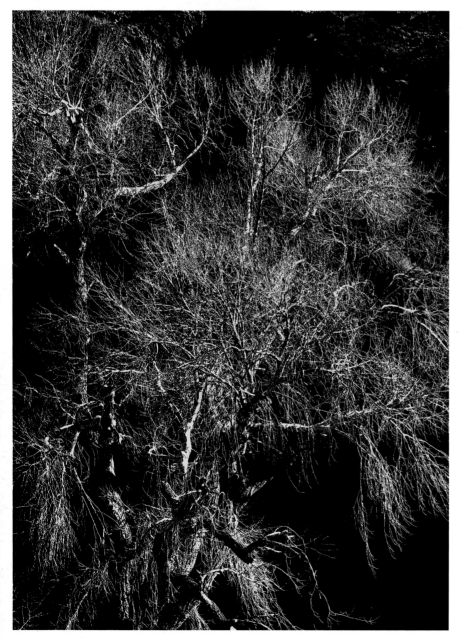

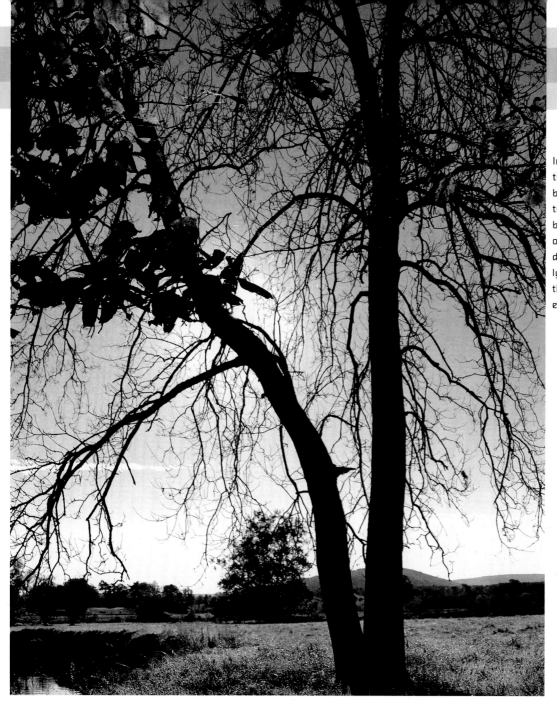

In this backlit scene, I positioned myself so the sun was blocked by one of the tree's trunks. This prevented the brightness from completely overwhelming the exposure. I did, however, meter to properly expose the sky. This created the strong shadows and silhouetted form of the tree.

The dynamic range of the sensor did not allow proper exposure of both the rocks and the sky, so I exposed for the rocks (below left). I recognized that the foggy sky had no distinguishing tonal breaks, but I knew that I could add a gradient of black to white in that area using image-processing tools in the computer (below right).

Metering Systems

Modern photographic technology has taken much of the guesswork out of setting exposure. But that does not mean that automated camera systems will always produce the best exposure for every one of your shots, especially in the high-contrast situations we have discussed. It is helpful to understand how your camera reads light in order to know when you can trust your camera's recommendation and when you need to insert yourself into the process.

In essence, the metering system reads the light energy and translates this reading to aperture and shutter speed values. Despite what the camera companies' ads might claim, a meter is an instrument that does not have a mind of its own. It will behave rather well when you feed it the right information for its calculations. It will behave rather poorly if you don't. It is not always easy to handle the light and dark areas of a scene and, with a single exposure, record detail in all areas. The solution is to make an exposure that allows just enough light to bring detail into the shadows but not so much that the image gets overwhelmed by the highlights. Under normal contrast lighting conditions, this is usually the average of the two intensities of light. Such a reading sorts out the light and dark tones accordingly, so some record as brighter than the average and some as darker.

As a simplified example, say you lock the shutter speed at 1/125 second to shoot a landscape where the brightness is relatively even throughout the scene. You might point the camera at the bright sky and get a reading of f/16, or at some light green foliage and get a reading of f/8, or at the dark ground for f/4. The average of these three readings is f/8—the middle value—which is the reading the meter will recommend if the weight of each brightness value within the frame is roughly equivalent. In essence, the meter has read and set up a range of tones that will be recorded. With f/8 as the middle gray, f/16 as a brighter value, and f/4 as a darker value, all are recorded just fine.

If, however, the darker area dominates the frame, then the reading will be skewed and the brighter area will become overexposed. In that case you have to make sure that the brighter area is taken into consideration by biasing the exposure toward the highlight. In other words, frame the scene to eliminate the dominant dark situation and point the camera so that there is more of a balance in the subsequent light reading. This is done by using the exposure lock function (AEL) to hold the more balanced reading and then reframing to your original composition.

Conversely, if the scene consists mostly of tones that are brighter than the green foliage, then you must compensate in the other direction. This can be done by either reframing and locking exposure on a balanced area, or by taking the reading from the brighter area and then using the exposure compensation function and add + EV. All the values work in lock step, so when a bright value represents middle gray, the dark values register as even darker (and perhaps underexposed to the point that no detail is seen); and making a dark value middle gray can cause all the bright values to become quite overexposed.

One of the ways to give your camera's meter the best information is to select a metering pattern and then read the light from an appropriate portion of the scene. D-SLRs generally have three metering patterns:

• Multi-pattern, such as Matrix, Honeycomb, or Evaluative

• Center-weighted averaging

• Spot or selective area control

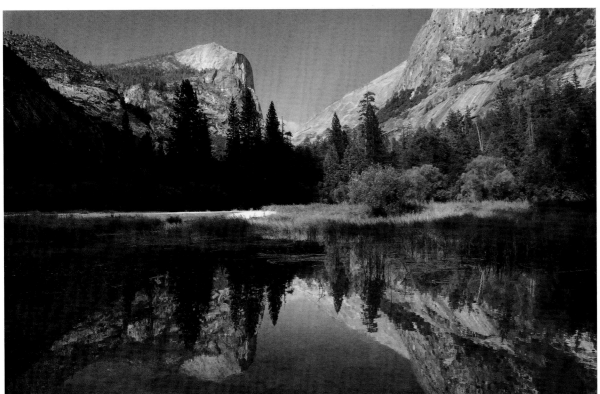

Today's sophisticated light meters provide excellent exposure in a variety of conditions. This seemingly complex lighting situation was handled well by Multi-pattern metering, yielding a range of tones that could be easily enhanced using image-processing software.

Multi-Pattern Metering

Multi-pattern metering is a pretty impressive technology and generally provides equally impressive results. It takes light readings from numerous areas around the frame, biases them to the active autofocus area, and calculates these various brightness values, then refers the calculation to a reference table in its memory. This is entirely controlled by a microprocessor. In other words, if area X has a certain light value and area Y another (and so on), the system compares this information with its database to derive an exposure recommendation.

Center-Weighted Averaging Metering

This was a popular method for metering light before advanced microprocessors got into the mix. With this method, the light is read in the complete area of the viewfinder, but the meter's calculation is weighted by approximately 70% for the central area. It is called "averaging" because it takes in all the various brightness levels and then averages them to a middle gray exposure reading.

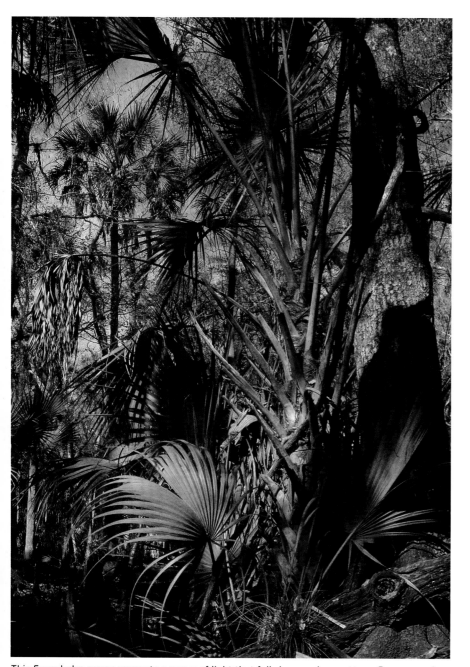

This Everglades scene presents a range of light that falls in a random pattern. From experience, I realized that Multi-pattern metering would over-compensate for the dominant shadow areas, causing the brighter highlights to be overexposed. The solution was to switch to Center-weighted metering, point the camera at the bottom part of the scene (where the bright palm frond sits), lock exposure, recompose, and shoot. This is known as biasing the exposure for the highlights.

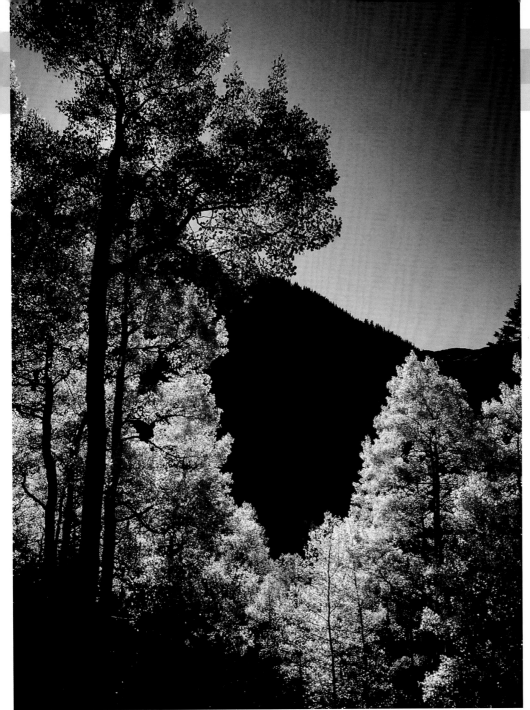

This is a very difficult tonal distribution to read, and most Multi-pattern systems will take too much of the shadow area into account and hopelessly overexposure the brighter areas, rendering the image useless. This exposure was made using Spot metering on the bright area in the tree in the lower portion of the frame, locking exposure, then recomposing.

Spot Metering

The third metering pattern you might choose is Spot metering, sometimes known as Selective spot or Partial metering. This works on the same principle as Center-weighted, except that it takes the reading from a specific and not a general area within the frame. That area can be a small circular spot at the very center of the viewfinder (in some cameras you can control the diameter of that spot from quite small to moderately large) or from a specific focusing target that you select. The tone you read becomes the middle of the recording range. If you put the spot on a bright white it will record gray; if you put it on a black value, it will record gray. When you work with Spot metering, you often work with exposure compensation as well (see page 97).

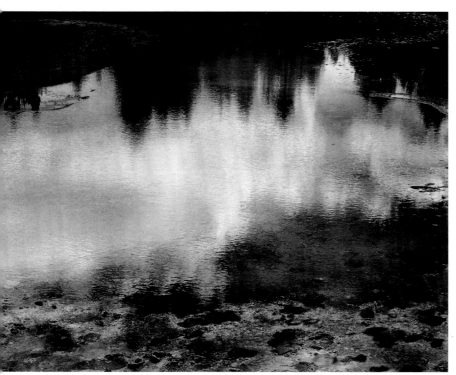

This distribution of tones presents a challenge to select the best metering mode. Some cameras' Multi-pattern systems would handle this exposure well; some might not. I often prefer a spot metering pattern because, by pointing the camera at any of the tones within the scene and locking exposure, I have more control over recording the distribution of tonal values.

Grayscale steps from black to middle gray (X) to white.

The Grayscale Spectrum

The grayscale spectrum of visible tonal values in a scene from light to dark can be divided into separate steps, though the demarcation is fairly arbitrary (11 steps are shown in the illustration above to the right). Think of the dynamic range of the sensor— its ability to capture tonal values from light to dark— as about five steps within the total range of the scene, with an additional step or two created when image-processing techniques are applied. If you were always able to match the middle value (middle gray) in the sensor's range with a similar value in the scene, then every exposure would be right.

However, There are also times, usually due to high contrast, when the range of light in the scene exceeds the sensor's dynamic range, or what can be recorded. Then you have to make a choice, with each decision in essence "moving" the middle gray to another point on the grayscale spectrum. This in turn affects how other values record. So, if you were to point the Spot meter and make tone Y (illustration above) be middle gray the dark areas would go darker still and record without any detail. Conversely, if you were to move the average exposure toward the darker areas, the brighter zones would be pushed into overexposure. When you take the time to work on exposure techniques and consider this scale, you'll see how tones, dynamic range, and exposure interact.

This might seem quite confusing in the abstract, but working with the camera, making readings exclusively from certain brightness values in the scene, and observing results will quickly show you how this system works. In fact, you can even make use of this knowledge to create very expressive exposures.

Handheld Meters

The metering system in your camera is an amazing instrument capable of delivering very good exposures under a wide range of lighting conditions. This would seem to make the use of hand held meters obsolete, and, in many ways it does. The main reason for using a handheld is for making very precise flash readings in the studio or the field. They also can be useful for making very accurate ambient (available) light readings. As long as you understand how the reflective light meter in your camera works, and you do not do studio work, the usefulness of a handheld meter is limited.

Exposure Modes

Most cameras have at least four exposure modes: Program, Aperture-priority, Shutter-priority, and Manual. Amateur-level camera models often have additional options for scene or subject modes, with settings for Action, Landscape, Parties, etc. These are fine for making snapshots, but they are a bit too pre-programmed to be of use to us here, so I won't cover them.

The metering patterns described previously define how light information is read and supplied to the exposure metering system. Exposure modes determine how that light is translated to aperture and shutter speed settings for different image effects. You can usually use the primary exposure modes with any metering pattern. However, if your camera offers subject modes, these won't necessarily work with every pattern.

Aperture-priority mode, often indicated as A or AV (Aperture Value), means that you select the aperture for a desired depth of field and the camera selects the shutter speed for a good exposure.

Shutter-priority mode (TV for Time Value, or simply S) allows you to select the shutter speed for a desired depiction of motion and the system picks the aperture that will yield a good exposure. In both instances the system takes the ISO, the metering pattern you set, and even the mounted lens into consideration.

In Program mode, the camera determines both the aperture and shutter speed by analyzing such shooting data as ISO setting and the lens in use, including factors like the program's interpretation of a handholdable shutter speed, and even the focal length (if using a zoom) in order to arrive at aperture and shutter speed settings.

Your camera might also include a variation known as Program Shift, which allows you to change the equivalent exposure "on the fly." For example, if Program yields f/8 at 1/125 second, you can shift to other equivalent combinations (e.g. f/5.6 at 1/250, f/4 at 1/500, etc.) just by turning a control on the camera. I'm a big fan of using Program Shift as it gives me flexibility in the field.

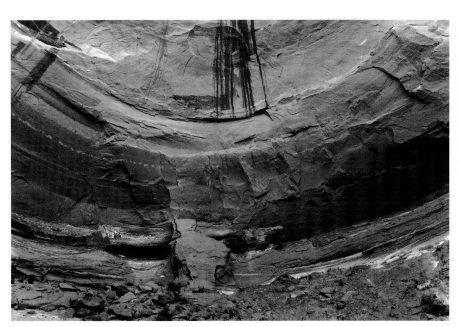

When set to Program mode, most D-SLRs have a control that will allow you to shift the shutter speed and aperture combination while maintaining an equivalent aperture.

Manual Exposure Mode

Manual exposure mode facilitates the creative control of exposure settings because you can make any settings you choose. The exposure scale in the camera's viewfinder provides you with an analog readout of how aperture and shutter speed settings are affecting the meter's recommended exposure. If the marker is in the middle of the scale, you are following this recommendation. Since you are in Manual mode to exert your creative choice, you probably want to do something a bit different—why use the middle reading that is the same as the exposure you would get using any of the auto modes? Hence, using the scale as a guideline, you can change the aperture or shutter speed to bias the exposure in whatever direction you desire. If you change a setting to provide more exposure, the pointer on the exposure scale will move to the + (plus) side and indicate precisely how many stops of adjustment you have applied. The same thing happens should you decide the scene needs less exposure than the meter's recommended setting, with the exposure pointer moving to the (-) minus side.

Why use Manual exposure mode? Some folks just like to fiddle. But in terms of advantages, it gives you absolute control over every nuance of exposure. Since you are making all of the exposure adjustments, you will gain an understanding of light as you work, since you are not relying on autoexposure to make decisions for you.

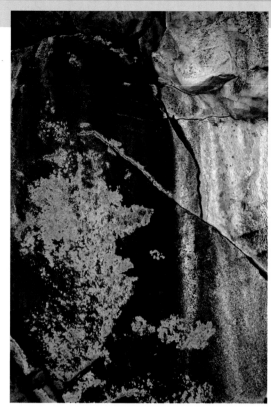

Use Manual exposure mode to break away from settings recommended by the camera in the autoexposure modes. Check the exposure scale in the viewfinder and move the marker away from the middle by changing the aperture and/or shutter speed settings.

Manual mode is useful in several ways:

1. You can read very specific areas of light and "place" those values on an exposure scale without using autoexposure lock. You also do not need to concern yourself about exposure compensation or which auto exposure mode is best.

2. You can quickly change the exposure. In Manual mode you can easily make an exposure adjustment just by turning the aperture ring/dial or the shutter control.

3. You can keep exposure constant, regardless of where you point the camera. Once you set the camera for the prevailing light, you do not need to alter exposure from shot to shot unless the light shifts. I find this beneficial when I have one scene in which the light is consistent and I want to take a number of exposures without reading and locking each time. This is easier and quite a liberating experience.

Here are my recommendations for using Manual exposure mode:

1. Switch the camera to Spot or Center-weighted metering. This allows you to know exactly where the reading is being made and what the camera is "thinking." These choices are more in the spirit of Manual mode.

2. Disable the link between the AF sensor and exposure. You usually do this in your camera's Custom Functions menu, a feature found in most D-SLRs that allows you to program your own settings. The autofocus points in the viewfinder are often linked to the meter readings—they are used as points of reference for making light readings on the active focusing area. Disengaging this link might happen automatically when you switch to Manual exposure mode, but it's good to have these unlinked in any case, even when using other exposure modes. Note that in some basic cameras you cannot make this disengagement unless you are in Manual exposure or manual focus mode.

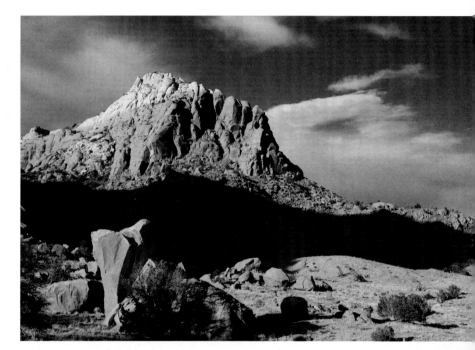

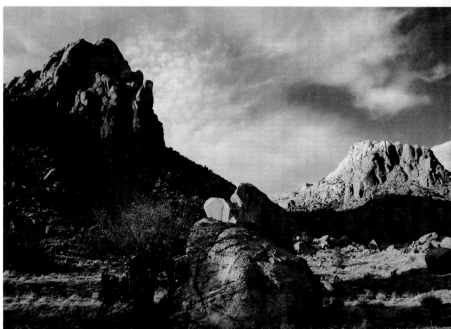

While shooting some formations near the Chama River Valley in New Mexico, I set the camera to Manual exposure mode and took a light reading. I kept that exposure setting for the rest of the shooting session as I strolled through the area and concentrated on the compositions. I was working with a fairly wide-angle lens set at f/11, so I just set focus for the hyperfocal distance and didn't worry much about focus or depth of field.

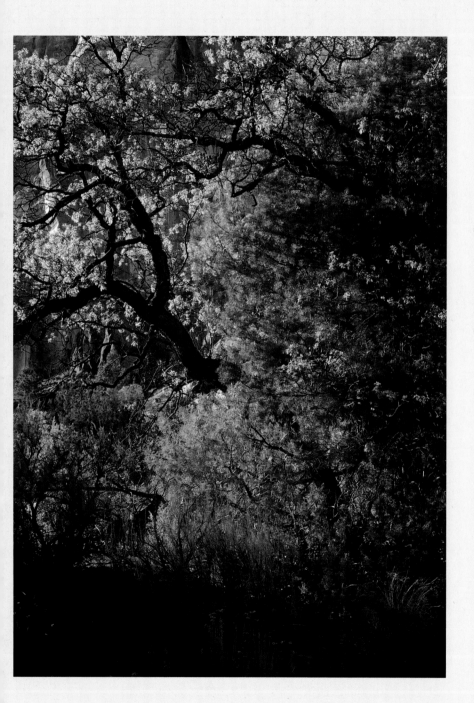

Autoexposure Lock

You can lock exposure for most digital cameras by pressing the shutter release halfway. Most D-SLRs also have a dedicated autoexposure lock button (AEL), often located on the back, that is handier to use because it separates exposure lock from the shutter release. AEL is a key exposure tool because it allows you to bias the reading toward highlights, which is the main technique for getting the best exposures in high-contrast situations. Note that some cameras link their autoexposure lock with the autofocus lock. I suggest you disengage the two, something that can often be done in the camera's Custom Function Menu. If you can't, then you might consider using AEL with manual focus.

AEL also comes in handy when a bright area in the scene is off to one side of your intended composition. In the photo at left, late afternoon sun spilling into the stand of trees had lit the upper left portion with a striking, diffuse glow. One way to capture that quality was to expose for the bright area and let the other areas go dark, creating contrast. This was easily done by using Center-weighted metering and pointing the camera at the upper left of the frame, locking exposure, recomposing, and shooting.

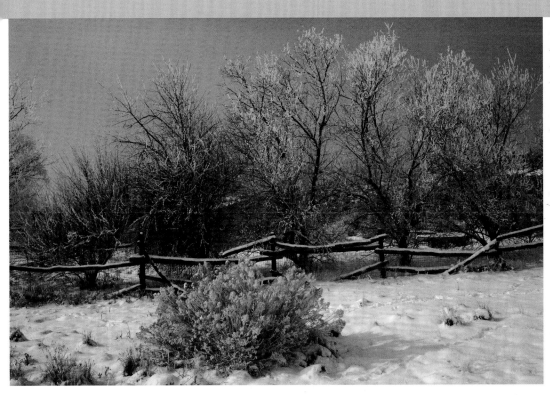

Snow-filled scenes can be tough to meter correctly due to the very bright reflections. In this photo, I set Aperture-priority mode and pointed the camera toward the foreground with exposure compensation set to +1. This sets the bright snow on a proper place on the exposure scale. If it is extremely bright you might have to go to +1.5.

Exposure Compensation

An important tool for working in the autoexposure modes (Program, Aperture-priority, Shutter-priority) is exposure compensation, usually accessed via a button or menu item and universally identified with a +/- icon. If you are in Aperture-priority mode when using exposure compensation, the exposure system will add or subtract exposure using the shutter speed; if in Shutter-priority mode, it will add or subtract exposure by changing the aperture. There are two lighting conditions in which you should consider using the autoexposure compensation function:

1. In scenes where there is bright glare, such as snow on a sunny day, the meter will tend to make everything darker than it appears to your eye. You add exposure to this scene by dialing in a +1 or +1.5 exposure compensation.

2. In scenes where dark values dominate yet some brighter areas are also present, and you want to record a variety of tonal values, the meter will tend to add too much exposure. This would overexpose the brighter areas and create muddy or poorly expose low tones that you'd like to keep deep in shadow. In this case dial in a -1 or -1.5 EV.

Autoexposure Bracketing & HDR

Making two or more exposures with more and less light than your base exposure is known as bracketing (also see page 70). You do this to insure the best exposure. It also can teach you about reading the brightness of a scene and how to set your camera's exposure accordingly. There's nothing wrong with making a series of bracketed exposures to get one optimal image when lighting is difficult to figure out.

You can use a D-SLR to bracket automatically, a function known as autoexposure bracketing (AEB). This can usually be applied from within the menu system or through a dedicated button on the camera. You can set the exposure bracket for one stop or more, or you can usually use 1/2 or 1/3 EV steps for more subtle changes. An exposure bracket is generally three shots (but with some camera models it might be more) recorded with a single press of the shutter button. Set the sequence and EV increment in the menu. One photo is at the meter's optimal exposure, one with less exposure, and one with more exposure.

If using Aperture-priority mode, the camera brackets the exposures by changing shutter speed settings (for example, f/8 at 1/125 second, at 1/60 second, and at 1/250 second); if shooting in Shutter-priority mode, the brack-ets are made by changing the aperture (e.g. f/8 at 1/125 second, f/5.6 at 1/125 second, and f/11 at 1/125 second). Note that if you are shooting in Manual exposure mode you can bracket by just turning the aperture and/or shutter speed dial as you shoot.

This technique has another application in digital photography, which is making HDR (high dynamic range) images. To create HDR photos, you make more than one recording of the same scene using different exposure settings. You combine them later to get more detail in shadow and highlight areas than you could with one exposure. HDR photography should be done on a tripod, though some daring photographers use high-speed exposure rates to get handheld HDR brackets.

Many swear by this technique; others find that while HDR produces more tonal range and helps address problems of high contrast, it makes the image look flat and false.

Bracketing photos so you can merge them using image-processing techniques is one way to defeat excessive contrast. The exposure above was metered so the sky was well exposed (leaving the ground too dark), while the picture to the right is properly exposed for the ground (the sky is blown out, losing texture and detail). The image below, enhanced in the computer, combines the best of each of these photos to make a single, pleasing image.

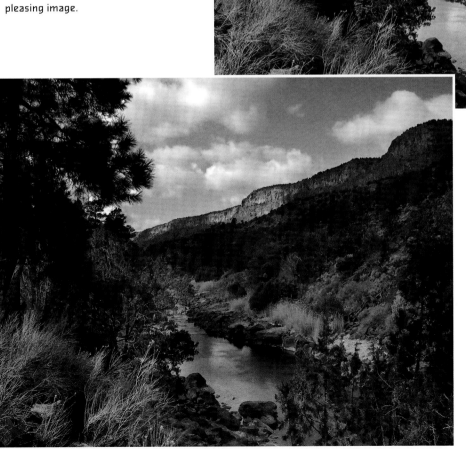

Exposure Diagnostics in the Field

There are two main goals when making black-and-white photos. One is to get the most image information, which means to record as wide a range of tonality as possible. The second is to know your intent and the image effects you desire.

The instant playback in cameras is one of digital photography's chief draws. You can inspect the image right after you shoot and keep it or trash it immediately. But relying on the camera's LCD to make critical photographic judgments is not always the best course. It's quite small with relatively low resolution and might be barely visible in bright daylight. Even when magnifying the image on the LCD, you can't be absolutely sure about sharpness, unless, of course, you can see that it is visibly out of focus, in which case you can decide to delete it.

You might think that you can simply look at the brightness of the image on the monitor and tell whether or not you have made a good exposure. This is not a good way to go about it, as the ambient light, more often than not, skews how the image looks on playback in the LCD. Thus, the image on the LCD screen is not the best indicator of exposure or focus.

The playback function in most D-SLRs, however, does offer various diagnostic tools to help you determine if you have done a good job on exposure. The most important are the highlight warning and the histogram.

Highlight Warning

The first line of defense is the overexposure or highlight warning (sometimes called blinkies). This function is often found in the Playback or Info menus. You might locate it by toggling through the Info options, or setting the warning as a default display mode via your menu system. This warning will either flash (blink) in overexposed areas of the image, or show those areas in black (or sometimes in a color of your choice).

I suggest you make it a habit to check the highlight warnings on the LCD after you shoot. This will alert you when bright values are clipped. The loss of these values is detrimental to image quality, especially if you plan to make prints.

In the cloud photo (opposite above), the edges of the clouds are too bright, which is readily evident when looking at the highlight exposure warning (as simulated opposite below) in the LCD immediately after exposure. The solution is to either use minus exposure compensation or to take a reading from a brighter point in the scene and lock it. Or, use Manual exposure mode and deliberately underexpose until you see the resulting warning disappear.

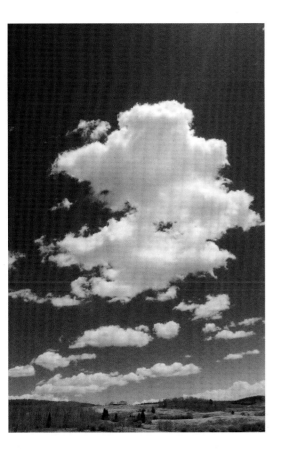

The Digital Dynamics of Overexposure!

Think of each pixel (picture element) on the sensor as a bucket that fills with water (light) as an exposure is made. If too much water comes into the bucket, the water will spill over the top. So, in our analogy, if too much light hits the picture element, it spills off and the pixel records as full, even though there may be more light in the scene; the pixel simply isn't recording any detail at that point. When printing the image, you will see nothing but paper unless you "fog" or add a tone or color to the area, a fairly unnatural look.

There's nothing wrong with overfilling a pixel if it occurs in small areas of the image, such as the glint of sunlight reflecting off a pond. But if there are large masses of pure white with no detail, then the picture will suffer. Indeed, harsh contrast is one of the greatest detriments to image quality.

If you notice that large areas of the image are overexposed, you should change your exposure settings. Cut back on exposure by stopping down the aperture or raising the shutter speed. This is easily done in Manual mode by moving the exposure scale indicator to the minus side of the null mark. If you are in an autoexposure mode, then read from a brighter area and use exposure lock to decrease exposure, or use exposure compensation and drop down 1 EV or more—whatever makes the blinkies stop flashing.

You need not react to every speck of overexposure warning that appears. For example, if you have spectral highlights in the scene—the glimmer of light off water that does not dominate the image, those highlights can be a nice touch as long as they are encompassed by darker values. In fact, when processing, I often add some spectral highlights for visual effect (see page 119).

Histograms

Another excellent way to check exposure is with the histogram, a graphic representation of the tonal values in a scene that shows exposure levels within the dynamic range of the sensor. Some cameras have live histograms that you can read prior to making the exposure.

Brightness values appear on the graph from left (darkest) to right (brightest). If you see an imbalance, or stacking, of the values to one side of the graph, your image will be dark (stacked left of center) or bright (stacked right of center). This may or may not be an exposure problem, depending on the characteristics of the scene. However, if the graph butts against the left or right axis and drops straight down, cutting the graph off, the image is clipped, and has no detail in the under or overexposed area(s).

Note that a bell-shaped or full histogram is not always the ideal. Some exposures are darker or lighter by intent or because of the characteristics of the scene. In other words, you might want the high-key (dominated by bright values) or low-key (dark and moody) effect. That's why I prefer working with the highlight warning diagnostic, as it identifies problems, not just the character of the image. Indeed, there are some great looking images that have a "lousy" histogram, and some with a "healthy" one that are just plain bland.

This histogram is a readout from Adobe Photoshop's Levels tool, but it simulates what you would see in the camera's LCD. Note that all of the tonal information is displayed well within the left (black) and right (white) axes of the graph. This indicates an image without blown highlights or shadows that can be easily enhanced in image processing later.

With no photo for reference, this histogram would probably indicate an image that is entirely too bright to be judged an acceptable exposure. But it is the display for the picture on the opposite page, and is exactly the rendition I wanted to create. Histograms are great guides, but don't use them to arbitrarily dictate exposure acceptability.

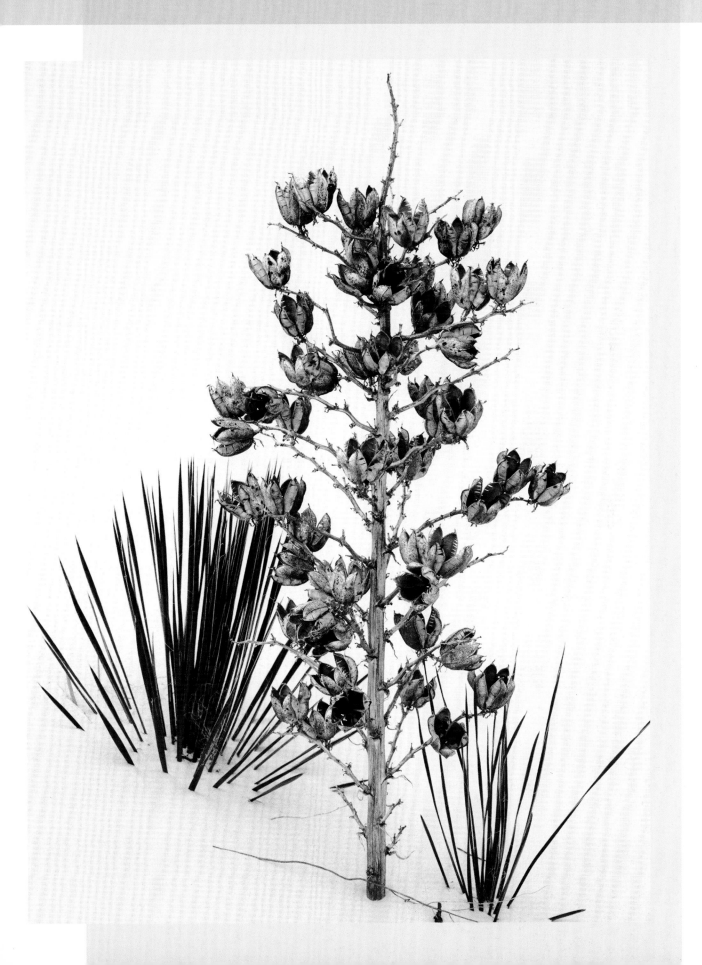

Test Your Camera's Exposure System

An excellent way to explore exposure options is to make tests to help you understand your camera and how it reacts to various lighting conditions. In truth, the sensor is only part of the story. How the image processor handles lighting values is also important. So set your camera to Multi-pattern metering and take it out in various lighting conditions to shoot sample photos: indoors, shady low light, mid-day bright sunlight, and even at night. Then do the same with Center-weighted and Spot metering, and work a full day in Manual exposure mode as well.

Don't do anything special with the exposure overrides or options, but just point and shoot at different subjects in different types of lighting. When you review your images, you'll immediately see how the camera has performed. Are subjects in the shade well exposed? Do highlights record harshly when you shoot in fairly high lighting? Is the balance between background and foreground pleasing when you use Multi-pattern metering?

All these tests will help you understand how your camera performs, and will reveal how accurate the metering system might be. In truth, not every digital camera reacts the same and not every metering system is as exact as we might like it to be. When you understand how your camera manages exposure, you'll have more freedom to think about what you are photographing, and not how you have to set the camera up to make the picture.

Summary of Exposure Tips and Guidelines

To sum up this chapter, here is a recap of major digital exposure guidelines.

• **Watch Those Highlights**

The important values that define the contrast range in your scene are those in which you want to record textural detail. Although your digital camera will deliver good exposures under most lighting conditions, the biggest problems usually occur with high-contrast scenes. Overexposure of highlights by more than one stop can cause them to be harsh, so pay close attention to them whenever you are photographing a scene with a wide range of brightness values.

• **See Like the Sensor**

The best way to get consistently good exposures is to learn the difference between how your eyes see and handle contrast and how the sensor records different brightness values from light to dark. If you test to analyze how your sensor behaves under various lighting conditions, you will discover that it records in a narrower range of brightness values than your eyes, compressing these values. Again, highlights, even those that your eyesight can easily handle, can cause overexposure problems for your camera.

• Study Light and Brightness Values

Consider how each type of subject and scene can be approached. If you want to make a quick check of how light and dark brightness values affect exposure, set up a bracketing sequence at +2 EV and take three pictures of a brightly lit scene with shadows and highlights. One exposure will compromise the two values, one will expose for the highlights, and one for the shadows. You'll see how making exposures for certain segments of the scene's brightness scale affects the other areas.

• Use the Histogram and Highlight Warning Diagnostics

When it comes to getting good exposures, the histogram and highlight warning are your true friends. Once you become adept at interpreting the histogram and paying attention to the highlight warning, you'll go a long way to making good exposures of every subject and scene.

• Follow the Light

One exposure technique I have used for many years is following the light and making a reading where it falls. In a landscape dotted with clouds, this means following the shafts of light and reading where they hit the ground, not reading the darker areas between them. Following the light and metering for the important subject in the scene gets you perhaps 90% of the way toward making good exposures.

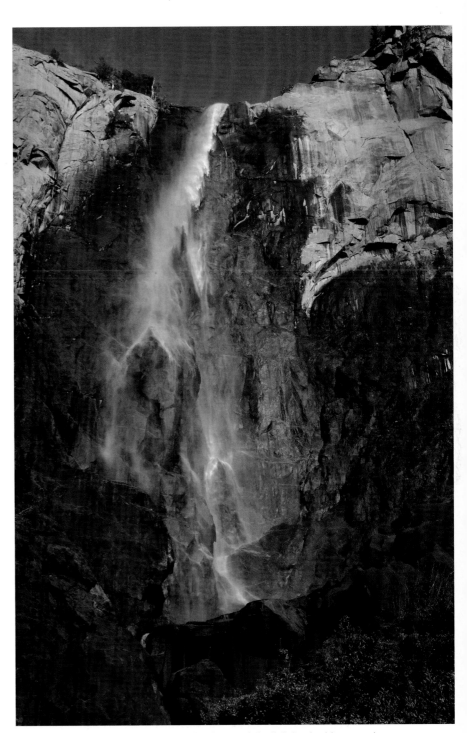

To control the highlights and capture the drama of the lighting in this scene, I followed the light and Spot metered off the bright area of the water cascading down this cliff in Yellowstone Park. This insured the highlights would not be overexposed, but made other areas darker than they appeared to my eye. However, it recreated both the emotional effect I felt when standing there and the way I envisioned the interplay of light and shadow when I photographed it.

Image Processing

6

Dedicated black-and-white photographers have developed negatives and made their own prints since the earliest days of photography. Processing has always been a key element in black-and-white photography—digital has not changed that fact. But the approach and procedures have changed radically with the advent of digital photography.

This chapter examines the digital processing workflow, from downloading the image file on your memory card to making it ready for the printer. There are many image-processing programs available that are updated on a regular basis. I cannot cover or anticipate all the new features and programs that are continually coming to market. Mostly I use examples from Adobe products: Photoshop, Lightroom, and Camera RAW. I have included tools and techniques that have remained (in one from or another) in most versions of these image-processing programs, and they should remain available in the future. The tools may look a little different in various brands of software, but the techniques are essentially the same.

My aim is to uncover the potential available in every image and to explore tools that allow you to mine that potential to its fullest. Though I cannot look at every possible processing scenario, I will examine how to handle common problems and ways to approach creative options. You will find that your best exposures lend themselves to additional creative work, while your miscues eat up a great deal of time if you work to fix major mistakes. Become practiced at analyzing your own images to judge what is best, and spend your time working on those.

RAW Converters

Because RAW files are proprietary, each camera model utilizes a different version of the format. The first step in processing a RAW file is to download it from your camera or memory card to a program that can decode your particular RAW version. This software is known as a RAW converter because the image file can now be converted to another format (JPEG, TIFF, PSD, etc.) that can be stored, printed, or processed further. If you choose to process the file, you can usually use

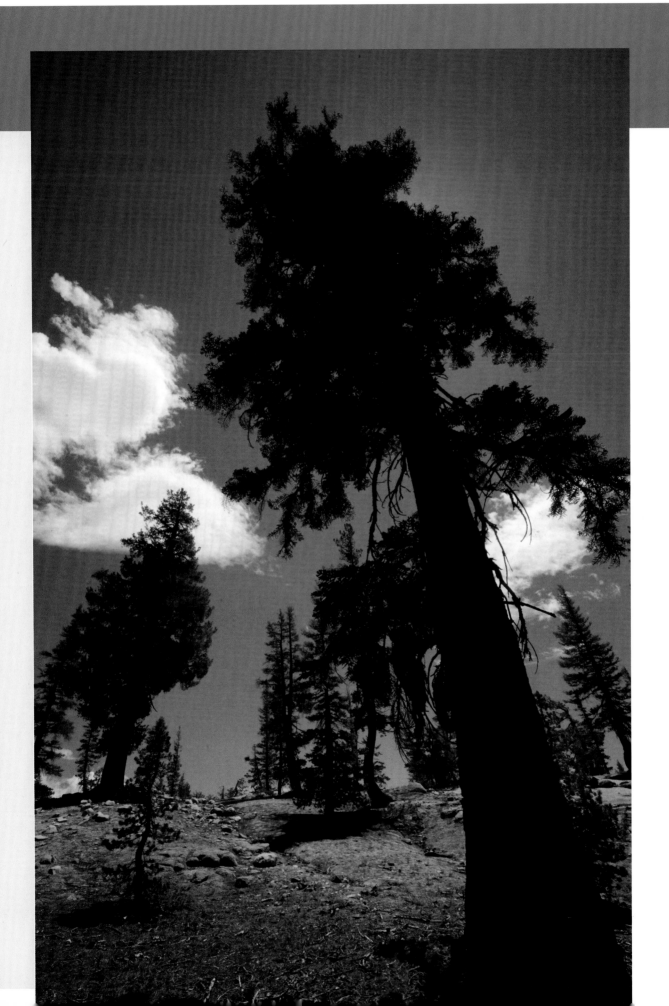

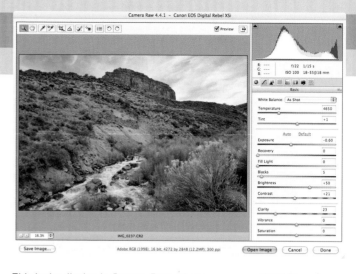

This is the display in Camera Raw when you open a RAW file from Adobe Bridge.

tools found in the converter, although these are not always as comprehensive as those you have in a full image-processing program such as Photoshop or Corel® Paint Shop Pro®. But you must use the converter to read the RAW file before you export it to a dedicated program, or to an email program or printer.

Camera manufacturers include some level of RAW conversion software with their cameras that offer RAW format. RAW conversion programs are also available from third-party suppliers who update these programs every so often to accommodate revised RAW formats as new cameras come to market. Many of these programs, such as Photoshop, Lightroom, Apple Aperture, Bibble, LightZone©, SilkyPix®, and Capture One, allow you to apply a number of processing steps after downloading, as do the proprietary converter programs from the camera companies.

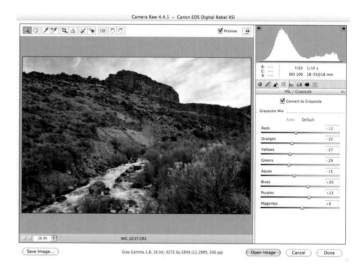

In this illustration, I have checked the "Convert to Grayscale" dialog function, which automatically displays a black-and-white version of the color photo. Note the position of the sliders. These represent the colors in the image rendered as grayscale values. All of these can be altered.

The image-processing controls found in many RAW conversion programs are similar to those shown here (Photoshop Camera Raw in CS3). When you click on an image in Photoshop's browser—Adobe® Bridge—and select a RAW file, the image automatically opens in Camera Raw, revealing a number of controls for working with the RAW image.

A number of programs not only provide RAW conversion and processing functions, but also organizing, editing, and printing controls.

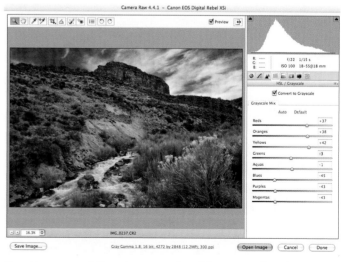

Here I have moved the color conversion sliders to emulate the scene as if a red filter were placed over the lens when exposing panchromatic film. The blue in the sky has become deeper and the red, orange, and yellow hues have become brighter.

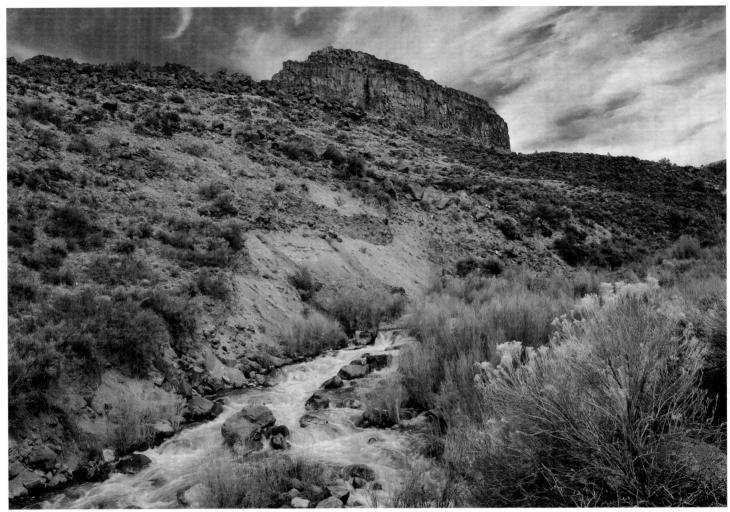

I exported the image to my image-processing program (Photoshop) and applied some selective burning (darkening specific areas) and dodging (lightening specific areas).

These often have color to black-and-white conversion selections that are preset to furnish certain effects. I have mixed feelings about using presets for conversion to monochrome. On one hand they are easy and emulate all sorts of interesting processing and film choices. On the other hand, they are somewhat for-mulaic, although with many you can use dia-log boxes to modify them as you see fit.

One good reason to shoot RAW is because the file maintains all of its original information, so it stays intact, preserving the integrity of your

Above shows some of the monochrome presets in Apple's Aperture that create filter effects similar to those found in the camera's Monochrome capture mode. Adobe Photoshop Lightroom (right) not only offers an array of RAW conversion presets, it allows you to create your own presets and save them for use on future images.

Once an image is open in Camera Raw, you can click on the blue line below the photo (top). This displays a dialog box that lets you define the terms of the RAW file according to color space, bit depth, size, and resolution in pixels per inch as it goes through the editing process.

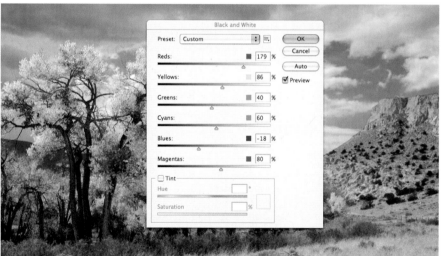

If you have not recorded in RAW format or are working from scanned images, you still can use sophisticated black-and-white conversion tools. This JPEG is being converted using the New Adjustment Layer > Black & White in Photoshop.

original file. Most RAW converters make adjustments and changes to a version (a copy) of the original, or, more precisely, to the instructions that define the original data. The distinctions are unimportant; the main point is that RAW files are not altered in the process. This is called non-destructive editing.

You can use the processing tools in these conversion programs as much as you prefer while working on RAW files, but my suggestion is to limit image adjustments in the RAW converter to certain key functions, like converting the RAW file to black and white and setting the maximum bit depth, desired resolution, and color space. Perform more specific applications—such as fine contrast, local exposure, and sharpening—using your dedicated image-processing program.

Color Conversion to Grayscale

An important aspect of converting RGB to black and white is to determine how various colors will be rendered in grayscale. There are a number of methods to do this in the computer, and several options about when during the image-processing workflow you want to make that conversion. In general, I find it best to convert RAW files to black and white in the RAW converter. This usually involves working with several sliders that allow you to selectively render various hues to grayscale individually

If you have recorded TIFF or JPEG file formats, make the conversion in your image-processing program using the drop-down under Layer in the Menu bar for New Adjustment Layer > Black & White. Other methods for rendering color to black and white found in these programs, such as Channel Mixer and the Mode conversion to Grayscale, lack the same level of refined control and customization available with the Black-and-White slider controls.

These slider tools allow you to make selective color contrast decisions that build the foundation image on which you can apply additional image processing as desired. Deciding how to render color in this way means, for example, that you can make a blue sky look brighter or darker in the monochrome image. Or, if your subject is a red rock formation, you can brighten the red so you will not have to dodge it or add contrast through Curves later.

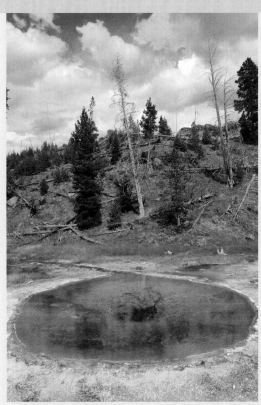

This photo can be interpreted in many ways depending upon how the colors are converted to grayscale in your software.

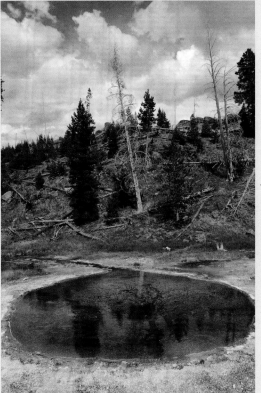

Using the New Adjustment Layer > Black & White in Photoshop, the sliders above show the default conversion values for a black-and-white version of the photo (left).

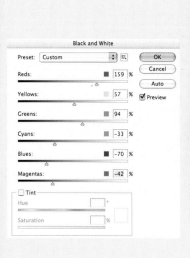

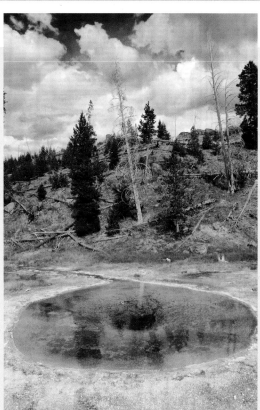

I moved the sliders to create a different black-and-white conversion, deciding to make the red values light and dropping the blue values to deepen the sky. Note the Preset drop-down at the top of the Black and White conversion screen (far left)—this offers choices that can automatically set the sliders to emulate the effects of different filters placed in front of the lens when used with panchromatic film.

Using Image-Processing Programs

Once you have completed all of the processing you choose to do in your RAW converter, you can export the new version to your full-featured image processor. Now you will begin the next stage of processing—refining the image and getting it ready for print or the web.

I have developed a certain workflow—a step-by-step approach to image processing; you may find another workflow is best for you. First, there is little point in making adjustments (except perhaps some minor exposure and contrast modifications) prior to converting from color to monochrome, as the only way to judge the effect of your work is to see it in black and white. My processing initially applies exposure and contrast changes globally, those that affect the entire image. After the global effects, I make local adjustments, or selective refinements on the image, then deal with color toning or other special effects, and end with sharpening.

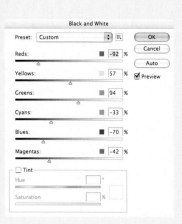

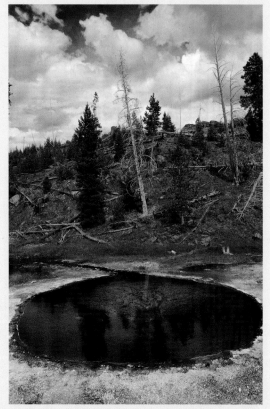

I moved the sliders again to create a variation with yet a different grayscale rendering of red values to make them darker.

There are multiple ways in image-processing programs to do this type of work. My aim is to describe the potential of image processing for black and white rather than explore every possible program and effect. Before we begin the steps in the work flow, there are two tools we should get familiar with: Layers and Layer Masks.

Working in Layers

I strongly suggest that you work in Layers when you process images. Think of Layers as a stack of effects or filters that you lay over the image. Each layer contains a change. You can modify the change, adjust the degree of the effect, and even eliminate it entirely if needed. With Layers, you are building changes in a step-by-step fashion on top of the image; you are not changing the image file itself (just as you did not change the base RAW file when you brought it into your RAW converter).

You can create a layer by using the Layer menu atop the workspace or use the icons at the base of the Layers Palette. A Duplicate Layer is a copy of the image or of a previous layer; a New Layer is a blank slate onto which you can add various effects; and an Adjustment Layer is one on which you can do a host of adjustments, including contrast, exposure, and even toning. You can even eliminate parts of the layer and protect other parts with Layer Masks, as well as using Layer Masks for local exposure control.

Layer Masks

A Layer Mask is quite useful for enhancing black-and-white photographs. Think of a Layer Mask as a cutout tool that allows you to modify a layer. It is created automatically when you make a New Adjustment Layer, or when you highlight an existing layer and click on the icon of a circle inside a rectangle found at the bottom of the Layers Palette.

I generally use the Brush tool to apply Layer Mask modifications. The mask is positioned over a layer, where you can paint on it with the Brush tool to hide portions of the layer (like cutting the mask away), revealing the layer below. You can use the Brush tool at different opacities and with different blending modes to control the degree to which you alter the appearance of the image layer on which you are working. And, if you inadvertently paint a section you want to keep as a mask, or overdo the painting, you can always repaint the error back to the masked display by inverting the Foreground/Background Color Box (from the default black to white).

Keep in mind that this is not intended to be an image-processing book or a Photoshop tutorial, but as I go through some techniques, I'll cover the various layer types and their modifications, including Layer Masks and painting.

Exposure

My first task in the image-processing program is to address the overall exposure, and this can be a "corrective" or "creative" change. By corrective I mean rectifying a deficiency of camera settings; by creative I mean creating or altering the mood. One effective method is to work with Levels in conjunction with a blending mode, at least in Photoshop.

My approach is not orthodox. To change overall exposure, I use one of two blending modes: Multiply to darken an image and Screen to lighten it. An easy way to make an entire image darker is to create a New Adjustment Layer > Levels from the Layer drop-down menu. A dialog box will appear allowing you to name the layer. It will also have a Mode drop-down—select Multiply (or Screen if you want to lighten the overall image). Once you make the change, you can modify the effect on the entire image using the Opacity slider in the Layers palette, or selectively lighten areas using a Layer Mask and the paint brush.

Getting exposure right is a key step in creating a fine black-and-white landscape. But performing these blending steps is not the end of the process. They merely form the foundation upon which to build the rest of the work.

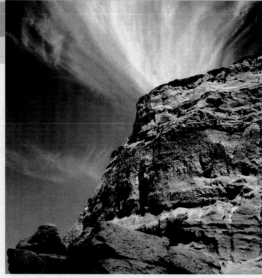

This is the result of selecting Multiply as the blending mode, without changing any of the Levels sliders. The exposure is much better, but a bit too dark. I can always return to the Levels dialog box later to make contrast adjustments by clicking on the Levels symbol in the Layers Palette.

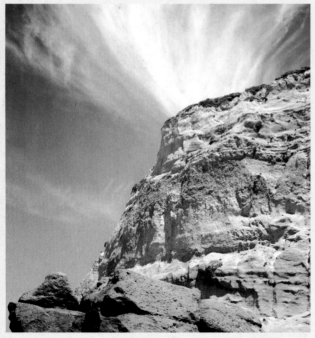

My original image above is a bit light. I created a New Adjustment Layer > Levels with Multiply selected in the Mode drop-down in order to darken the entire picture.

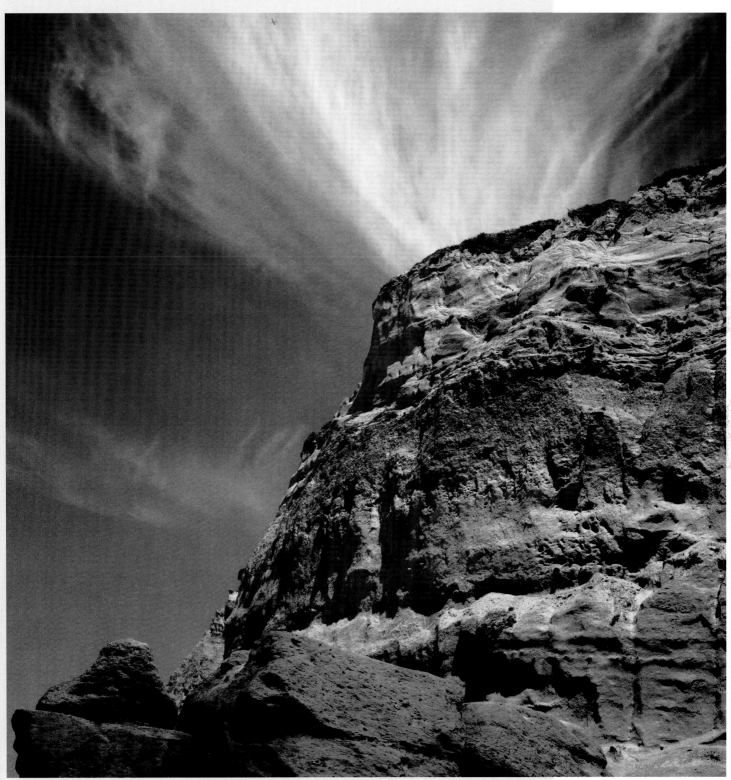

I backed-off the Multiply effect by lowering Opacity to 47% (located in the upper right of the Layers palette, as shown in the screen on the opposite page). Using Opacity is like a rheostat control, providing a very fine degree of adjustment.

Contrast

My next step is to deal globally with contrast: Proper contrast is the heart of black-and-white photography. Again I utilize the New Adjustment Layer control by opening the option for Curves. (Some photographers find it easier to work with Levels first and then "graduate" to Curves, but both are easily utilized for contrast work.) Just as with exposure, contrast adjustments can be made to correct for poor contrast or be used as a creative, interpretive tool.

Often images with the veiled effect shown below are easily corrected by working with the control for Curves in the New Adjustment Layer drop-down. You will notice a diagonal line that crosses through a histogram.

As originally exposed, this photo is rather dull, almost with a gray veil over the image. This condition can occur due to a lack of contrast in the scene or a misreading of exposure.

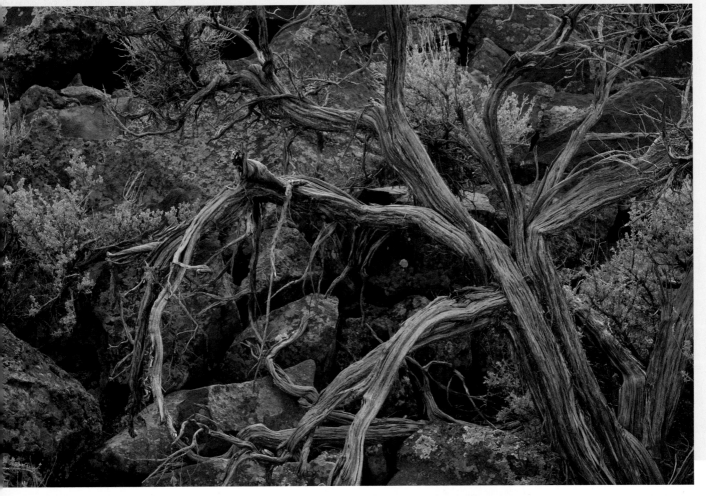

To fill the gamut, or the full range, and make the most out of the grayscale values in the scene, I'll compress (move toward the center) contrast both on the shadow (left) and highlight (right) sides of the curve to align with the histogram. This is done by dragging the triangles at the base of the curve.

The result of this simple adjustment is seen in a much more lively, or snappier rendition of the image. For darkroom printers, this is like going from a #2 to a #3.5 contrast grade filter with variable contrast paper.

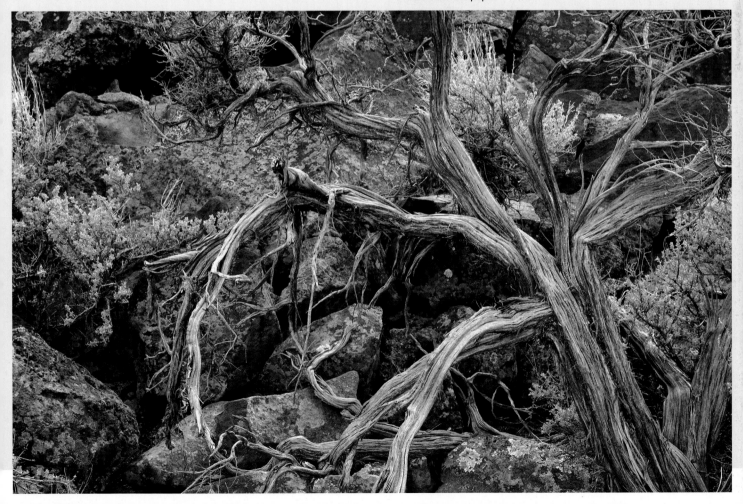

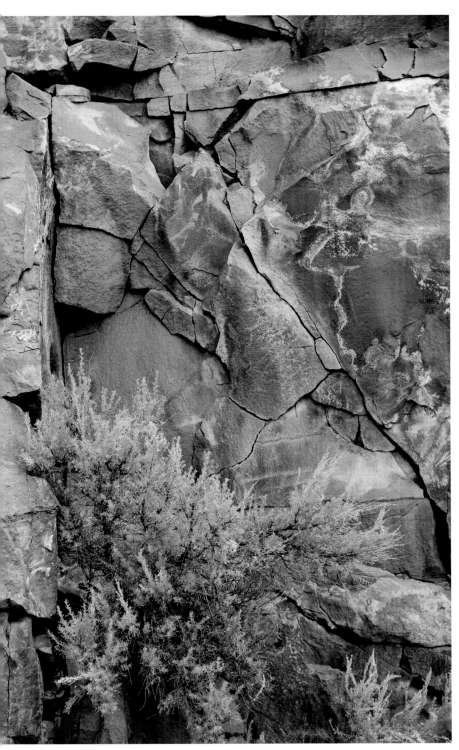

This photo was made in open shade. Because it was apparent that the original RAW image lacked contrast, a global adjustment was made to the grayscale version using the Contrast slider in the RAW converter. Even so, the picture could still benefit from some additional snap.

The Curves dialog box for a New Adjustment Layer verifies that the image at left is flat—the middle gray values are bunched in the center of the histogram, with little information at the edges of the graph.

The Curves control is one of the most effective tools available to enhance the contrast of an image. I suggest that you do this step even if you think the image already has good contrast, as there always seems to be hidden potential that it can reveal. This technique is one I apply to many images that I plan to print. It is a way to bring out a silvery or "specular snap" quality to images by darkening the deepest shadows and adding sparkle to the highlights.

For precise results, check the Show Clipping box in the Curves dialog. (See screen above. You can do the same in Levels by pressing the Alt/Option key as you drag the sliders.) When that box is checked and you move the Highlight (right) slider, the preview goes black until you begin to clip (cut off) the highlights

With the Show Clipping box checked in the Curves dialog (opposite page), the black image (top) shows white areas where highlight clipping will occur as you move the right slider. Conversely, the white image shows dark areas where shadow clipping will occur as you move the left slider. Detail will be lost in any of the clipped areas.

in certain areas. The same goes for the Shadow areas, which you can also show as being clipped by moving the Shadow (left) slider. A small amount of highlight clipping begins to create these specular snap areas, while small areas of shadow clipping deepens contrast and brings extra "pop" to the photo. The final image (right) shows the result of applying this method.

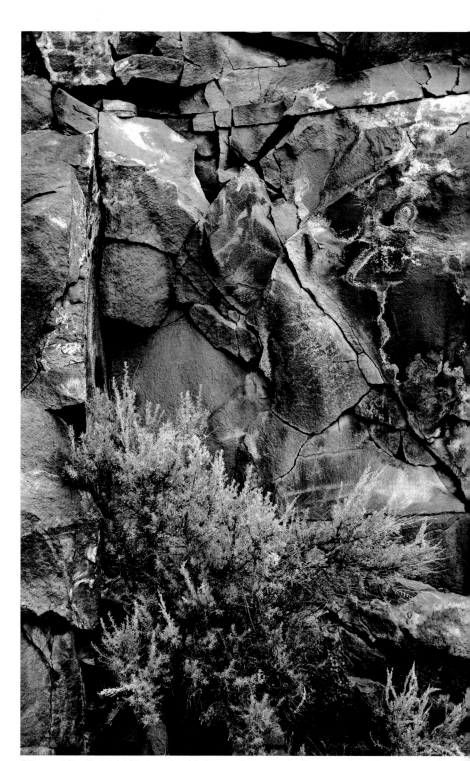

After making Curves adjustments, this image shows marked improvement over the original in terms of tonal character.

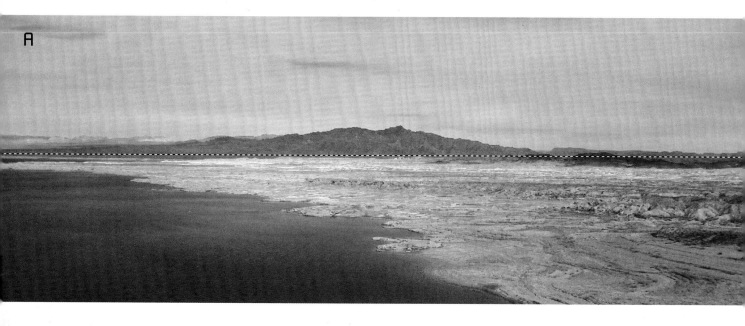

A

Selective Exposure and Contrast Control

Once you have the foundation image completed, think about how to refine it by using selective tonal control, which in digital and in traditional darkroom practice is called burning and dodging. There are many ways to do this using image-processing software, from using the Burn and Dodge tools to creating New Layers and painting on them as if they were masks for increasing or reducing contrast. In addition, you can also use Selection tools to outline certain areas within the image to which you apply the Curves, Levels, and other exposure and contrast techniques. I'll begin with Selection tools, as they can save unnecessary work and frustration.

B

Selection Tools

There are several different Selection tools, variously known as Marquee (in several shapes), Lasso (a few different types), Quick Selection, Magic Wand, and Drawing. All define the area within an image that you want to alter (or protect from changes, depending on your intent.).

A. I wanted to darken the sky without affecting the ground, so I used the Rectangular Marquee tool to cover the horizon line and sky, shown by the dotted outline.

B. Once the selection was drawn, I wanted to soften the border between the selected and non-selected areas so it would not create a hard edge. To do this, I clicked on the Refine Edges button in the Options Bar to display a dialog box where I raised the feathering for a smoother blend.

C. With the sky selected, I created a New Adjustment Layer > Curves dialog to darken the sky by moving the left slider (black point) to the right so it touched the shadow information in the histogram.

D. The sky now looked like I wanted, but the mountains had gone a bit too dark in some areas. Because I was working with an Adjustment Layer (Curves), I had a Layer Mask automatically available, so I lowered opacity and painted some of the mountains using the Brush tool.

E. The final result shows some additional darkening of tonal values in the water.

C

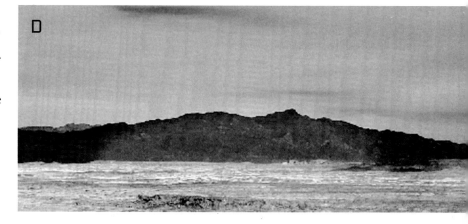

D

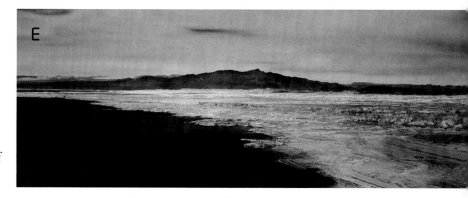

E

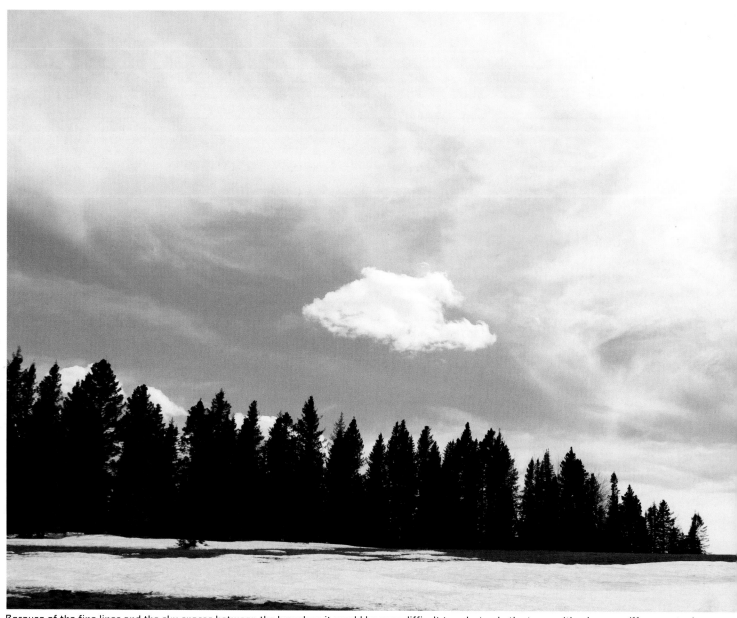

Because of the fine lines and the sky spaces between the branches, it would be very difficult to select only the trees with a Lasso or Marquee tool.

There are many scenes where certain Selection tools are impractical; for example, it would be next to impossible to draw around all the branches within this skyscape with trees (above). Better choices in this situation would be plug-ins, such as Vertus Fluid Mask, or the Quick Selection tool found in various image editing programs, because they can define very fine borders between tonal values.

In this image I used the Quick Selection tool
and drew a line across the upper portion of the
scene. To check how it worked and to see if I
had to manually add to the selection, I went to
the bottom of the Photoshop Tools Palette and
clicked on the Quick Mask to turn the unse-
lected area red (below). The Quick Selection
tool did a pretty good job, so I then used a
New Adjustment Layer Levels > to add density
to the sky area.

An icon near the bottom of the Photoshop Tools Palette looks
like a circle inside a square. Click on this to create a mask
showing the border created by the Quick Selection tool.

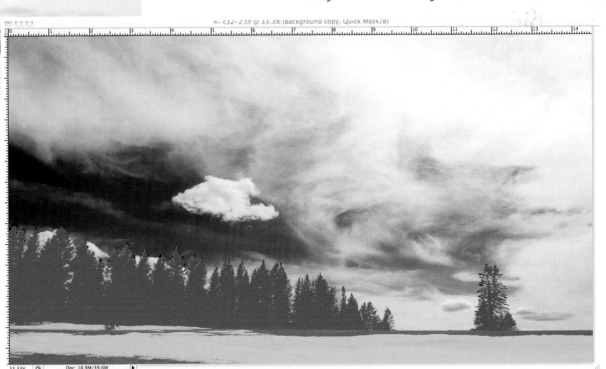

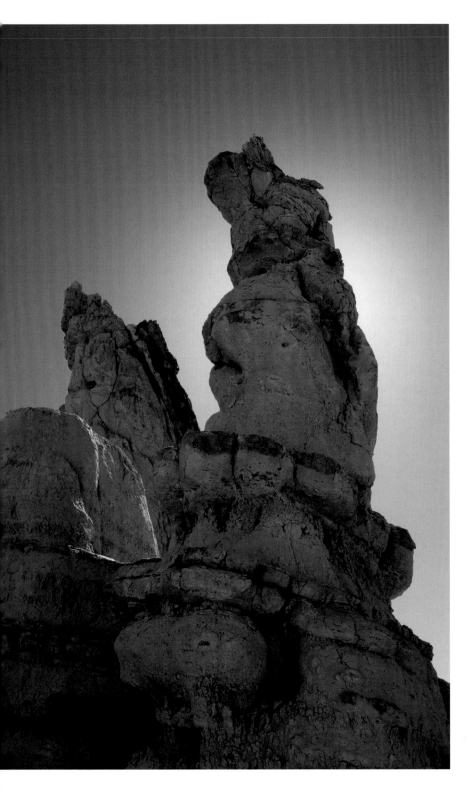

The Magic Wand in Photoshop is another handy Selection tool (other programs have a similar tool). It identifies pixel characteristics and lets you set how the selection is defined in terms of edge and tonal differences (in Photoshop that is called tolerance—smaller numbers narrow the difference between pixel values when the selection is made). Simply click on a part of the image and the tool automatically selects pixels according to the degree of tolerance you choose. If the first click does not select all the area desired, simply use the modifier in the tool bar that adds areas to the selection and click again.

I used the Magic Wand to heighten contrast in the color photo of rock formations reaching into a darkening sky (left). I had already lowered the saturation on this image (see page 137), but wanted to adjust contrast to lighten the formation and darken the sky. Since this meant two areas in the image were going in opposite brightness directions, I had to work on each area individually.

The contrast difference between the two sections made it easy to select the sky with the Magic Wand. I then opened the Refine Edge dialog and made the edge between sky and rock more defined (harder) by decreasing the Feather value (the blending between tonal borders) to 1.6 pixels. In some cases you might want to have more of a blend; that's when you would raise the Feather value.

The Levels graph for the selection of the rock formation is stacked to the dark side of the histogram. Moving the white point and middle sliders to the left will lighten the selected area.

Now comes the trick for working on the two different portions of the picture. I opened Levels to add contrast to the sky by moving the black point and middle sliders to the right. Then I used the Select > Inverse command from the Menu bar, switching the "selected" and "protected" areas in the image—from the sky to the rocks—so that additional adjustments would now affect only the rocks. I lightened that area using another New Adjustment Layer > Levels by moving the white point and middle sliders to the left.

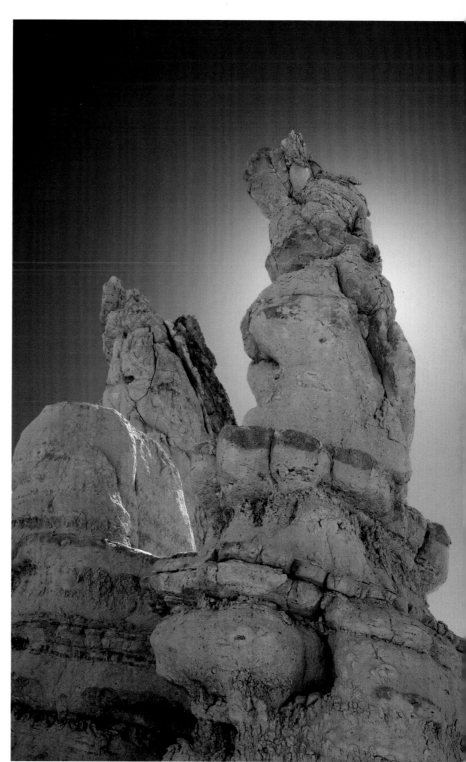

The Magic Wand was extremely useful in finally creating just the level of contrast I wanted in this low saturation photo.

Refining Local Exposure and Contrast

The terms "burning" and "dodging" used in digital image-processing are borrowed directly from traditional darkroom parlance. In film days, these two methods were done with your hand, with cutouts in cardboard, or even with chemical bleaching.

Digital photography allows for infinitely more control in all respects using a variety of tools and techniques for burning and dodging. I have already discussed the use of Selection tools, Layer Masks, and other techniques to adjust images; now its time to outline ways to add touches of refinement to the process, where just a taste of burning and dodging can be effective. This work is done at the end, right before sharpening and saving. It is always a good idea to take a few moments to contemplate where these enhancements can be most effective.

The pictures below show an example of burning. Working in Layers (always), I made a copy of the original (Layer > Duplicate Layer) on which to do my "hand work." With the Burn tool selected, I applied it to the darker areas of the image with a Midtone exposure of 38% selected in the option bar. The effect, as shown in the photo below to thr right, creates additional tonal variation for texture and depth between light and shadow.

Another way to selectively add density (darken an area) is to make a New Layer (Layer > New > Layer) and use the Brush tool to paint deeper tones on it. From the New Layer dialog box, select an Overlay blending mode and check off the Fill with Overlay-neutral color (50% gray) box. This allows you to add density to select areas using the Brush tool. When using the

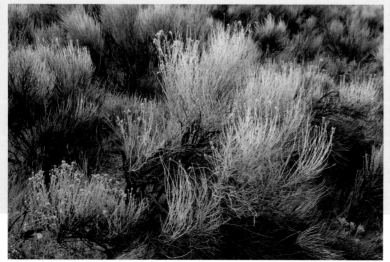
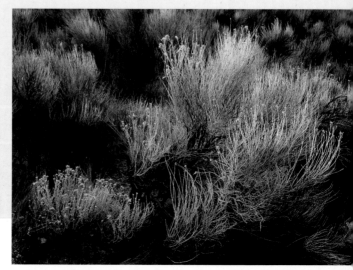

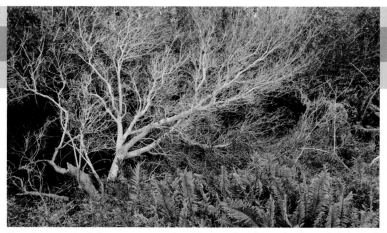 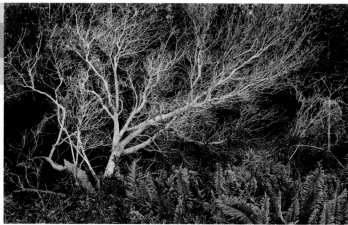

The photo to the left was converted to black and white and adjusted globally for contrast with the Levels tool. I next made local refinements by painting on a New Layer, as illustrated in the photo on the right.

Brush for this task, I choose a soft edge and keep the opacity at 30% or lower; this gives me more control because each stroke is cumulative.

While doing this burning work, I like to brush mostly where light and dark tonal values meet, with particular emphasis on darkening the corners and edges of the image to create a direction and center of light, as shown in the photo above right. To lighten areas using this technique, simply switch the

New Layer

Name: Layer 2 OK

☐ Use Previous Layer to Create Clipping Mask Cancel

Color: ☐None ⬍

Mode: Overlay ⬍ Opacity: 100 ▸ %

☑ Fill with Overlay-neutral color (50% gray)

The New Layer dialog box shows selections for Mode, Opacity, and the checkbox for Fill with Overlay-neutral color (50% gray).

Foreground/Background Color Box in the Tools Palette so the white box is in the front and use the Brush as a dodging tool. I did this to the branches of the tree, lightening them in the photo below.

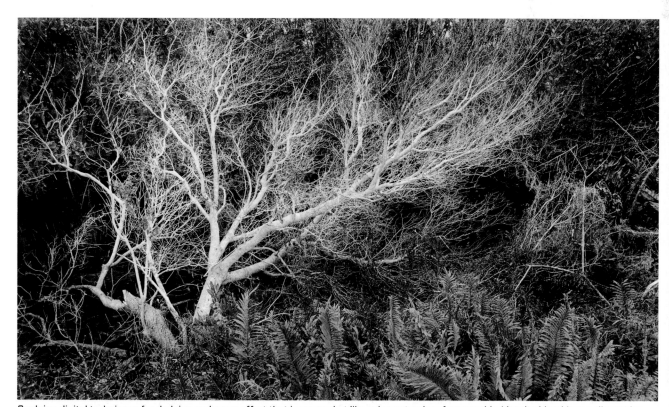

Applying digital techniques for dodging makes an effect that is somewhat like using potassium ferracyanide (density bleach) on a silver print.

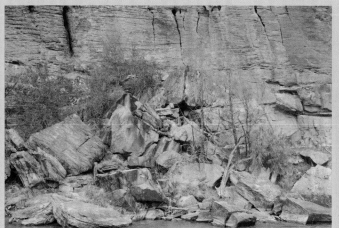
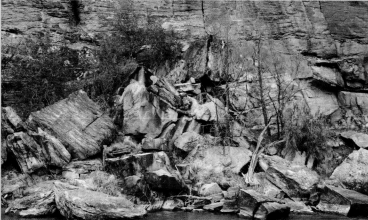

Above is the image as recorded by my camera, photographed using monochrome Picture Style with orange filter effect in RAW mode. The photo to the right is my final result.

A

Workflow

This image of a rock fall along the Chama River in New Mexico illustrates a typical workflow for a black-and-white landscape photo.

A. I began by adding a New Adjustment Layer > Curves to increase the contrast because the picture was shot in flat light caused by the shadow of the cliff falling over the scene. This screen shows both Highlight and Shadow sliders pinched a bit toward the middle to meet either end of the graph, which will make the light and dark areas pop more from the picture.

B. Next I created two New Layers, both with Overlay blending mode and filled with neutral gray. I selected black and white Foreground Color Boxes and used the Brush to selectively add (burn) and subtract (dodge) density from the image to polish it just a bit more.

C. The Layer Palette shows both the Burn and Dodge layers. The Sharpen layer (see next step) is done as a final step.

B

C

D. This last step, sharpening, makes the image crisper and defines the many edges in this shot. I used a technique known as High Pass sharpening. The first step is to highlight the Background layer and make a duplicate of it (Layer > Duplicate), which I named Sharpen. After highlighting the Sharpen layer in the Layers Palette, I went to the Filter option in the menu bar to select Other > High Pass, opening the High Pass dialog box, which looks kind of like an etch-a-sketch

D

This sharpening method requires a bit of practice but is very effective. You want to move the Radius slider so that many of the lines show through the layer without seeing a tracing of the entire image. This sharpens selectively, not overall, so it is ideal for an image like this. Try different settings to see the results and you'll get a good feel as to how much to sharpen for each image.

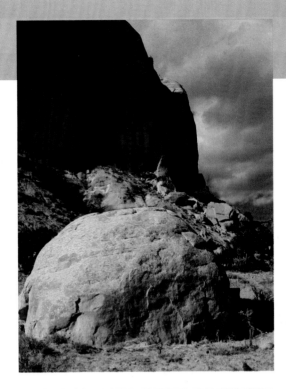

Special Effects

There are literally thousands of filters and variations of special effects actions available in popular image-processing programs or as plug-ins. I have chosen a few effects here that you might consider for your work.

Toning

Toning emulates the effect that results from bathing black-and-white prints in solutions that meld various colorizing chemicals (such as sodium sulphides) with the silver in the print. There are several general tones in black-and-white printing: neutral, which retains the grayscale look; warm, which yields a range from amber to brown tones (including the classic sepia tone effect); and cold, which adds a blue or magenta look to an image.

Toning a picture in image-processing software can be quite simple, using Hue/Saturation controls (found as a New Adjustment Layer), or it can be a more complex process, accomplished by converting the image to grayscale and then to Duotone (see page 131).

The easiest way to tone an image is to open a New Adjustment Layer > Hue/Saturation, which I did to give the above neutral image a sepia tone. Be sure to click Colorize in the dialog box. The top (Hue) slider changes the color; the middle slider (Saturation) changes the depth of color; and the bottom slider (Lightness) allows you to tweak light and dark effects.

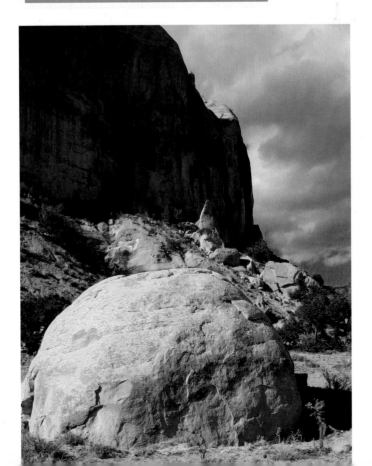

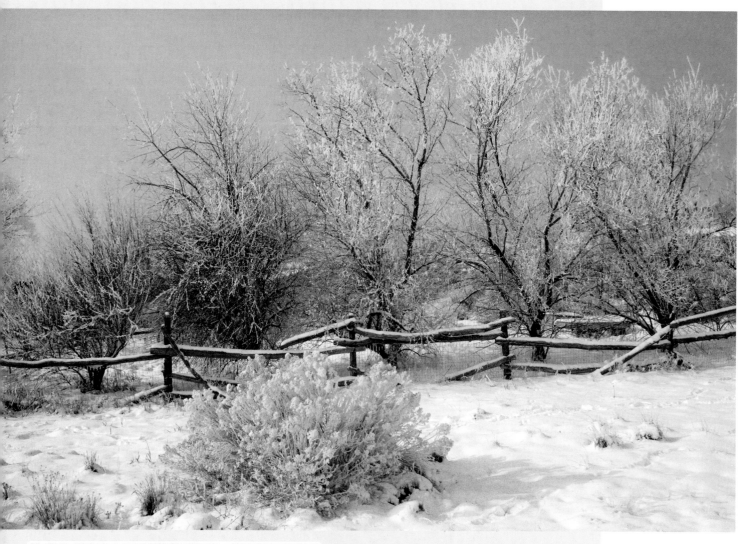

The tone you choose is a matter of taste guided by the image itself. This wintry scene benefits from a cool blue tone, which is easily attained by moving the Hue slider to the right.

Duotones, Tritones, Quadtones

A duotone is a technique used by publishers to add fidelity to a monochrome print reproduced in a book or magazine—in other words, it is a pre-press operation. The technique has been adapted by photographers to explore an almost infinite variety of tones for inkjet printing because duotones increase the tonal range of a grayscale image. While making digital duotones provides an extraordinary number of toning and colorization options, don't be overwhelmed. In fact, you can Save and Load any Duotone, Tritone, or Quadtone curve you might create by using buttons in the Duotone Options dialog (below) and apply it to other images.

I wanted to convert my photo of a stream moving over a group of tree roots (top right) to a sepia tritone. To begin, I convert the image to grayscale (if it is in RGB) in the Photoshop Menu Bar drop-down for Image > Mode > Grayscale. Once that is done, open the Mode menu again and choose Duotone to display the Duotone Options dialog box.

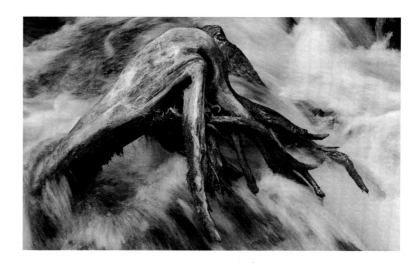

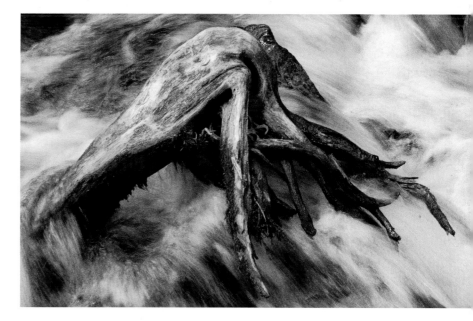

This dialog box (left) opens when you select the Duotone option in the Mode drop-down. Notice the Type drop-down in the upper left of this dialog. There you can choose Duotone, Tritone (three colors, which I selected) or Quadtone (for four colors in the mix). You can change colors by clicking on any color box to display the Ink Color dialog box (above), where you can choose a saturation and lightness of any hue by clicking inside the large color picker swatch.

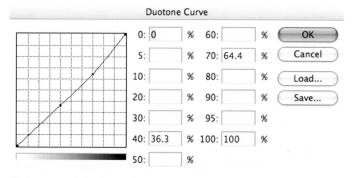

Click on one of the Curves icons next to an ink color in the Duotone Options dialog (top) to display a new screen that adjusts a tone curve of that color (bottom). While this control was created mainly for pre-press work (reproduction in books and magazines), we photographers have hijacked it for our own needs.

From the drop-down for Type, select Duotone or Tritone, then double-click in the appropriate color box to select an ink color from the color picker that displays.

I always leave the first box black (as in black ink), then choose the main color in the second box, and a reinforcing gray in the third box. You can even modify the intensity of the color and how it will print by adjusting the tone curve for that ink color, as shown in the Duotone Curve screen to the left.

Any of these coloring enhancements should be added after the exposure, contrast, and refinement steps are complete. Doing so prior to those steps yields less control over the final look.

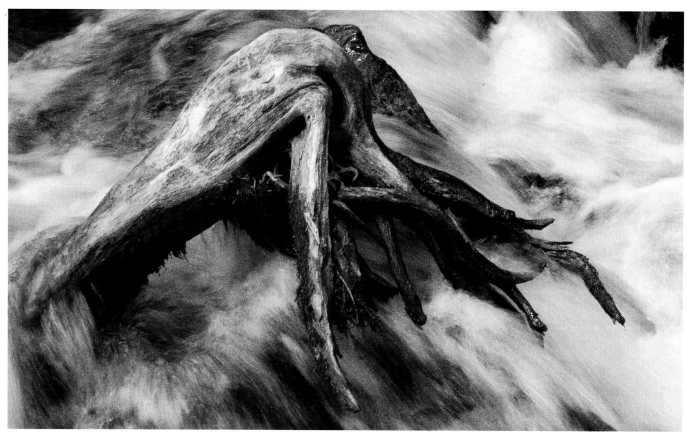

The final image has a unique tone due to the color mix and distribution of the color chosen via the curve.

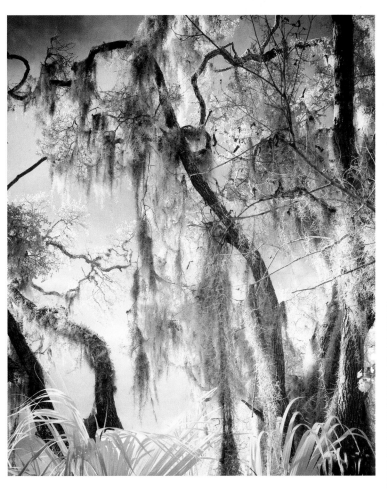

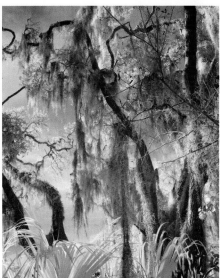

Emulations

While you can create just about any look you
want with the tools in Photoshop and other
full-service image-processing programs, there
are also numerous one-click actions and filters
that can emulate various toning and other
effects. Making a picture look like a cyanotype
(an historical process now practiced as an alter-
native process) is one choice, but many varia-
tions are possible with digital processing. All
these images (right) were made using either
plug-ins, actions, or a series of processing steps
aimed at creating specific effects.

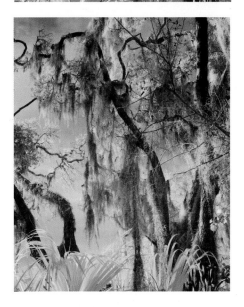

Colorization

In the old days, when photographers lacked color recording materials, they relied on all sorts of elaborate processes and colorization techniques, using oils, pastels, and other pigments to add color to images. With digital, we now have all-color all the time, which we must convert if we want black and white—a bit of irony that historians may ponder down the road. Colorized images, while derided by some as an oddity, have a certain look that I find appealing. You can see that colorized style by researching Autochrome processes, by looking at old postcards in flea markets, or just by playing around with your images and seeing how the effect works.

A. Using Layers and Layer Masks, it is easy to selectively colorize an image. I began here with a color image made in the Wild and Scenic River area of the Rio Grande in Northern New Mexico

B. I then used a New Adjustment Layer > Black & White to convert it to grayscale. Because I used an Adjustment Layer, I had a layer mask automatically available, so I then used the Brush tool to paint back a portion of the layer mask to reveal some of the color underneath. If you over-paint, you can switch the Foreground/Background Color Box from black to white and redo it, going back and forth between the two until you get it just right. Also, play with the opacity of the brush as you work.

C. The trick is to use a low opacity setting for the Brush (30%), and adjust it as needed to hide just enough of the mask to show a pleasing degree of color.

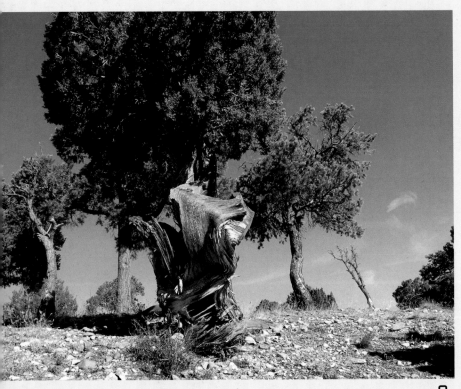

A

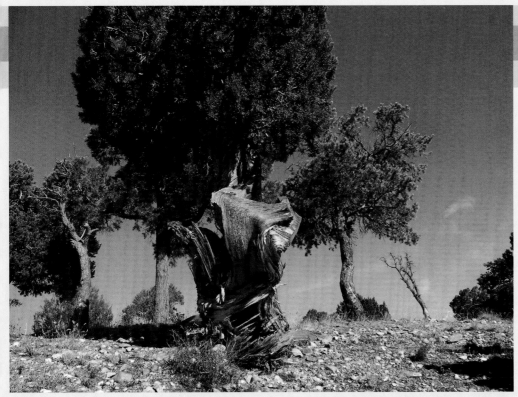

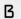

C

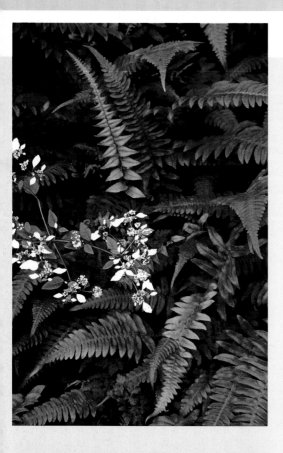

Hand Tinting

Although tinting is very similar to colorization, I thought it should be included as a tip of the hat to all those generations of photographers who hand colored their images with oils, pastels, and pencils. There is a long tradition for hand tinting black-and-white photos, and this technique is also quite easy to emulate using software.

I generally work with two colors chosen with The Color Picker that I place in the Foreground and Background Color Box. I then use the Brush and "dip" it into those colors, changing opacity and size as I brush on the image to create various hues and intensities. The progression, shown in the Fern picture (opposite), illustrates a couple of the steps going from a black and white to a hand-tinted image. I rarely set the brush opacity above 20% for this process.

Using the Color Picker for tinting allows you to choose from an incredible range of color. When you click OK, you get the color "loaded" into the Color Boxes in the Tools Palette.

Low Saturation

Low saturation color can be appealing because it combines black-and-white tonality with a soft touch of color throughout. For example, the color-rich image (top right) was made on a foggy morning in late fall. I used a plug-in to create a new version of these birch trees. I then took an extra step to give the picture an entirely different mood by opening a New Adjustment Layer > Hue / Saturation and decreased the saturation by sliding the Saturation control to the left resulting in the photo to the far right.

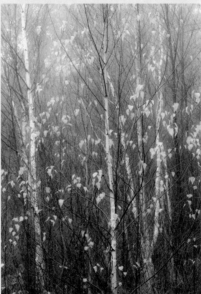

I used a plug-in called Nik Color Efex to add a glow to the original image that emphasized the fog.

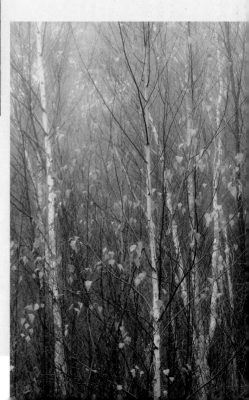

High Contrast

There are many ways to bring a high contrast look to your images, including compressing the tonal scale using Levels or Curves. Some programs have "one-button" access to a high contrast effect. However, a more complex method that I enjoy starts with making a New Adjustment Layer > Threshold to achieve a pen and ink look. Threshold creates a two-level grayscale image, essentially pure black and pure white. The good thing is that it does so as a layer, which you can put to good effect, as described in the captions.

I can move the Threshold slider back and forth to create various degrees of the effect (top). I next converted the image to black and white using New Adjustment Layer > Black & White. Finally, I added a New Adjustment Layer > Levels on top of all the other changes to get the tone exactly as I wanted (directly above).

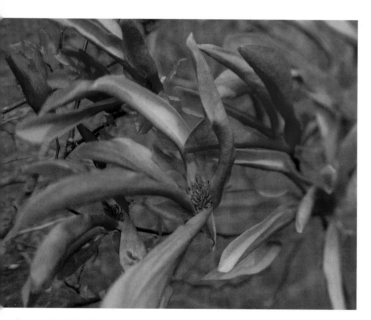

When I saw this photo above of a blossom, I knew it could be transformed into an interesting high-contrast black-and-white image. I opened a New Adjustment Layer > Threshold dialog box and adjusted the Opacity slider to 32%, then clicked OK. The Threshold graph then displayed (directly above).

The Layers Palette outlines the steps for using these New Adjustment Layers to create a high-contrast black-and-white image.

Combining Bracketed Exposures

There are numerous programs and plug-ins, as well as image-processing tools, that can help you get more out of the contrast range of a scene. It is essential, of course, that you first bracket exposures and shoot using a tripod so the frame does not vary. This technique can be effective in a situation when the contrast is extremely challenging and you don't have the time or patience to wait for the right light.

I opened two pictures (above right and immediately right) in my image processor, identical to each other except shot at different exposure values. I selected the –EV shot using Select > All, copied it, and pasted it onto the lighter photo (making sure the dimensions of both images are the same). The darker exposure automatically becomes a new a layer.

With that layer highlighted, I went to Layer > Layer Mask > Hide All. This command displays the lighter Background image. Now, selecting the Brush for painting, I set the Mode to Normal and the Foreground Color Box in the Tool Palette to white. By painting on the sky, the river, and some of the branches along the shore, I was able to reveal the darker layer for those portions of the image. Combining the two photos and using a layer mask increased the range of tones and contrast, creating a more dramatic image.

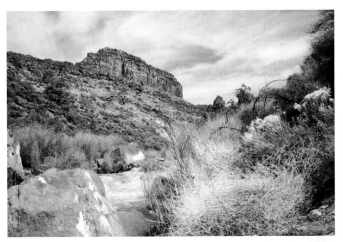

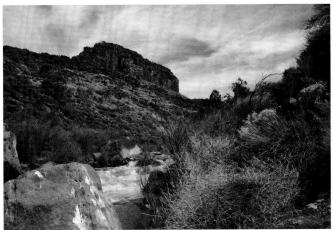

These two pictures show +1 EV (top) and –1EV exposures of this scene along the Rio Pueblo River in New Mexico.

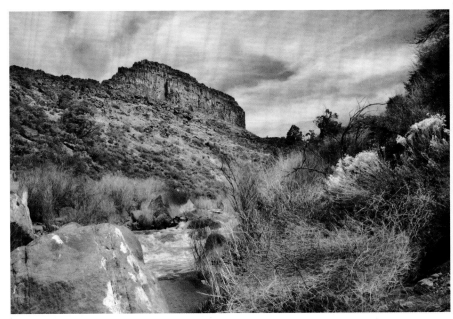

This is the result of combining bracketed exposures and creating a new photo by using the Brush tool and a Layer Mask.

The grain was added quite easily to this photo using the Filter drop-down in Photoshop's Menu bar. The menu offers a Noise > Added Noise option as well as the choice of using a Uniform or random (Gaussian) pattern (below right).

Grain

It's ironic that for years photographers did everything they could to decrease or eliminate grain, and now digital photographers often go to great lengths to add it back. It does bring cohesion to some images and also emulates an old-time effect. Grain can be added as a layer easily enough with various programs and plug-ins.

There are numerous plug-in programs that can be added to Photoshop's architecture (and to other major image-processing programs). Once installed, they are usually found in the Filter menus. This filter is from Alien Skin; all the folders open to reveal many special-effects options.

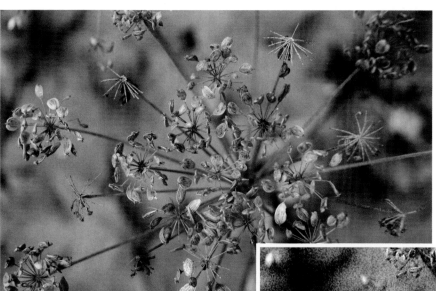

This filter is dubbed Big Fat Grain, one of the choices in Alien Skin's Exposure. Applied to an image like the one above, the plug-in creates a layer, which you can cut back by using a layer mask, if desired, as I did here to hide the grain in those areas around the central clusters of seeds (right).

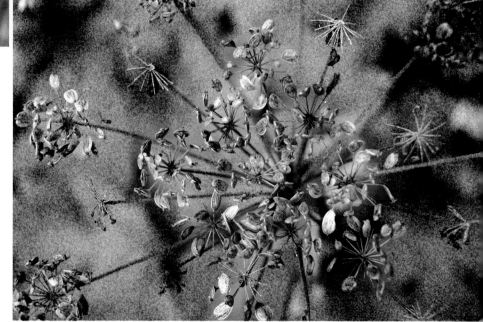

Printing

The photographic print completes the creative circle you began when you first viewed the image through your viewfinder. Preparation for printing starts when you record the image, and printmaking really takes place during the image-processing stage. The physical aspect of making prints is a mechanical task in many respects, although there is a true craft in setting up both the image file and the hardware to create a final print. Hardware calibration could be a book onto itself, and I will not go into great detail here, though I do encourage you to avoid frustration by paying attention to this vital segment of the process.

It might seem that black-and-white printmakers should be free from the rigors of color management issues, at least as far as neutral grayscale prints are concerned. Unfortunately, that's not the case. The goal of color management is to create agreement between what you have on the computer screen and what comes out of the printer. This agreement involves contrast, tonal relationships, and brightness; it also involves the elimination of unwanted color cast on black and white images. In some cases, for example when adding toning to an image, it also means matching the color on the screen with the print.

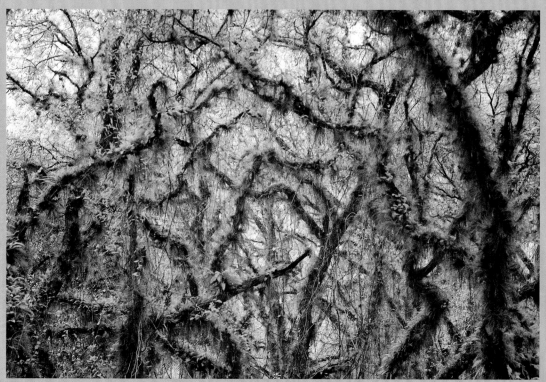

Color management is always important, and especially so when making toned and colorized prints, such as this blue-tone image. You want the print to have the same color as the image displayed on your monitor.

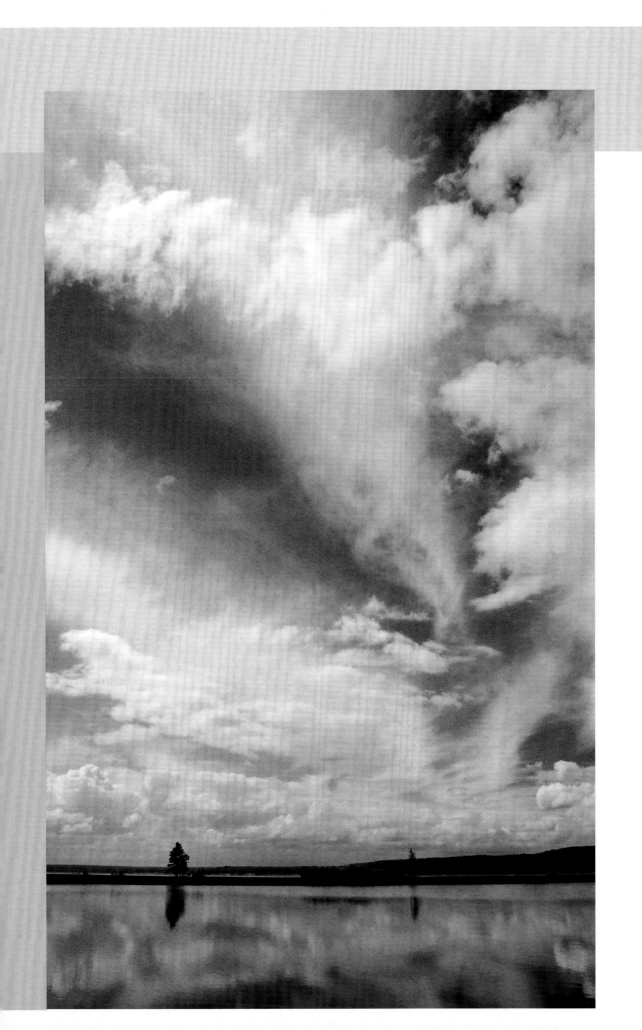

There are two steps to the color management process. One is calibrating the monitor with a certain standard, and the other is making sure that the profile of the ink/paper/printer combination you use is correct. This was once an arduous task, but has been made much easier with the use of software wizards that walk you through the process. The whole point is to make sure, for example, that pixel value "X" on the computer screen will look like pixel value "X" the print.

Calibration packages usually include hardware and software. These examples illustrate screens from a step-by-step wizard that makes the calibration process easy to perform.

It is best to use a monitor that is geared toward graphics work. I use a Macintosh. I rarely see mismatches between screen and print when using this monitor connected to my Mac laptop or tower, as long as I have the proper paper profile set. At minimum, the monitor should allow options to change contrast, brightness, and color settings (magenta/green and blue/yellow). Check the photographic forums and other online resources for current models that other photographers use.

If you print from a laptop, be careful about ambient light and the angle of the monitor's tilt. You will notice quite different contrast and colorization on a laptop depending on the type of light (outdoors, indoors) and the angle at which the monitor is set. When printing, try to keep the tilt and light as close as possible to what they were when you last calibrated. This can be tough with a laptop, but you should be aware of the effect these factors have on the appearance of contrast and tones.

You can always test your equipment before calibrating to determine if different settings are needed. Some people assume they will require major adjustments to their screen, but that may not be the case (though monitors can shift in color or contrast over time). Hold a sheet of the photo paper on which you plan to print next to a blank document (white) on the display. If the white document on the display doesn't match the white of the actual paper, then you will definitely need to calibrate your monitor.

Third-party calibration products are usually sold as hardware and software combinations that help you make color value and luminance (brightness) settings for your display. This usually involves attaching a device to the screen and following a wizard that leads you through the calibration process. A series of color patches on the monitor is read by the device to set the International Color Consortium (ICC—a color management industry standard organization) profile for the display.

computer-related, profiles get tweaked and updated, so check the printer company's web site occasionally to see if the profiles have changed.

Other profiles can be obtained from third-parties. If you use paper not from the printer manufacturer (and there is no reason not to), you can usually download profiles from that paper company's web site for your specific printer. If the paper company does not offer profiles, you can create a custom profile using specially dedicated hardware/software packages. This can take a few hours and the profiling package can be quite expensive.

Paper Profiles

All the calibration in the world will not be much help if you fail to use the paper profile in your print setup. A paper profile is simply a set of instructions sent from the computer to the printer that informs the printer how to render the image with the specific paper and ink you will be using. (If you want to see the result of a profile mismatch, print on glossy paper with a matte paper profile, or vice versa—it is not a pretty sight.)

A profile exists for the printer, the paper, and the ink—they all work together. Many profiles are provided by the printer manufacturer when you install the printer software (these companies also sell their own brands of paper and ink for use with their printers). However, do not count on these profiles being the most current information available. Like all things

```
e-sRGB
HP Photosmart 8700-Premium High-Gloss Film(tricolor+bluephoto+black)
HP Photosmart 8700-Premium High-Gloss Film(tricolor+bluephoto+gray)
HP Photosmart 8700-Premium High-Gloss Film(tricolor+photo+black)
HP Photosmart 8700-Premium High-Gloss Film(tricolor+photo+gray)
HP Photosmart 8700-Premium Paper(tricolor+bluephoto+black)
HP Photosmart 8700-Premium Paper(tricolor+bluephoto+gray)
HP Photosmart 8700-Premium Paper(tricolor+photo+black)
HP Photosmart 8700-Premium Paper(tricolor+photo+gray)
HP Photosmart 8700-Premium Plus Photo(tricolor+bluephoto+black)
HP Photosmart 8700-Premium Plus Photo(tricolor+bluephoto+gray)
HP Photosmart 8700-Premium Plus Photo(tricolor+photo+black)
HP Photosmart 8700-Premium Plus Photo(tricolor+photo+gray)
hp7960 - hp photo paper - 6 ink
hp7960 - hp photo paper - 8 ink
hp7960 - hp premium high gloss film - 6 ink
hp7960 - hp premium high gloss film - 8 ink
hp7960 - hp premium paper - 6 ink
hp7960 - hp premium paper - 8 ink
hp7960 - hp premium plus photo paper - 6 ink
hp7960 - hp premium plus photo paper - 8 ink
hp7960 - plain paper - 8 ink
KODAK DC Series Digital Camera
Nikon WinMonitor 4.0.0.3000
NTSC (1953)
PAL/SECAM
Pro4800 ARMP_MK
Pro4800 ARMP_PK
Pro4800 EMP_MK
Pro4800 EMP_PK
Pro4800 PGP
Pro4800 PGPP
Pro4800 PGPP250
Pro4800 PLPP
Pro4800 PLPP250
Pro4800 PPG250
```

Profiles are available from the printer manufacturer and are usually downloaded to your computer when you install the printer software—also known as the printer driver. Select the matching profile from the Printer Profile drop-down in the processing program.

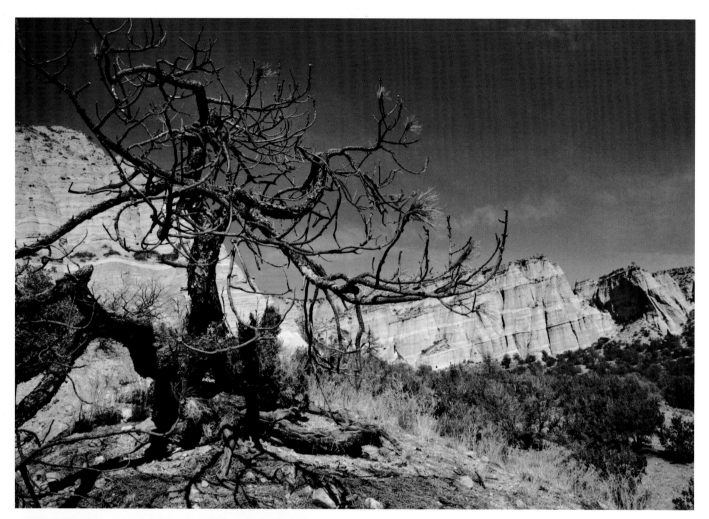

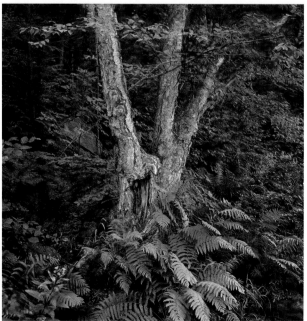

I usually print a cool or neutral image (above) on a neutral or bright white paper. On the other hand, a warmer paper provides a type of "underpainting" to a print, which can enhance a warm-toned image, like the ferns surrounding this tree trunk (left).

Papers

There is a wide variety of photo paper available in every price range, giving you a number of choices for printing your photos. Everyone has opinions about the best paper for their images, and I am not about to suggest one over another, as it is largely a matter of personal preference. I will say that a high gloss finish is not something favored by galleries or, in general, collectors and buyers of prints. The prevailing wisdom is that a fairly heavy paper with a semi-gloss (pearl or luster) surface is preferable. There are numerous papers that are labeled exhibition-quality, and generally you

get what you pay for in this market. I suggest getting sampler packs, or even going to a dealer or web site and getting swatch books with the various surfaces and weights to see which samples most appeal to you.

Papers come in warm (almost yellow white), neutral (bright but not "hard" white) and cold (stark white) coloration. These differences can effect your images. The differences can seem subtle, but if you place different types of paper side by side, you will soon realize there are many choices, like comparing the different "off-white" sample swatches at a designer paint store.

As you gain more experience printing your photos, you'll see which papers match the different tones in your images. I suggest you choose two or three surfaces and stick with them. You will get to know the papers, how they work with different types of images, how they work with toned and colorized images, and how well they reproduce shadow and highlight values.

Inks

There are two types of inks, thus two general types of printers: dye and pigment. Dye inks are generally thought to be richer in color; pigment inks are said to be more archival (longer lasting), at least when used with certain papers. Past differences along these lines have narrowed, however. The main distinction is the way pigment inks create grayscale values. In dye ink printers, gray and light gray are

```
---- Photo Black ----
  Premium Luster Photo Paper
✓ Premium Glossy Photo Paper
  Premium Semigloss Photo Paper
  Proofing Paper Semimatte
  Plain Paper - Photo Black
---- Matte Black ----
  Enhanced Matte Paper
  Archival Matte Paper
  Velvet Fine Art Paper
  UltraSmooth Fine Art Paper
  Watercolor Paper - Radiant White
  Photo Quality Ink Jet Paper
  Singleweight Matte Paper
  Plain Paper - Matte Black
```

Choose between Photo Black and Matte Black when matching paper to pigment inks. This listing from an Epson printer shows the matches between the ink and paper surface.

usually created by using black ink and another color: It's a color composite grayscale. I use pigment ink printers because they have black, light black, and very light black ink (grays) for creating grayscale values. Yes, some color is used (and of course color ink is used when you make toned prints), but not nearly in the proportion used by dye ink printers. The pigment ink printers therefore yield rich black and white prints, while nearly eliminating color casts on the print.

In many pigment ink printers, you might have an option to work with Matte Black or Photo Black inks (you might have to swap these out when you choose one or the other using some older printer models). Photo Black ink is used on glossy, semi-gloss, and luster surfaces, while matte black inks are used on art papers (flat matte or watercolor surfaces that are usually thicker stock). In some cases, choosing a certain paper in the profile will result in the printer automatically switching inks for you.

Printing Step by Step

Begin the printing process from the Image Size dialog box in your image-processing program. Depending on the size of the image file you have to work with (Pixel Dimensions), you can choose the Resolution (in pixels per inch, ppi) and print size (or Document Size) in terms of Width and Height. These values are interdependent, so you cannot choose a larger print size than is possible for the selected resolution. If you tried to do so, you would have to decrease resolution or have the program "manufacture" additional image information by using the resampling option.

For a given file size, lower resolutions will result in larger print sizes, but will not provide as sharp an image as higher resolutions. For good printing results, the resolution should be between 200 and 260 ppi, depending on the file size. Larger files are able to withstand a bit less resolution. Some photographers advocate that 300 ppi is an optimal resolution for making prints, but I find that 240 ppi is best for most black-and-white landscape printing.

If you set a resolution of 240 ppi and the print size is less than you desire, you can use the resampling tools in your program to increase print size, or utilize a third-party program such as onOne's Genuine Fractals. Resampling allows you to make a print larger than the resolution or the file size normally allow.

The Image Size dialog box shows the relationship between print size and resolution. For the same sized file (23.4 megabytes), a print with 72 ppi selected in the Resolution field (top) will print at a size bigger than 48 x 32 inches (122 x 91 cm—although you should not make prints at 72 ppi because that resolution is far too low to create a sharp print!). If Resolution increases to 200 (lower illustration), the print size correspondingly decreases to approximately 17 x 11 inches (432 x 280mm).

However, both resampling and third-party methods construct new information from old (therefore adding to the size of the image file), and there is a point beyond which image quality noticeably deteriorates.

A. Resolution set to 300 ppi for an image file that is 27.5 megabytes will print at approximately 6 x 9 inches (148 mm x 210 mm).

B. By decreasing the resolution to 240 ppi, the print size will increase to 7.5 x 11 inches (191 mm x 279 mm) for the same file (27.5 megabytes).

C. However, to enlarge the print size to 10 x 14.8 inches (254 mm x 376 mm) while keeping the resolution at 240 ppi, I checked the Resample Image box. This adds data to the file. I selected the option for Bicubic Smoother. This almost doubles the file size to 48.8 megabytes, a manufactured increase that is within the bounds of the program's ability for this particular file.

Use resampling judiciously. I have gotten good results with a modest application of the resampling function. It works best when increases in print size are kept within certain limits and when used for images without a great amount of detail. It is a good idea to test in order to determine the acceptable limits with the resampling program that you use.

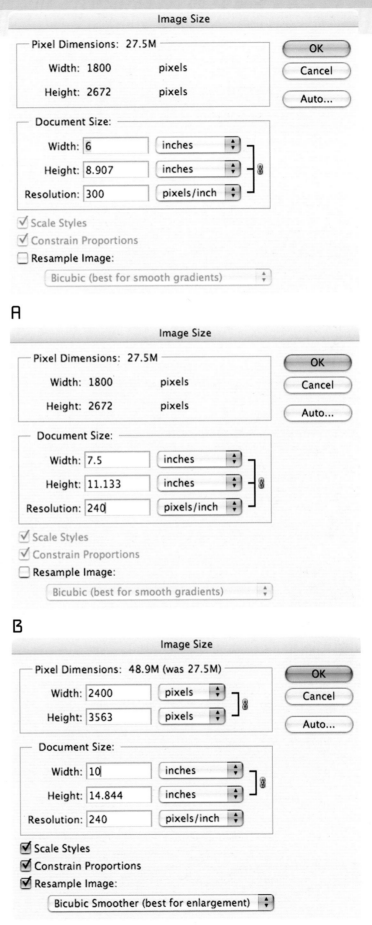

The Page Setup dialog lets you choose the printer and communicates to the printer the size of paper you are using. This illustrates settings for the printer using a 13 x 19 inch (353 mm x 500 mm) paper manually feed from the rear. This step is crucial because any conflict between the loaded paper and the paper identified in the drop-down will stop the printing and force you to change either the paper or the information before you can proceed.

The illustration above shows the Print window (File > Print) for a Macintosh operating system running Photoshop CS3 and connected to an Epson 3800 printer. This may not look exactly like the print window on your setup, but they all ask for essentially the same information. After confirming the information in this box, I click the Print button to display the print box shown at right, which is used to inform the system that Color Management will not be handled by the printer.

Once you have set the dimensions in the Image Size dialog, find the Page Setup dialog box in you image-processing program. Here you choose the printer (should you have more than one available) and paper size. When using heavy-weight paper, you might have to load it from the rear or through a front loading slot rather than via a paper tray. How you load it should be part of the paper selection in Page Setup as well. Failure to properly identify how you are loading the paper will usually get you a blinking light and a misfeed signal when you try to print.

The next step is setting up what I refer to as the "printer/computer handshake." Each printer and operating system will offer a different dialog box (I won't attempt to recreate them all here). They all ask for essentially the same information: Is color management being handled by the image-processing program (here Photoshop) or the printer? What paper is being used?

In the sample dialog box on the opposite page, bottom left, I have chosen to let Photoshop handle color (Color Handling drop-down). I usually do not want the printer handling the color.

Just beneath that section in the dialog box, I select the Printer Profile from the list available in that drop-down. Here I have selected an Epson paper with a code: Pro38 EMP, which means enhanced matte paper for the Pro 3800 model printer; note that both the printer and paper choices are important here. Then I choose Relative Colormetric for a true rendition of the chosen adjustments, and finally check the box for Black Point Compensation.

The next step is to hit the Print button in the lower right of the dialog. This does not start the printing yet; it displays another dialog box with drop-downs (opposite, bottom right). This dialog informs the system that you are not using the printer for color management. Do this by selecting Printer Color Management in the lowest drop-down menu, then marking the choice for Off (No Color Adjustments). Now you can print away.

Though some advanced photographers may create special printer-managed setups, it is usually best to have your image-processing program handle color management when printing.

Most of the work in making prints comes in the image processing stage of the work. Printing is a fairly mechanical output, on paper, of that processing work. There is nothing artful about the actual printing process itself; in fact, the more automatic you can make it, the better. The work in printing comes in preparing the method for color management and the proper profiling of the paper you use. Once you test and properly set up the printing process, you should be able to make prints that match what you see on your screen.

The goal is to spend your time making expressive images in the shooting and processing stages, so that all you have to do at the print stage is to click your mouse a few times to print an image. If you find yourself struggling with the mechanics, you should step back and review the steps for creating the print. Once the image is on the screen, the printing should go one, two, three.

Glossary

angle of view
The area that can be recorded by a lens, usually measured in degrees across the diagonal of the film frame. Angle of view depends on both the focal length of the lens and the size of its image area.

anti-aliasing
A technique that reduces or eliminates the jagged appearance of lines or edges in an image by filling in nearby pixels with intermediate values.

aperture
The opening in the lens that allows light to enter the camera. Aperture is usually described as an f/number. The higher the f/number, the smaller the aperture; and the lower the f/number, the larger the aperture.

artifact
Information that is not part of the scene but appears in the image due to technology. Artifacts can occur in film or digital images and include increased grain, flare, static marks, color flaws, noise, etc.

automatic exposure
An option in which the camera computer system measures light and adjusts shutter speed and lens aperture to create proper image density on sensitized media.

automatic focus
When the camera automatically adjusts the lens elements to sharply render the subject.

available light
The amount of illumination at a given location that applies to natural and artificial light sources but not those supplied specifically for photography. It is also called existing light or ambient light.

backlight
Light that projects toward the camera from behind the subject.

bit depth
The number of bits per pixel that determines the number of colors the image can display. Eight bits per pixel is the minimum requirement for a photo-quality color image.

bracketing
A sequence of pictures taken of the same subject but varying one or more exposure settings, manually or automatically, between each exposure.

brightness
Intensity of light energy, measured by the amplitude of the light vibrations. See also, luminance.

card reader
A device that connects to your computer and enables the quick and easy download of images from memory card to computer.

chromatic aberration
Occurs when light rays of different colors are focused on different planes, causing loss of sharpness and colored halos around objects in the image.

close-up
A general term used to describe an image created by closely focusing on a subject. Often involves the use of special lenses or extension tubes. Also, an automated exposure setting that automatically selects a large aperture (not available with all cameras).

contrast
The difference between two or more tones in terms of luminance, density, or darkness.

contrast filter
A colored filter that lightens or darkens the monotone representation of a colored area or object in a black-and-white photograph.

critical focus
The most sharply focused plane within an image.

cropping
The process of extracting a portion of the image area. If this portion of the image is enlarged, resolution is subsequently lowered.

depth of field (DOF)
The image space in front of and behind the plane of focus that appears acceptably sharp in the photograph. Determined by aperture, focal length, and subject distance.

EV
Exposure value. A number that quantifies the amount of light within an scene, allowing you to determine the relative combinations of aperture and shutter speed to accurately reproduce the light levels of that exposure.

EXIF
Exchangeable Image File Format. This format is used for storing an image file's interchange information.

exposure
When light enters the camera and reacts with the sensitized medium. The term can also refer to the amount of light that strikes the light sensitive medium.

file format
The form in which digital images are stored and recorded, e.g., JPEG, RAW, TIFF, etc.

filter
Usually a piece of plastic or glass used to control how certain wavelengths of light are recorded. A filter absorbs selected wavelengths, preventing them from reaching the light sensitive medium. Also, software available in image-processing computer programs can produce special filter effects.

focal length
When the lens is focused on infinity, it is the distance from the optical center of the lens to the focal plane.

focal plane
The plane perpendicular to the axis of the lens that is the sharpest point of focus.

focus
An optimum sharpness or image clarity that occurs when a lens creates a sharp image by converging light rays to specific points at the focal plane. The word also refers to the act of adjusting the lens to achieve optimal image sharpness.

f/stop
The size of the aperture or diaphragm opening of a lens, also referred to as f/number or stop. The term stands for the ratio of the focal length (f) of the lens to the width of its aperture opening. (f/1.4 = wide opening and f/22 = narrow opening.) Each stop up (lower f/number) doubles the amount of light reaching the sensitized medium. Each stop down (higher f/number) halves the amount of light reaching the sensitized medium.

gray card
A card used to take accurate exposure readings. It typically has a white side that reflects 90% of the light and a gray side that reflects 18%.

grayscale
A successive series of tones ranging between black and white, which have no color. Also, an image with purely luminance data and no chroma information.

histogram
A two-dimensional graphic representation of image tones. Histograms plot brightness along the horizontal axis and number of pixels along the vertical axis, and are useful for determining if an image will be under or overexposed.

image-processing program
Software that allows for image alteration and enhancement.

interpolation
Process used to increase image resolution by creating new pixels based on existing pixels. The software intelligently looks at existing pixels and creates new pixels to fill the gaps and achieve a higher resolution.

ISO
A term for industry standards from the International Organization for Standardization. When an ISO number is applied to film, it indicates the relative light sensitivity of the recording medium. Digital sensors use film ISO equivalents, which are based on enhancing the data stream or boosting the signal.

JPEG
A lossy compression file format that examines an image for redundant information and then removes it. At low compression/high quality, the loss of data has a negligible effect on the photo. However, JPEG should not be used as a working format—the file should be reopened and saved in a format such as TIFF, which does not compress the image.

lens
A piece of optical glass on the front of a camera that has been precisely calibrated to allow focus.

lens hood
Also called a lens shade. This is a short tube that can be attached to the front of a lens to reduce flare. It keeps undesirable light from reaching the front of the lens and also protects the front of the lens.

light meter
Also called an exposure meter, it is a device that measures light levels and calculates the correct aperture and shutter speed.

macro lens
A lens designed to be at top sharpness over a flat field when focused at close distances and reproduction ratios up to 1:1.

Manual exposure mode
A camera operating mode that requires the user to determine and set both the aperture and shutter speed. This is the opposite of automatic exposure.

memory
The storage capacity of a hard drive or other recording media.

memory card
A solid state removable storage medium used in digital devices. They can store still images, moving images, or sound, as well as related file data. There are several different types, including CompactFlash, SmartMedia, and xD, or Sony's proprietary Memory Stick, to name a few.

menu
A listing of features, functions, or options displayed on a screen that can be selected and activated by the user.

middle gray
Halfway between black and white, it is an average gray tone with 18% reflectance. See also, gray card.

midtone
The tone that appears as medium brightness, or medium gray tone, in a photographic print.

noise
The digital equivalent of grain, appearing as random dots or changes in color value in an image. It is often caused by a number of different factors, such as a high ISO setting, heat, sensor design, etc. Though usually undesirable, it may be added for creative effect using an image-processing program. See also, chrominance noise and luminance.

overexposed
When too much light is recorded with the image, causing the photo to be too light in tone.

perspective
Visual cues in a two-dimensional image that give the impression of the three-dimensional space between the camera and image elements. Such cues include lines converging towards a vanishing point, aerial haze, difference sizes of common objects, different zones of focus, etc.

pixel
Derived from picture element. A pixel is the base component of a digital image. Every individual pixel can have a distinct color and tone. All other things being equal, more pixels in a digital image results in higher quality, though this is affected as well by bit depth and pixel density.

plug-in
Third-party software created to augment an existing software program.

Program mode
In Program exposure mode, the camera selects a combination of shutter speed and aperture automatically.

RAW
An image file format that has little internal processing applied by the camera. It contains 12-bit color information, a wider range of data than 8-bit formats such as JPEG.

RAW+JPEG
An image file format that records two files per capture; one RAW file and one JPEG file.

resolution
The amount of data available for an image as applied to image size. It is expressed in pixels or megapixels, or sometimes as lines per inch on a monitor or dots per inch on a printed image.

RGB mode
Red, Green, and Blue. This is the color model most commonly used to display color images on video systems, film recorders, and computer monitors. It displays all visible colors as combinations of red, green, and blue. RGB mode is the most common color mode for viewing and working with digital files onscreen.

saturation
The degree to which a color of fixed tone varies from the neutral, grey tone; low saturation produces pastel shades whereas high saturation gives pure color.

sharp
A term used to describe the quality of an image as clear, crisp, and perfectly focused, as opposed to fuzzy, obscure, or unfocused.

Shutter-priority mode
An automatic exposure mode in which you manually select the shutter speed and the camera automatically selects the aperture.

SLR
Single-lens reflex. A camera with a mirror that reflects the image entering the lens through a pentaprism or pentamirror onto the viewfinder screen. When you take the picture, the mirror reflexes out of the way, the focal plane shutter opens, and the image is recorded.

standard lens
Also known as a normal lens, this is a fixed-focal-length lens usually in the range of 45 to 55mm for 35mm format (or the equivalent range for small-format sensors). In contrast to wide-angle or telephoto lenses, a standard lens views a realistically proportionate perspective of a scene.

stop down
Reduces the size of the diaphragm opening by using a higher f/number.

stop up
Increases the size of the diaphragm opening by using a lower f/number.

telephoto effect
When objects in an image appear closer than they really are through the use of a telephoto lens.

telephoto lens
A lens with a long focal length that enlarges the subject and produces a narrower angle of view than you would see with your eyes.

TIFF
Tagged Image File Format. This popular digital format uses lossless compression.

tripod
A three-legged stand that stabilizes the camera and eliminates camera shake caused by body movement or vibration. Tripods are usually adjustable for height and angle.

vignetting
A reduction in light at the edge of an image due to use of a filter or an inappropriate lens hood for the particular lens.

wide-angle lens
A lens that produces a greater angle of view than you would see with your eyes, often causing the image to appear stretched. See also, short lens.

zoom lens
A lens that can be adjusted to cover a wide range of focal lengths.

Index

4/3 sensor *see sensor, 4/3*

A

abstract images 19, **42–43**

Adobe Bridge 108

Adobe RGB 58

aperture 41, 62, 63, 69, 77, 79–80, **83**, 84, 85, 93, 94, 98, 103

Aperture-priority mode 62, **93**, 97, 98

Apple Aperture 08

APS-C *see sensor, APS-C*

autoexposure bracketing (AEB) **70**, 73, **98**, 105, 139

autoexposure lock (AEL) 73, 94, **96**

autofocus (AF) *see focusing, autofocus*

B

Bayer pattern 14, 76

Bibble 108

bracketing *see autoexposure bracketing*

Bridge *see Adobe Bridge*

brightness 13, 15, 26, 28, 32, 42, 57, 76, 88, 90, 92, 104, 105, 145

burning 78, 109, 120, 126–127, 128

C

Calibration (monitor) 144–145

Camera Raw *see Photoshop Camera Raw*

camera support *see tripod*

Capture One 108

Center-weighted Average metering *see metering, Center-weighted average*

clipping 100, 102, **118–119**

close-up photography *see macro photography*

color cast 59, 142, 147

color contrast filters 13, **26–27**, 58

color correction (software techniques)

color management
 monitor 144–145
 printing 142, 150–151

color space 57, **58**, 110

colorization 131, **134**

composition **36–52**

compositional zones **48**

compression 56, 57

computer monitor *see monitor, computer*

contrast 9, 14, 28, 32, 60, 85, 86, 104, 111, 112, **116–118**, 120, 128, 138, 144

conversion to grayscale 13, 14, 26, 27, 42, **56–57**, 108, **109–112**

curves 111, **116–119**, 128, 138

custom functions **73**

D

density **12**, 26, 126

depth of field 40, **61–65**, 69, 83

depth-of-field preview 63, 69

digital filters (in camera) *see monochrome digital filters*

dodge 78, 111, 120, 128

driver *see printer driver*

duotones 129, **131–132**

DX sensor *see sensor, APS-C*

dynamic range 60, 74, **85–87**, 92
 see also High Dynamic Range (HDR)

E

equivalent exposure **84–85**, 93

exposure **74–105**

exposure compensation 32, 73, 89, 91, 94, **97**, 102

exposure modes **93–95**

exposure value (EV) 70, 81, **84–85**, 139

F

file formats 13, **56–57**

 JPEG 13, 14, 54, 56, 57, 589, 106, 111

 TIFF 13, 56, 57, 106, 111

 RAW **13**, 56, 57, 106, 111

filters

 in-camera 26, **27**, 58

 infrared 30, 31

 lens 26, 42, 58

 software 110, 113, 128, 133, 141

focal length 40, 61, 62, 72, 73, 83

focal length magnification factor 83

focusing 66

 autofocus **66**, 69, 90, 95

 manual 66, 69, 73, 96

foreshortening **40**

f/stop 83, 97

 see also aperture

full-frame *see sensor, full-frame*

G

grain **140**

grayscale 14, 19, **24–27**, 36, 42, 56–57, 58, **92**, 108, 111, 131, 142, 147

H

handholding 30, 69, 79, 81, 82, 83, 84, 9h

histogram **102**, 105, 116

high contrast **138**

high dynamic range (HDR) 98

highlight warning 100, **102**, 105

hue/saturation 129, 137

hyperfocal distance **62**, 95

I

ICC (International Color Consortium) 145

interpretation 14, 16, **19**, 20

image processing **106–141**

image stabilization (IS) system 73, 81

infrared photography **30–31**

inks 132, 147

interpolate 23

 see also resample image

ISO 60, 72, **79–80**, 84, 85, 93

J

JPEG *see file formats, JPEG*

K

key

 high key **18**, 102

 low key **18**, 29, 102

L

Layers **113**, 120, 126, 128, 13

Layer Mask **113**, 134

LCD screen *see monitor, LCD*

lens(es) 40

 macro 40

 normal 40

 telephoto 40, 63, 82, 83

 wide-angle 40, 48, 95

 zoom 62, 93

light 8, 9, 19, **28–29**, 30–31, 47

Lightroom 106, 108, 110, 133

Lightzone 108

low saturation 125, **137**

M

macro lens *see lens, macro*

macro photography 69

magnification factor *see focal length magnification factor*

Manual exposure mode **94–95**, 98, 104

megapixels (MP) 13

memory card 54, 57, 76, 106

merge 70, 99

metering 84, **88–93**

 Center-weighted average 89, **90**, 96, 104

 Multi-pattern 89, **90**, 104

 Spot 29, 32, 89, **91**, 104, 105

midtones 26, 53, 126

monitor

 computer 12, 142, 144

 LCD (camera) 24, 54, 58, 100

monochrome digital filters 27, 59

multi-pattern metering *see metering, multi-pattern*

N

Noise 60, 74, 79, 80, 88, 140

noise reduction 80

normal lens *see lens, normal*

neutral

 color adjustment 126, 128, 142

 paper property 146, 147

O

overexpsoure 34, 85, 89, 90, **91**, 92, 97, 100, 101, 102, 104

P

Paint Shop Pro 108

Panchromatic **26**, 27, 35, 42 108, 112

paper (for photo prints) 133, 145, **146–147**

perspective **40**

photo finishing lab 23, 54

Photoshop 56, 106, 108, 110, 111, 114, 123, 124, 131, 133, 141, 150, 151

Photoshop Camera Raw 13, 56, 57, 108

plug-ins 57, 106, 108, 122, 129, 137, 139, 140, 141

ppi (pixels per inch) 57, 148, 149

previsualization 35, **52**, 53

printer 12, 57, 106, 108, 117, 142–147

printer driver 145

printing 142–151

profiling 144, 145, 151

Program exposure mode **93**, 97

Q

quality (of image files) 56, 57

R

RAW *see file formats*

RAW conversion (software) **108**

resample image 148, 149

resolution

 image file 12, 56, 110

 optical 23

 printer 148–149

RGB (color channels) **14**, 26, 27, 30, 58, 77, 111, 131

rule of thirds **38**

S

scanning **22–23**

selection tools 120, **121–123**, 124 125

selective focus 40

selective adjustments 120–128

sensor 12, 30, 60, 74, 76, 79, 83, 85, 101, 104

 4/3 12

 APS-C (DX) 12

 full-frame (FX) 12

sharpening (software) 128

sharpness (lens/image) 40, **61–66**, 83

Shutter-priority mode 83, **93**, 97, 98

shutter release **72**, 96

shutter speed 30, 72, 77, 79, **80–83**, 84, 88, 93, 94, 97, 98, 101

Silkypix 108

spot metering *see metering, spot*

sRGB 58

stacking **40**

T

telephoto lens *see lens, telephoto*

TIFF *see file formats*

tonality 9, 12, 14, 18, 76, 100, 142

tone curve 31, 35, 58, **60**

toning 9, 35, 59, 113, **129–132**

tripod 9, 31, 69, 72, 73, 79, 81, 82, 85, 86, 98, 139

V

viewfinder 12, 30, 34, 63, 66, 72, 90, 91, 94, 95, 142

W

wheel and spoke **39**

wide-angle lens *see lens, wide-angle*

workflow 57, 106, 111, 112, **128**

Z

zoom lens *see lens, zoom*